PATTERN IN THE MATERIAL FOLK CULTURE

OF THE EASTERN UNITED STATES

UNIVERSITY OF PENNSYLVANIA
PUBLICATIONS IN FOLKLORE AND FOLKLIFE

Editor: Kenneth S. Goldstein; *Associate Editors:* Dan Ben-Amos,
Tristram Potter Coffin, Dell Hymes, John Szwed, Don Yoder;
Consulting Editors: Samuel G. Armistead, Maria Brooks, Daniel
Hoffman, David Sapir, Biljana Sljivic-Simsic

PATTERN IN
THE MATERIAL
Folk Culture
OF THE EASTERN
UNITED STATES

BY *Henry Glassie*

Philadelphia University of Pennsylvania Press

This small book is dedicated to the memory of

CARL J. POCH

a craftsman who could build
with precision and spirit
anything from a dulcimer to a house,
from childish delight to a manly philosophy

Apology and Acknowledgment

This is not a survey of a well-ordered subject field with an impressive bibliography, definite methods, and goals. It is an impressionistic introduction—an essay with which I have fussed for a year and a half in hopes of stimulating work in an area which has not received the study it needs. Toward this end I have attempted to discover patterns where patterns are unclear and may not exist (the line between pattern and oversimplification is a fine one), to offer a set of ideas which others can try, discard, or modify, and to utilize suggestive examples which have taken me out to the ends of some pretty weak limbs.

The concepts and examples in this essay result primarily from fieldwork. Many of the figures present unassimilated bits of this work; they are captioned with place and date of collection; in the conventional sense, these are my contribution. The text includes parenthetical references to this data and a synthesis of the impressions brought in from the field during the last seven years. The brevity of this period, I think, gives this essay a modern tone and an easily assailed naivete.

The number of footnotes might seem to contradict the defensive claim that this is a field product. Some of them, indeed, give my sources, but more are designed so that they provide a loose bibliographical essay. The lists of works in the footnotes are not complete; I know works not cited; other scholars know of a host of works I should have found, and I did not cite most works

more than once, although near complete bibliographies of the subjects treated would have required repetitious reference. The footnotes should lead you away from this essay and suggest to you the kinds of sources which yield folk cultural information. The bibliography lists the works mentioned in the footnotes plus a few which influenced my thought but to which it was not convenient to make direct reference. It is there for you to browse through and was constructed mainly to help you to find the works I used.

We students of folklife have talked too much in the past tense, our methods have been too few, our fields of investigation too limited. Our energies could be easily dissipated in a picayune ballad-style war of origins and feverish antiquarian collecting dealing with a tiny piece of culture, say, the log cabin. I would have preferred to spend the time I put into this essay writing up the results of one of the field projects I have completed. And I would have liked to have spent more time putting this together. But, I became concerned about the narrowness of material folk culture studies—my own particularly—and I felt that I should attempt to write something which might enable some of those who are becoming interested in material folk culture in America to sidestep a few comfortable pitfalls, and which might goad others into action.

My greatest debt is to Professor Fred Kniffen, who sparked my interest in material culture and who has remained a constant inspiration and friend. Without him both this book and I would have been quite different.

I owe much to my university professors, to Munro S. Edmonson, who suffered through an independent studies course with me during my mountain ballad collecting phase and showed me new ways to think; to Louis C. Jones and Bruce Buckley at Cooperstown; and to MacEdward Leach, Kenneth Goldstein, Don Yoder, and Tristram P. Coffin at the University of Pennsylvania. Ideas which originated with all of these men can be found in the

following pages, though none could agree with everything in this essay.

I have, in addition, benefited greatly from discussions with Professors E. Estyn Evans, Warren E. Roberts, Norbert F. Riedl, Austin E. Fife, James Marston Fitch, and Bernard L. Fontana, and with Ralph Rinzler and Michael Owen Jones.

Donald M. Winkelman suggested that I write an introduction to material folk culture and many have helped in the research his suggestion and my obsessive interest necessitated. Personnel at the libraries of the University of Pennsylvania, Columbia University, the Adirondack Museum, the Pennsylvania Historical and Museum Commission, the New York State Historical Association, the Marine Historical Association, and the Library of Congress hunted up books for me. I was given cordial access to the private libraries of Fred Kniffen, Eric de Jonge, David Winslow, Kenneth Goldstein, and Don Yoder. I was helped in obtaining information by Minor Wine Thomas, Jr., George Campbell and Per E. Guldbeck of the Farmers' Museum, Cooperstown, New York; Edmund E. Lynch, Marine Historical Association, Mystic, Connecticut; Darrell D. Henning, Nassau County Historical Museum, Long Island, New York; A. L. Cook, Hadley Farm Museum, Hadley, Massachusetts; Robert C. Bucher, Historic· Schaefferstown, Inc., Schaefferstown, Pennsylvania; Donald McTernan, Hagley Museum, Wilmington, Delaware; and H. J. Swinney, Adirondack Museum, Blue Mountain Lake, New York.

It is customary to state that one's informants were so numerous that a list of their names would be too lengthy to publish. Although this is true again, there are some who were outstandingly helpful while the material you will find in this essay was being gathered: William Houck, Vernon Center, N.Y.; Willis Barsheid, Palatine Bridge, N.Y.; Mr. and Mrs. Jesse Wells, Toddsville, N.Y.; Mrs. Ken Tyler and Mr. and Mrs. Fenton Wedderspoon, Pierstown, N.Y.; Dorrance Weir, Oaksville, N.Y.; F. H.

Shelton, Kerhonksen, N.Y.; Herman Benton, Livingston Manor, N.Y.; Marie Kocyan, Wilkes-Barre, Pa.; Ralph Wagner, Harrisburg, Pa.; Mr. and Mrs. John Brendel, Reinholds, Pa.; John O. Livingston, Mt. Pleasant, Pa.; H. F. Dautrich, Reading, Pa.; Joseph Grismayer, Lebanon, Pa.; Leonard Divers, Philadelphia, Pa.; Lou Sesher, Lock Four, Pa.; Ola Belle Reed, Rising Sun, Md.; Alice Poch, Washington, D.C.; Robert Johnson, Port Royal, Va.; Robert Tribble, Tappahannock, Va.; Otis Banks and N. O. Rigsby, Orchid, Va.; Lee Bradshaw, Mineral, Va.; B. B. Harris, Gum Spring, Va.; Mrs. George Hall, Boonesville, Va.; Roy Hedrick, Alderson, W. Va.; N. T. Ward, Leonard and Clifford Glenn, Charlie Trivett, and Mr. and Mrs. Mack Presnell, Sugar Grove, N.C.; Mr. and Mrs. J. E. Cison, Brevard, N.C.; Mrs. Gordon Turner, Del Rio, Tenn.; Raymond Tanksley, Ooltewah, Tenn.; Homer Martin, Alpharetta, Ga.; Richard Hutto, Oakman, Ala.; Ervin Bell and Wicks Henry, Philadelphia, Miss.; Mr. and Mrs. T. B. Everett, Enterprise, Miss.; Clarence A. Zeringue, Vacherie, La.

While the tedious last drafts were being prepared at night, I was kept happily busy during the day at the Pennsylvania Historical and Museum Commission by the best bosses a bureaucratic folklorist could have: S. K. Stevens, Donald H. Kent, and Mae Kruger.

Steady help was provided by my family. My grandmother proved a marvelous informant. My father took many pictures of buildings in Europe for me which helped in comparative statements. My mother kept a lookout for the odd sort of books I like. My wife, Betty-Jo, and children, Polly and Harry, ungrumblingly accompanied me on many long, exhausting journeys in the backwoods and welcomed me home from the others. Betty-Jo typed the manuscript and checked the bibliography.

Dillsburg,
Pennsylvania
February, 1968

Contents

Illustrations

in other disciplines, folklorists fret about the definition of their subject. Today, they are studying things as different as West African tales, Irish fiddle tunes, the superstitions of American college students, and Czechoslovakian plows; a simple definition which can comfortably cover such a variety of interests is not easily invented. The American folklorist, whether trained in literature or anthropology, thinks of folklore mainly in terms of oral traditions: the verbal arts or oral literature of all types of culture. In Europe the meaning of folklore, whether called regional ethnology or rendered *Volkskunde*, has expanded in the opposite direction; there scholars are concerned with folk-life: anything—customs and material as well as oral traditions—which is folk cultural. Through his concern with the "lore" half of the word, the American scholar has

come up with a consistent definition for folklore studies;[1] the European scholar by looking at the "folk" part has arrived at a different but equally logical definition.[2] The subject matter of the folklorist's discipline as exposed in scholarly publication, as taught in the universities, should encompass both the American's oral traditions and the European's folklife.

The objects that man has learned to make are traditionally termed material culture. Culture is intellectual, rational, and abstract; it cannot be material, but material can be cultural and "material culture" embraces those segments of human learning which provide a person with plans, methods, and reasons for producing things which can be seen and touched. The material culture within the United

[1]See Francis Lee Utley, "Folk Literature: An Operational Definition," and William R. Bascom, "Folklore and Anthropology," in Alan Dundes, ed., *The Study of Folklore* (Englewood Cliffs, N.J., 1965), pp. 7–33. See too: Richard M. Dorson, ed., *Folklore Research Around the World: A North American Point of View* (Bloomington, 1961); Alan Dundes, "The American Concept of Folklore," *Journal of the Folklore Institute*, III:3 (December, 1966), pp. 226–249.

[2]See Sigurd Erixon, "Regional European Ethnology," *Folkliv*, 1937:2/3, pp. 89–108; 1938:3, pp. 263–294; Sigurd Erixon, "Folklife Research in Our Time," *Gwerin*, 3 (1962), pp. 271–291; Sigurd Erixon, "European Ethnology in Our Time," *Ethnologia Europaea*, I:1 (1967), pp. 3–11; Don Yoder, "The Folklife Studies Movement," *Pennsylvania Folklife*, 13:3 (July, 1963), pp. 43–56; Alexander Fenton, "An Approach to Folk Life Studies," *Keystone Folklore Quarterly*, XII:1 (Spring, 1967), pp. 5–21. See too: Ronald H. Buchanan, "A Decade of Folklife Study," *Ulster Folklife*, 11 (1965), pp. 63–75; Ronald H. Buchanan, "Geography and Folk Life," *Folk Life*, I (1963), pp. 5–15; J. Geraint Jenkins, "Folklife Studies and the Museum," *Museums Journal*, 61:3 (December, 1961), pp. 3–7; J. W. Y. Higgs, *Folk Life Collection and Classification* (London, 1963).

States which is folk cannot be isolated with the folklorists'
usual tools. The European folklife student's identification
of "folk" with the past human masses of a nation may hold
for a small country, such as Ireland or Norway, but it fails
in a land where recent migration has been rapid and con-
stant, where eight generations of industrialization and ur-
banization have transformed a heterogeneous population
into a nonfolk mass. It would likewise be unwise to try to
force material folk culture into the consensus definition of
the American folklorist. It is not necessarily passed around
by word of mouth; it does not depend on oral transmission
or mutation for its preservation or the preservation of its
folk nature. The definition of material folk culture must
rest on a definition of the adjective "folk."

Considerations of the word "folk" have generally
consisted of discussions of a group of people, usually the
"folk society"—a homogeneous, sacred, self-perpetuating,
largely self-sufficient group isolated by any of many
means, such as language or topography, from the larger
society with which it moderately interacts.[3] As concept
and actuality, the folk society deserves study, but it is not
of great use in the formation of a modern definition of
folk culture. Because the folk society can exist only in a

[3]See Robert Redfield, "The Folk Society," *American Journal of
Sociology*, LII:4 (January, 1947), pp. 293–311; George M. Foster, "What
Is Folk Culture?," *American Anthropologist*, 55:2,1 (April–June, 1953),
pp. 159–173. Redfield's works like *The Little Community and Peasant
Society and Culture* (Chicago, 1960) and *The Primitive World and Its
Transformations* (Ithaca, 1962) have exerted much influence upon
American literary folklorists.

state of participation with the greater society, the accept-
ance of an element by its members does not guarantee the
folk nature of that element: an old blacksmith-made
(folk) rake and an old cast-iron (nonfolk) coffee mill may
be viewed in exactly the same manner. Examples of folk
societies exist in the eastern United States, the Old Order
Amish being, perhaps, the most dramatic, but these distinct
conservative societies will eventually be overcome by the
greater society. Folk culture, however, is tough and will
persist. Almost daily the folk society problem becomes less
crucial in an analysis of the folk culture of the eastern
United States, and the unit of inquiry becomes less the
community than the person whose culture is an individual-
istic synthesis of folk—the remnants, possibly though not
necessarily, of one or more folk societies—and nonfolk
components. Increasingly in the future, the student of
American culture will be dealing with a single society
dominated by a governmentally and economically en-
dorsed popular culture within which each individual will
have available two possibilities for cultural deviation: one
progressively oriented, the other conservatively oriented;
the latter may form the subject matter of folkloristic study.

Something which can be modified by "folk" is tra-
ditional. To be traditional it must be old and acceptable to
the individual or group which produced it—old enough
for there to be a record of its past in the producer's cul-
ture, such as early reports in print or extant datable items,
or (to apply a better test) old enough for the producer to
consider it old—"old timey," "old fashioned." "Pro-

duced," for a material item, say a wagon, means con-
structed; for an oral item, a tale, it would mean told. The
composition of a new tale is analogous not with the con-
struction of a wagon, but with the invention of a new
wagon type: the telling of a tale and the building of a
wagon are frequently repeated parallel culminations of
culturally determined know-how. The wagon type would
not have to be invented, nor the tale type composed, by
the group whose traditions incorporate that form, but a
tale told or a wagon built by a person who does not have
that tale or wagon as a part of his own tradition cannot be
folk.

During the time of the construction of a folk ob-
ject, the tradition out of which it is produced cannot be
part of the popular (mass, normative) or academic (elite,
progressive) cultures of the greater society with which the
object's maker has had contact, and as a member of which
he may function.[4] The nonpopular, nonacademic nature of
an object is tested by comparing it with the products pub-
licly supported by the spokesmen for those cultures—
weeklies with broad circulation and technical journals, for

[4]The proportion of folk to nonfolk elements in the cultural
makeup of an individual varies from person to person, but everyone
carries some folk culture. To employ distinctions beautifully worked
out in Ward H. Goodenough, *Cooperation in Change* (New York,
1963), pp. 259–265, a person can have folk elements in his private
culture and even his operating culture, when the public culture he
shares is totally nonfolk. The public culture of a folk society contains
both popular and folk elements, where the public culture of a popular
society is completely popular. It is the public culture of popular society
which I am setting up as the opposite of folk culture.

example. This comparison is easily made with modern material, for we carry the popular and academic cultures: because we know that modern farmers buy and use tractors, we know that a man who whittles out ox yokes and drives oxen is not conforming to the popular norm. It is more difficult to make judgments on items produced in the past; as a result, things no more folk than an electric toothbrush or a Johnny Cash LP are constantly labeled folk. A perusal of contemporary builders' manuals and the periodicals of the agricultural improvement societies may reveal that a house built in 1832 which appears quite folk today was, when new, a modish dwelling. In addition to an understanding of the stable folk culture, the folklorist must possess a solid knowledge of the continually changing popular culture.

Essentially, then, a folk thing is traditional and nonpopular; material folk culture is composed of objects produced out of a nonpopular tradition in proximity to popular culture. By centering on production rather than transfer, this definition allows for such innovations within folk tradition as the chairs which Chester Cornett, Kentucky craftsman, makes with unusually broad feet designed so that they will not punch holes in linoleum floors,[5] and the quilt made by Maggie Oberholtzer near Denver, Penn-

[5]For Cornett: Michael Owen Jones, "A Traditional Chairmaker at Work," *Mountain Life and Work*, XLIII:1 (Spring, 1967), pp. 10–13. For the framework he has constructed in order to study individualistic folk craftsmen and a photo of the chair in question, see Michael Owen Jones, "The Study of Traditional Furniture: Review and Preview," *Keystone Folklore Quarterly*, XII:4 (Winter, 1967), pp. 233–245.

sylvania, and designed by her friend and neighbor, Johnnie Brendel, which combines the previously uncombined Pennsylvania German traditions of appliqué quilting and the artistic and religious motif of Adam and Eve in Eden. The definition also consciously avoids the qualifier "unreflective," which is frequently encountered in definitions of folklore.[6] In the past the folk builder might have built traditionally because he knew no other way. The mass media have provided today's folk builder with a comparative knowledge of popular culture, so that while he may adhere to a traditional pattern without reflection, he is more likely to continue building in a folk fashion because he feels that it is the best—most lasting, most moral—way to build. If that which is folk were restricted to that which is unreflective, the future folklorists' subject matter would be limited to the semiautomatic acts a child learns when he is beginning to walk and talk.

To determine whether or not an object can be classed as folk, and in order to describe an object well enough for its historic and geographic connections to be accurately and completely revealed, any material object

[6]An application of unconsciousness to material culture is Norbert F. Riedl, "Folklore and the Study of Material Aspects of Folk Culture," *Journal of American Folklore*, 79:314 (October–December, 1966), pp. 557–563. The conscious-unconscious distinction has been presented as synonymous for the nonfolk-folk one. A definition based on the models selected by a folk producer would seem to be easier to manipulate than one based on the kind of psychology operative during production. As yet unconducted psychological studies may or may not reveal that folk producers go through different mental processes during production, regardless of model and material, than do popular producers.

must be broken down into its components: fundamentally, it will have form, construction, and use. Of these basic parts the most important is form. The typology and cross-cultural classification of material culture must be based on form only; that is, in the establishment of a chair type, the construction of the chair and the use to which it is put are not considerations. Any object's form can be separated into primary characteristics (those used to define the type into which the example fits), and secondary characteristics (other attributes of the form which, though they may be culturally significant, are not of use in the definition of the type). The primary characteristics of a usual American folk house type, for example, would be height and floor plan; stylish trim and appendages, such as porches and additions, would be secondary characteristics.

Form is of utmost importance because it is the most persistent, the least changing of an object's components.[7] A distinctive building form, typified by a rectangular floor plan, a door in one gable end, and a gable roof which projected forward over the door, was carried across Europe as a part of the neolithic complex, and continued to be employed commonly into the Iron Age on much of the Continent. It was built of horizontal log, clay, stone, or vertical posts sunk into the ground and filled with wattle and daub or clay; it was used as a dwelling, a stable, or a

[7]Cf. Fred Kniffen, "To Know the Land and its People," *Landscape*, 9:3 (Spring, 1960), p. 22; Edward T. Hall, *The Silent Language* (New York, 1964), p. 84.

granary.[8] While the connection between the prehistoric and modern examples is uncertain, the same form is found today in Central Europe and Scandinavia, built usually of horizontal log or stone, and used as a dwelling, a hay barn, bakeoven, a house for the drying of flax, grain or malt, the smoking of meat, or, in Finnish areas, for bathing.[9] Settlers from the Continent introduced this form into America where it is found in upstate New York, and from Pennsylvania[10] west and especially southward; it is built of log, frame, stone, brick, or cinder block, and is used as a smokehouse, stable, tool shed, corncrib, a bakeoven, chicken coop, coal house, springhouse, pump house or well house, summer kitchen or washhouse (Fig. 1).

[8]John M. Tyler, *The New Stone Age in Northern Europe* (New York, 1921), p. 75; Marija Gimbutas, *The Prehistory of Eastern Europe*, I (Cambridge, 1956), pp. 60, 71, 118–120, 140, 144–145; Marija Gimbutas, *The Balts* (London, 1963), pp. 51–52, 81–82; V. Gordon Childe, *Prehistoric Migrations in Europe* (Oslo, 1950), pp. 86–87, 101–103, 118–120, 224–225; S. J. De Laet, *The Low Countries* (London, 1958), pp. 62, 88.

[9]Josef Vařeka, "Koliby Zvané Kram," *Slovenský Národopis*, IX:4 (1961), pp. 628–636; Rudolf Bednárik, "K Štúdiu Cholvarkov na Kysuciach," *Sborník Slovenského Národného Múzea Etnografia*, LVII (1963), pp. 28–39; Ján Podolák, "Zimná Doprava Sena z Horských Lúk na Západnej Strane Veľkej Fatry," *Slovenský Národopis*, X:4 (1962), pp. 565–574; Ilmar Talve, "Om Bastubad På Svensk Landsbygd," *Folk-Liv*, XVI (1952), pp. 62–73; Ilmar Talve, *Bastu och Torkhus i Nord-europa* (Stockholm, 1960); Halvor Vreim, "The Ancient Settlements in Finnmark, Norway," *Folkliv*, 1937:2/3, pp. 169–204.

[10]For Pennsylvania examples see: Eleanor Raymond, *Early Domestic Architecture of Pennsylvania* (New York, 1931), p. 94; Charles Morse Stotz, *The Early Architecture of Western Pennsylvania* (New York and Pittsburgh, 1936), pp. 147, 149.

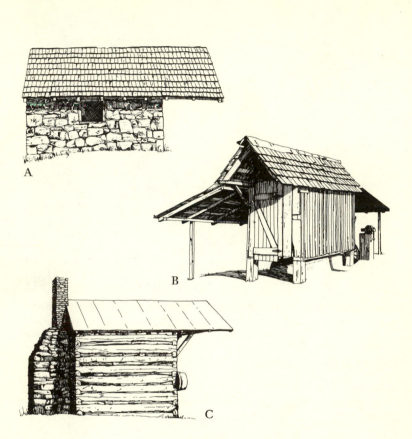

FIGURE 1

THE PROJECTING ROOF,
RECTANGULAR OUTBUILDING TYPE

A. Stone springhouse, west of Reinholds, Lancaster County, Pennsylvania (May, 1968). B. Frame board and batten feed house, Pine Hill, near Enterprise, Clarke County, Mississippi (November, 1962). The sheds on the side and rear serve for storage and provide an area for simple blacksmithing. C. V-notched log washhouse, near Beaver Creek, Washington County, Maryland (July, 1963). Another example may be found in Fig. 11.

Although construction is not of use in the establishment of types, the student of material folk culture must be concerned with both the form and material of construction, observable from the finished product, and the process of construction which may be inferred from the object and can be understood through description, but which is best learned through a close observation of the process in progress. Construction is highly variable and more subject to influence from technologically oriented popular culture than form; still, in some instances a traditional form can be replaced by a nontraditional one while the techniques employed in the production of the new object remain folk. This has occurred particularly as a part of the craft revivals of our century; Southern Mountain craftsmen have, for example, made Dutch colonial chairs[11] and Tyrolean baskets[12] after designs presented to them by urban art-craft people, using completely traditional mountain chair- and basket-making techniques.

An object folk in form or construction is in itself at least partially folk; an object which was not folk when it was produced cannot become folk by usage or association, and a folk-produced object does not lose its folk status

[11]Ralph C. Erskine, *The Mountains and the Mountain Shop* (Tryon, 1913).

[12]Frances Louisa Goodrich, *Mountain Homespun* (New Haven, 1931), p. 27. Much has been written on the craft revival in the mountains; for examples: Hettie Wright Graham, "The Fireside Industries of Kentucky," *The Craftsman*, I:4 (January, 1902), pp. 45–48; Bernice A. Stevens, "The Revival of Handicrafts," in Thomas R. Ford, ed., *The Southern Appalachian Region* (Lexington, 1962), pp. 279–288. Such well-meaning ladies have done a lot to muddy the folk cultural waters.

when utilized in a nonfolk manner. A guitar manufactured in a Kalamazoo factory is not folk even when played by a bluesman from the Mississippi Delta, for the object is not reinterpreted and then newly produced in the way that a song the same man might have learned from a popular source would be. When a family moves from a one-story folk house into a modern two-story house and continues to live on only the ground floor, apportioning the space in the new house the way they did that in the old, they are using the house in a traditional way.[13] They might paint it in traditional colors—the porch ceiling light blue in southern Pennsylvania, for example, or the backs of the doors black in eastern Virginia—and hang its walls with pictures from their old house such as the prints of the dark Virgin which characterize the old-time Polish-American home; the decoration, then, could be folk, but the house, its walls and proportions, remains uncompromisingly nonfolk. Conversely, when a suburban matron buys a homemade lard bucket at an antique shop and uses it for a planter, its use has no relation to its intended or traditional use, but, provided that it was traditional and nonpopular when produced, it remains a folk bucket no matter how many zinnias she packs into it.

Ideally, perhaps, a folk object would be marketed locally and locally used.[14] The folklorist, old style, is horri-

[13]Exactly this has happened in many parts of rural America, and also in the fishing villages on the Scottish and Irish coasts; see: Peter F. Anson, *Scots Fisherfolk* (Banff, 1950), p. 14; Robin Flower, *The Western Island* (New York, 1945), pp. 46–47.

[14]See Bruce R. Buckley and M. W. Thomas, Jr., "Traditional

fied by commercialism,[15] but the fact remains that the early commercial recordings contained inviolable folksong and some of material folk culture was produced not for barter in a backwoods hamlet, but commercially with a crass eye for profit. In the late 1830's, for instance, the Marcus Beebe Plow and Wheel Barrow Shop, South Wilbraham, Mass.,[16] turned out and shipped south wooden swing plows (Fig. 2A), which were based on a pattern introduced from Holland into East Anglia probably in the late sixteenth century and which flourished after 1730 in Scotland and the eastern counties of England.[17] The swing plow with wooden moldboard was traditional in eight-

Crafts in America," in Steve Kenin, Ralph Rinzler, and Mary Vernon, *Newport Folk Festival July 1966* (New York, 1966), pp. 42–43, 65–66, 68, 70.

[15]For a recent statement: James Reeves, *The Idiom of the People* (New York, 1965), p. 15.

[16]Marcus Beebe (1812–1891) was trained as a blacksmith in Tolland County, Connecticut and set up shop in the adjacent county of Hampden, Massachusetts. Beginning in 1834 he took part in a family venture which consisted of shipping "all sorts of New England country products"—maple sugar and cider as well as plows and wheelbarrows—to New Orleans. The family shipping business continued well into the second half of the nineteenth century, though Marcus seems to have gone out of the plow-making business before the Civil War. See Louise Beebe Wilder, *Lucius Beebe of Wakefield and Sylenda Morris Beebe, His Wife: Their Forbears and Descendents* (New York, 1930), pp. 69–70, 85, 116.

[17]J. B. Passmore, *The English Plough* (London, 1930), pp. 6, 10–12; Olga Beaumont and J. W. Y. Higgs, "Agriculture: Farm Implements," in Charles Singer, E. J. Holmyard, A. R. Hall and Trevor I. Williams, eds., *A History of Technology*, IV (London, 1958), pp. 2–4; H. A. Beecham and John Higgs, *The Story of Farm Tools* (London, 1961), pp. 3, 9–11.

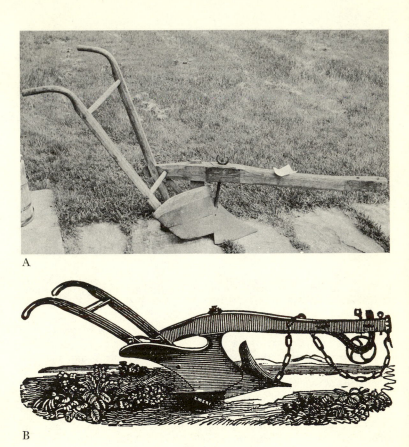

A

B

FIGURE 2

PLOWS OF THE EARLY
NINETEENTH CENTURY

A. Swing plow with wooden moldboard made in the Marcus Beebe shop at South Wilbraham (now Hampden), Massachusetts, Hadley Farm Museum, Hadley, Massachusetts. B. Contemporary plow with cast iron moldboard; from J. W. O'Neill, *The American Farmer's New and Universal Handbook* (Philadelphia, 1859), p. 37.

eenth century New England[18] but was archaic in the early nineteenth century when Beebe was making his: an English traveler in New York State in 1830 noted, "the ploughs in use are all single, with cast-iron *mould-boards* and *shares,* well adapted to the country; the cost about 8 or 10 dollars each;"[19] plows with cast-iron moldboards had been patented by 1800[20] and the agricultural writers of the period agreed that "the cast iron plough is now most generally used among the best farmers, and considered decidedly the best,"[21] and that "the wood plough, as generally made, had many objectionable points and properties. . . ."[22]

Some contemporary folklorists, dissatisfied with traditional sallies at tradition, are shifting their studies so that they move inward from the item to inspect the individual and his culture, rather than outward, away from

[18]For examples see: Percy Wells Bidwell and John I. Falconer, *History of Agriculture in the Northern United States, 1620–1820* (New York, 1941), pp. 123–124, see also pp. 208–210, 282–286; Erwin O. Christensen, *The Index of American Design* (New York and Washington, 1959), p. 45; Edward C. Kendall, "John Deere's Steel Plow," *Contributions from the Museum of History and Technology,* 218:2 (Washington, 1959), pp. 16–17.

[19]John Fowler, *Journal of a Tour in the State of New York in the Year 1830* (London, 1831), p. 78.

[20]Ellen D. Smith, "The Smith Plow," *A Collection of Papers Read Before the Bucks County Historical Society,* III (1909), pp. 11–14; Ulysses Prentiss Hedrick, *A History of Agriculture in the State of New York* (New York, 1966), pp. 291–293.

[21]Edward James Hooper, *The Practical Farmer, Gardener and Housewife* (Cincinnati, 1842), p. 322.

[22]Rev. John L. Blake, *The Modern Farmer; or, Home in the Country* (Auburn, Buffalo and Cincinnati, 1854), p. 192.

the item, in a quest for hypothetical origins and unusual connections. Historic-geographic[23] worries—types and taxonomy, systems of cultural relationship—must precede functional and psychological considerations. But, this does not mean that material folk culture will have to endure half a century of random, competitive collection and bibliographic annotation; it does mean that historic-geographic studies are legitimate ends in themselves and that psychological or functional studies which lack historic-geographic foundations can be naive, especially in complicated folk cultural matters. The best student of folk culture is both fieldworker and theorist, and a modern study of material culture might include the detailed description and ordering of field data, the historic-geographic connections of types, construction and uses, as well as functional and psychological speculations. It will be necessary to know not only what an object is and what its history and distribution are, but also what its role in the culture of the producer and user is, and what mental intricacies surround, support, and are reflected in its existence. Psychological studies of folk traditions have been generally concerned with content—the plot of a folktale, for example—and within material culture there are problems of content worthy of investigation, such

[23]"Historic-geographic" is not meant as a reference to the Finnish method in all of its aspects. Modern material culture studies depend on the location of as many examples as possible, the establishment of types and subtypes, and the spatial and temporal ordering of these, not to find an *ur* form, but to understand the extant record. Contemporary studies use the past to understand the present, rather than the present to understand the past.

as why the children of white farmers in the Lowland South are often given carefully homemade Negro dolls (Fig. 3) with which to play. Of greater importance, however, is the psychology of the carrier of folk traditions, regardless of specific content. Is it easier to adhere to an old way than it is to conform to the normative standards of popular culture? Why, in our world, would someone continue to sing ballads or make baskets?

PATTERNS OF FOLK AND POPULAR INTERACTION

The folklorist is accustomed to discovering a Grub Street hack at the source of today's folk ballad and a line of oral transmission patched with broadsides, cheap songsters, and wax. Similarly, material folk culture has constantly felt the influence of popular culture. At the beginning of a treatment of the interplay of folk and popular cultures, however, it is necessary to state that some material folk traditions exist which seem to have been influenced in no way by the "higher levels of culture"; the outbuilding with the projecting roof (Fig. 1) is an example, the haystacks of the Upland South provide another.

The most usual result of the influence of popular upon folk material during the past 130 years in America, and particularly the past fifty, has been the replacement of the traditional object by its popular equivalent. The popular object has been accepted by the innovative individual because it saves him time, is more quickly produced or

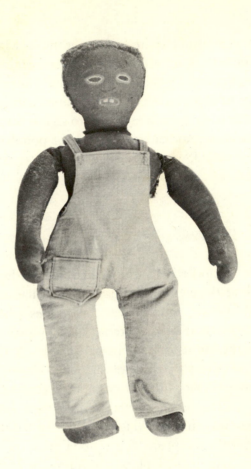

HOMEMADE BLACK DOLL

When this cloth doll was new, in about 1937, it had a railroad red bandana around its neck. A couple of generations of white children have left the doll, named after an elderly, well-liked, local Negro, in good condition; North Garden, Albemarle County, Virginia (September, 1965).

bought, and is easier to use than the traditional object—
and also because it is new. Slick salesmen and the numer-
ous publications and officials of both the government and
private agencies are persistent in recommending nontradi-
tional material to individuals and groups which maintain
some traditional orientation.[24] The recognized leaders of
such groups will often embrace the up-to-date to reinforce
their status. The members of a group which has a weak
orientation toward tradition tend to follow the leader,
with the individuals having the highest proportion of folk
elements in their culture being last in line. The more tradi-
tionally oriented groups are split by progress: the innova-
tive leader is not completely followed because of the exist-
ence of leaders who are supported by a conservative,
antiprogress norm.[25] The replacement of folk by popular
practices through this incomplete and frequently prestige-
stimulated process results, on the one hand, with the di-
minishing of the tradition, but, on the other, with the
establishment of the folk nature of certain practices and

[24]For example: W. M. Williams, *The Country Craftsman* (Lon-
don, 1958), p. 59.

[25]You should be referred here to B. Benvenuti, *Farming in Cul-
tural Change* (Assen, 1962); Gwyn E. Jones, "The Nature and Conse-
quences of Technical Change in Farming," *Folk Life*, 3 (1965), pp.
79–87; George M. Beal, "Decision Making in Social Change," in H. J.
Schweitzer, *Rural Sociology in a Changing Urbanized Society* (Urbana,
1966), pp. 51–94. My generalizations result also from observation, par-
ticularly of the gradual but complete acceptance of Bermuda grass in a
Mississippi farm community (1962–1963) and the erratic and incomplete
acceptance of the telephone in a North Carolina Blue Ridge community
(1963–1964).

objects. In the late 1860's and early 1870's the agricultural writers recommended the use of various patent metal spiles, the short tubes used to conduct the sap from the hole drilled in the maple tree into the bucket. These were quickly adopted by maple syrup and sugar producers. And the plastic tubes recently introduced to replace the metal spile have also been widely accepted. But a few small producers continue to make and use wooden spiles of the type which has been in use since the mid-eighteenth century; the wooden spile is surely folk and has been for about one hundred years.[26]

Popular culture's agents frequently apply extensive and unpleasant pressure to conservative individuals or groups in an attempt to bring them into line with modern thinking, but only rarely has it been felt necessary to legislate against folk tradition. Building codes, however, occasionally prevent the construction or maintenance of folk housing;[27] many traditional hunting and fishing techniques have been outlawed; and homemade corn liquor remains "blockade," "bootleg," "moonshine"—illegal.[28] The laws

[26]Darrell D. Henning, "Maple Sugaring: History of a Folk Technology," *Keystone Folklore Quarterly*, XI:4 (Winter, 1966), pp. 253–255.

[27]For example: Margaret Fay Shaw, *Folksongs and Folklore of South Uist* (London, 1955), p. 17.

[28]Moonshine is one aspect of American material folk culture which has interested people: Margaret W. Morley, *The Carolina Mountains* (Boston and New York, 1913), chapter XX; Horace Kephart, *Our Southern Highlanders* (New York, 1926), chapters V–XI; Charles Morrow Wilson, *Backwoods America* (Chapel Hill, 1934), chapter XIV; Thomas D. Clark, *The Kentucky* (New York and

against it restrict the extent to which it is produced, but the distillation of corn persists. It persists because it is economical: it is less expensive than "bonded liquor" and can be made and sold for good profit with a minimum of capital outlay; accordingly it is common in areas where the income is low. It persists in dry country because there any kind of whiskey is supposed to be hard to find. But moonshine is not to be found in many areas where the economic situation might suggest its presence. This is because its persistence is due primarily to the fact that, in the Upland South particularly, its technology, marketing, flavor, and the attitudes which allow it to exist are traditional: moonshining goes back through the eighteenth century in America and to an earlier time in Ireland.[29] In many sections of the South corn liquor is preferred to bottled-in-bond, and flavored with bubble gum (as at least one Negro from the Carolina Sea Islands makes it) or with a peppermint stick dissolved into it (as it often is along the

Toronto, 1942), chapter XXI; Charles S. Pendleton, "Illicit Whiskey-Making," *Tennessee Folklore Society Bulletin*, XII:1 (March, 1946), pp. 1–16; Muriel Earley Sheppard, *Cabins in the Laurel* (Chapel Hill, 1946), chapter XIII; Loyal Durand, Jr., " 'Mountain Moonshining' in East Tennessee," *The Geographical Review*, XLVI:2 (April, 1956), pp. 168–181; Leonard W. Roberts, *Up Cutshin and Down Greasy* (Lexington, 1959), chapter 4; Charles Morrow Wilson, *The Bodacious Ozarks* (New York, 1959), chapter IV; Harry M. Caudill, *Night Comes to the Cumberlands* (Boston and Toronto, 1963), chapter 12; William Price Fox, "The Lost Art of Moonshine," *The Saturday Evening Post*, 239:7 (March 25, 1966), pp. 34–35; Cratis Williams, "Moonshining in the Mountains," *North Carolina Folklore*, XV:1 (May, 1967), pp. 11–17.

[29]Kevin Danaher, *In Ireland Long Ago* (Cork, 1964), pp. 58–63.

Blue Ridge), or mixed half and half with water and a large spoonful of sugar (the way the mountain farmer drinks it), it can be a fine drink.

When similar material exists at the same time in the inventories of adjacent cultures and in the mind of an individual, a mutual or one-sided movement of influence often results in the increased similarity of the two traditions. By the end of the last century, the banjo, which has clear African antecedents,[30] had been developed into two five-string forms. One was the popular, factory-produced banjo, with its minstrel show and college music club heritage, which had frets and a large head held taut by mechanical brackets. The other had no frets and a head only about six inches in diameter which was stretched over a light wooden or tin rim forced gently into a thicker wooden rim (Fig. 4A, B). This second, folk, type was found in the Southern Mountains; its strings were catgut and its head was groundhog, cat, or squirrel skin: "The one I learned on, my brother made it, a homemade banja. Killed a cat, tanned its hide, made the head, and he carved out the rest of it. And then we bought one."[31] Most Southern Mountain banjo pickers play "store-boughten"

[30]Gene Bluestein, "America's Folk Instrument: Notes on the Five-String Banjo," *Western Folklore*, XXIII:4 (October, 1964), pp. 241–248.

[31]Edgar A. Ashley, high school math teacher, banjo-picker, and tale-teller from Grassy Creek, Ashe County, North Carolina; tape-recorded interview, August 7, 1962. *Märchen* learned from his father and told by Mr. Ashley can be found in *Tennessee Folklore Society Bulletin*, XXX:3 (September, 1964), pp. 97–102; *Mountain Life and Work*, XL:2 (Summer, 1964), pp. 52–56.

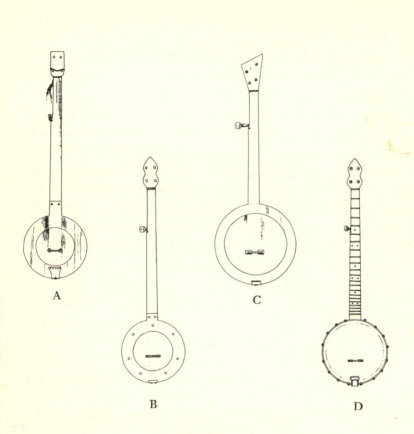

<div align="center">

FIGURE 4

FIVE-STRING BANJOES
MADE IN THE SOUTHERN MOUNTAINS

</div>

A. Mack Presnell's "old piece of a banjer," made by Leonard Glenn about 1947, west of Sugar Grove, Watauga County, North Carolina (July, 1963). B. Curly maple, fretless banjo, made by Leonard Glenn in 1963, west of Sugar Grove, Watauga County, North Carolina (June, 1963). C. Cherry, fretless banjo, made by Edd L. Presnell in 1962, near Banner Elk, Watauga County, North Carolina (October, 1962). D. Bracket banjo with flush, inlaid frets made by Leonard Glenn in 1964, west of Sugar Grove, Watauga County, North Carolina (August, 1964).

instruments, but in northwestern North Carolina and ad-
jacent southwestern Virginia there are still several men
who make banjoes of the old type, not because they can-
not afford or are unaware of factory products, but be-
cause they prefer a fretless instrument: "I would not take
fifty bracket banjers for one good fretless."[32] These mod-
ern fretless banjoes are held together with screws, strung
with metal strings, and the heads are regularly ordered
from a musical supply house; otherwise they are essentially
the same as those in use sixty and more years ago. Within
the past decade the banjo builders have experimented with
instruments which look more like the "northern" or
"bracket" banjoes: occasionally they are built with frets
or with a head that is larger than usual (Fig. 4C), on most
the peg head is contoured like a mass-produced banjo (Fig.
4B), and very recently homemade imitations of expensive
instruments like those seen on television, complete with
mechanical pegs and brackets, have been produced (Fig.
4D).

The interaction of popular and folk cultures has
not resulted exclusively in modifications of folk culture,
for some folk traditions, such as the regional and ethnic
cookery made available in restaurants, festivals, bazaars,

[32]Mack Presnell, 67-year-old farmer, tale-teller, dulcimer and
banjo player, from near Sugar Grove, Watauga County, North Caro-
lina; interview June 16, 1963. Mr. Presnell would rather pick the banjo
with his "magic finger" than work his small, steep farm. He would
rather fish than pick the banjo.

and, especially, cookbooks,[33] have been absorbed by the popular culture.

Popular material objects may be based directly on folk models, and a folk tradition may, in turn, derive from a popular model. The English settlers in the New World,

[33]The number of regional and ethnic cookbooks is enormous; for representative examples of the kinds of books which have carried American folk cuisine into the popular kitchen see: Imogene Wolcott, *The Yankee Cook Book* (New York, 1939); Eleanor Early, *New England Cookbook* (New York, 1954); Haydn S. Pearson, *The Countryman's Cookbook* (New York and London, 1946); Ann Hark and Preston A. Barba, *Pennsylvania German Cookery* (Allentown, 1956); Ruth Hutchison, *The New Pennsylvania Dutch Cookbook* (New York, 1966); Mary Emma Showalter, *Mennonite Community Cookbook* (Philadelphia and Toronto, 1950); Mrs. B. C. Howard, *Fifty Years in a Maryland Kitchen* (New York, 1944); Marion Cabell Tyree, *Housekeeping in Old Virginia* (Louisville, 1890); *Ocracoke Cook Book* (Ocracoke, n.d.); Mary Ruth Chiles and Mrs. William P. Trotter, eds., *Mountain Makin's in the Smokies* (Gatlinburg, 1957); Lessie Bowers, *Plantation Recipes* (New York, 1959); Mary Vereen Huguenin and Anne Montague Stoney, eds., *Charleston Receipts* (Charleston, 1966); Marjorie Kinnan Rawlings, *Cross Creek Cookery* (New York, 1942); Mary Land, *Louisiana Cookery* (Baton Rouge, 1954); *A book of famous Old New Orleans Recipes Used in the South for more than 200 years* (New Orleans, n.d.); Mary Faulk Koock, *The Texas Cookbook* (Boston and Toronto, 1965); Yeffe Kimball and Jean Anderson, *The Art of American Indian Cooking* (Garden City, 1965); Anne London and Bertha Kahn Bishov, *The Complete American-Jewish Cookbook* (Cleveland and New York, 1952); Jennie Grossinger, *The Art of Jewish Cooking* (New York, 1958); Theresa F. Bucchieri, *Feasting with Nonna Serafina* (South Brunswick, N.J., 1966); Josephine J. Dauzvardis, *Popular Lithuanian Recipes* (Chicago, 1955); Yasmine Betar, *Finest Recipes from the Middle East* (Washington, 1964); traditional Negro cookery has been featured in a "Soul Food" column in the monthly Sunday supplement *Tuesday*. Some of these cookbooks are surprisingly useful for the serious student of material culture.

of course, brought with them no tools designed specifically for chopping cornstalks. In the South, corn knives based on the machetes used to cut sugar cane and the similar knives of butchers came into use (Fig. 5A); a Virginia correspondent to *The American Farmer* in 1819 wrote: "Many farmers cut their corn with hoes. . . . The better course is to use knives, made in the form of a butcher's cleaver. They may be made of old straw knives, the blade about ten, and the shank and handles fifteen inches long."[34] In the Northeast a distinctive corn knife type (Fig. 5B–E) was devised, probably out of the ancient sickle-scythe tradition,[35] for, in those areas in which the L-shaped corn knife was used, some preferred to cut their corn with a grass hook or sickle.[36] To fill the demand for a commercially produced corn knife during the mid-nineteenth century, the popular manufacturers began turning out, and selling for about half a dollar, corn knives which were reproductions of the traditional northern and

[34]*The American Farmer*, I:38 (December 17, 1819), p. 306; see too: James Ringgold, "On the Best Mode of Harvesting Indian Corn," *The American Farmer*, IV:16 (July 5, 1822), pp. 125–126.

[35]Axel Steensberg, *Ancient Harvesting Instruments: A Study in Archaeology and Human Geography* (Copenhagen, 1943), illustrates and describes in detail ancient and medieval angular sickles and short scythes very similar to the northern corn knife form. Possibly a sort of reverse evolution, cued by the thickness of the cornstalk, led from the balanced sickle to the corn knife.

[36]Charles S. Plumb, *Indian Corn Culture* (Chicago, 1895), pp. 102–103. See too: Neil Adams McNall, *An Agricultural History of the Genesee Valley, 1790–1860* (Philadelphia, 1952), p. 129.

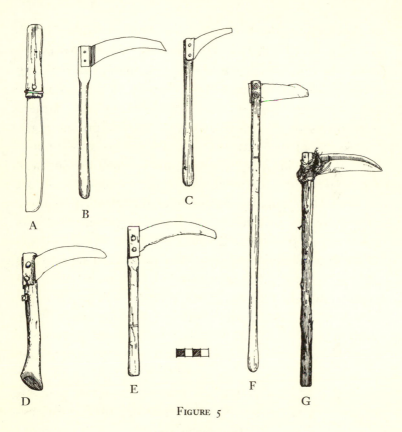

FIGURE 5

CORN KNIVES

A. Southwest of Tappahannock, Essex County, Virginia (August, 1966). B. From *American Agriculturist*, XXVII:10 (October, 1868), p. 395. The scale does not apply to this example. C. Near Dwight, Hampshire County, Massachusetts (August, 1966). D. Between Lisbon and Hartwick, Otsego County, New York (July, 1965). E. East of South Edmeston, Otsego County, New York (November, 1964). F. South of Orchid, Louisa County, Virginia (August, 1966). G. West of Orchid, Louisa County, Virginia (August, 1966).

southern implements.[37] The preeminence of Yankee factories seems to have led to the spread of the northern corn knife form, so that since about 1880 many of the corn knives made in the South have been patterned after the northern ones (Fig. 5F–G). The northern and southern corn knives of the early 1800's were folk products; the corn knives of the nineteenth century factories were popular imitations of folk originals; the homemade northern corn knife of the late nineteenth century is a folk product reinforced by popular acceptance; the modern southern corn knife constructed on the northern pattern is a folk imitation of a popular model.

The folklorist cringes when an untruth is passed off as "just folklore"; the serious student of material culture is equally anguished by the way the term "folk art" is popularly used. In both cases "folk" has been qualitatively interpreted to mean that which is substandard: the usual statement on "folk art" takes into account only two kinds of American art—academic and "folk."[38] Most of the antiquarians who employ the term do worry about their use of it and they have proposed a number of alternatives— naive, provincial, unself-conscious, primitive, anonymous, pioneer, and nonacademic (this last being perhaps the only

[37]"Implements for Cutting Up Corn," *American Agriculturist*, XXVII:10 (October, 1868), p. 395. Both corn knife types are used in Pennsylvania; for examples: Russell S. Baver, "Corn Culture in Pennsylvania," *Pennsylvania Folklife*, 12:1 (Spring, 1961), p. 35; Kiehl and Christian Newswanger, *Amishland* (New York, 1954), p. 55.

[38]For example: Nina Fletcher Little, *The Abby Aldrich Rockefeller Folk Art Collection* (Boston and Toronto, 1957), p. XIII.

term which can happily encompass the hodgepodge of objects normally displayed in "folk art" galleries).[39] The distinctions made in this essay between folk and popular cultures can be used as a guide to "folk art." Most of "folk art" is not folk because it is popular; the paintings made on velvet by young ladies in the seminaries and academies, for example.[40] Another big piece of "folk art" is not folk be-

[39]*Antiques*, LVII:5 (May, 1950), includes "What is American Folk Art? A Symposium," pp. 355–362. The contributions are of varying worth. Jean Lipman's expresses the tired clichés best (or worst). The folklorist will be able to agree completely with none of them, but those which attempt to subdivide folk art are the most useful: that of E. P. Richardson (see also the introduction to his *A Short History of Painting in America* [New York, 1963]), that of James Thomas Flexner (you might also read his "The Cult of the Primitives," *American Heritage*, VI:2 [February, 1955], pp. 38–47), and that of Janet R. McFarlane and Louis C. Jones (see too: Agnes Halsey Jones and Louis C. Jones, *New-Found Folk Art of the Young Republic* [Cooperstown, 1960], pp. 7–9).

[40]These pictures are counted folk art in Holger Cahill, *American Folk Art: The Art of the Common Man in America 1750–1900* (New York, 1932), pp. 11, 18, plates 79–108. The great interest in "folk art" began with Cahill; since his time some advances in definition and treatment have been made; see: Louis C. Jones, "Style in American Folk Art," in Henry Glassie and Ralph Rinzler, *Newport Folk Festival 1967* (New York, 1967), pp. 9, 35; and William P. Campbell, *101 American Primitive Water Colors and Pastels from the Collection of Edgar William and Bernice Chrysler Garbisch* (Washington, 1966). In this last, a careful distinction is made between Pennsylvania German *fraktur* which is folk art and the art of the nineteenth century schoolgirls which is not. Others, however, have made no progress toward a cultural understanding of "folk art"; for examples: Peter C. Welsh, *American Folk Art: The Art and Spirit of a People* (Washington, 1965), see also *Curator*, X:1 (1967), pp. 60–78; and Mary Black and Jean Lipman, *American Folk Painting* (New York, 1966), see also *Art in America*, 54:6 (November-December, 1966), pp. 113–128.

cause, although it does not reflect a popular norm, it is not traditional; such would be the daubings of untutored geniuses.[41] A problem harder to attack is determining how much of the material which is genuinely folk, is art.[42] Art is the application of an aesthetic, so that it can include more than paintings and sculpture; listen to this democratic voice from the New Deal days:

> We now recognize that the aesthetic experience can be as deep and as genuine to the one who uses soil, or wood, or grass to shape his best concept as to one who does the same with paint or marble; and that the spade, the ax, and the scythe are as much tools for artistic expression as are the brush and the chisel.[43]

However, art cannot include things which the producer did not consider aesthetically, even when we find them pleasing. The bulk of folk material which is at all art is secondarily art—it is craft, that which is primarily practical and secondarily aesthetic in function. The decoy

[41]The work of the Scot, Willie Robbie, is interesting in that it is, while not pop, not traditional; his creations, however, may be the source of a Lowland tradition which could be or become folk; see Kenneth S. Goldstein, "William Robbie: Folk Artist of the Buchan District, Aberdeenshire," in Horace P. Beck, ed., *Folklore in Action: Essays for Discussion in Honor of MacEdward Leach* (Philadelphia, 1962), pp. 101–111.

[42]In his influential book, *The Shape of Time* (New Haven and London, 1962), pp. 14–16, George Kubler offers the useful concept of an aesthetic to practical continuum with the antagonistic corollaries that there is a distinction between art and craft, and that all things are a mixture of the aesthetic and the practical.

[43]Allen Eaton in *Rural Handicrafts in the United States* (Washington, 1946), p. 8.

existed mainly to lure birds within shotgun range. In some instances the craftsman transcended necessity and carved and painted a decoy which pleased him; most of the time, though, the decoy was designed to please only the ducks (Fig. 6). Recently some traditional makers of decoys, like Lem Ward of Crisfield, Maryland, have taken the pains to produce folk sculpture for the collector's shelf instead of stool to float in the gunner's rig.[44] But in the eastern United States there has been little painting[45] or sculpture produced primarily as the fulfillment of a folk aesthetic, and the one area of material folk culture which can parallel much of oral tradition in that it thrives and is produced and maintained more for aesthetic than practical reasons is exterior decoration. The geometric painting on barns found not only in Pennsylvania, but in Ohio and Virginia too,[46] and the neat islands of bright perennial

[44]For some material on the decoy see: Joel Barber, *Wild Fowl Decoys* (New York, 1954); Eugene V. Connett, *Duck Decoys* (New York, 1953); David S. Webster and William Kehoe, *Decoys at Shelburne Museum* (Shelburne, 1961); William J. Mackey, Jr., *American Bird Decoys* (New York, 1965); C. A. Porter Hopkins, "Maryland Decoys and Their Makers," *The Maryland Conservationist*, XLII:6 (November-December, 1965), pp. 2–5; Adele Earnest, *The Art of the Decoy* (New York, 1965).

[45]Cf. Lura Beam, *A Maine Hamlet* (New York, 1957), p. 186.

[46]Much has been written on hex signs; this has almost all dealt with whether or not they have magical significance, a proposition which has been neither proved nor disproved; for examples, see: John Joseph Stoudt, *The Decorated Barns of Eastern Pennsylvania* (Plymouth Meeting, 1945); Louis J. Heizmann, "Are Barn Signs Hex Marks?," *Historical Review of Berks County*, XII:1 (October, 1946), pp. 11–14; Alfred L. Shoemaker, *Hex No!* (Lancaster, 1953), a pamphlet constantly reprinted with different names; Olive G. Zehner, "The

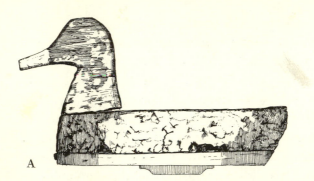

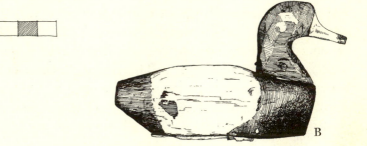

FIGURE 6

DUCK DECOYS

A. Cork bluebill decoy, Cape Hatteras, Dare County, North Carolina.
B. Wooden bluebill decoy, Currituck Sound, Currituck County, North
Carolina. Both are from the private collection of T. W. Sandoz, Chevy
Chase, Maryland. The suppliers of hunting equipment (Herter's Cata-
log, 77 [Waseca, Minn., 1967], pp. 4–16) maintain "a complete testing
laboratory," keep abreast of "scientific tests by some of the country's
leading ornithologists," and tell the hunter that he must have a decoy
with "every feather, muscle, and detail molded in"; still, Mr. Sandoz,
with many years as a hunter behind him, said of these decoys: "The
ducks will sit down to something like that. I've seen it many a time.
They'll come up and peck it on the bill. . . . They're crude but they'll
do the job" (August 20, 1967).

flowers bordered by whitewashed rocks found in front yards throughout the South are among America's grandest folk artistic expressions.

 ## REGIONAL PATTERNS

In general, folk material exhibits major variation over space and minor variation through time, while the products of popular or academic culture exhibit minor variation over space and major variation through time. The natural divisions of folk material are, then, spatial, where the natural divisions of popular material are temporal; that is, a search for patterns in folk material yields regions, where a search for patterns in popular material yields periods. It is a mistake to confront problems of folk cultural classification with the linear historical methods which have been deployed with good results in studies of popular and academic cultures; the fruits of this mistake are preserved in literary anthologies which stick the ballads in the medieval section and architectural surveys which restrict folk architecture to the pre-Georgian sector of the colonial period. While ordering his data, the student of folk cul-

Hills from Hamburg," *The Pennsylvania Dutchman*, IV:11 (February 1, 1953), pp. 16, 13; August C. Mahr, "Origin and Significance of Pennsylvania Dutch Barn Symbols," in Dundes, *The Study of Folklore*, pp. 373–399; Elmer L. Smith and Mel Horst, *Hex Signs and Other Barn Decorations* (Witmer, 1965). The more important questions of the forms, colors, distributions, and aesthetic meanings of the hex signs have yet to be answered.

ture should listen more closely to the cultural geographer than to the historian, for he must labor in the geographer's dimension and he shares a major goal with the geographer —the establishment of regions.

Because folklore collection in America has been spotty, the term "region" has been loosely used in folk-loristic publications. A cultural region is not an isolated pocket where funny old stories may be gathered in, nor is it an area marked off by arbitrary political boundaries or a noncultural clutch of topographical features. A region is a section of a geographical whole established by an analysis of comparable material found throughout the whole. Language which is both generally possessed and immediately apparent, has been used to cut the eastern United States up into digestible pieces, and material folk culture can be used in the same way.[47]

The material folk culture regions of the eastern United States must be based on the products of the general

[47]You should read this important article: Fred Kniffen, "Folk Housing: Key to Diffusion," *Annals of the Association of American Geographers*, 55:4 (December, 1965), pp. 549–577. This article and the regional section of the essay you have in hand are roughly parallel in purpose and content. Many of the conclusions are similar, which is not surprising considering the fact that Professor Kniffen and I employ similar methods and have been in constant contact. The careful reader of both papers will discern many small differences and some basic ones too; I, for example, feel that he has greatly underestimated the Tidewa-ter influence on the inland South. It might be interesting to compare our maps, his based, apparently, mainly on barn types and construction, mine attempting to employ more criteria, but falling back primarily on architecture.

farmer and the rural tradesmen, such as the blacksmith and house carpenter, on whom he partially depended. The material of the specialist-farmer or the nonagricultural rural group may be used to suggest subregions. The material of city folks and recent immigrants forms exotic islands in the still dominant patterns established by the general farmer during the early periods of settlement. Architecture, because of the natural tenacity of its fabric, the immobility and complexity of its examples, and the practical conservatism of its builders and users, has maintained its regional integrity and is of greatest use in the drawing of regions. The size and exposed position of buildings render them easily studied in a quantitative manner, and in the leaping and lingering treatment of the material folk culture of the eastern United States which follows, each region will be described basically in terms of folk architecture. Other material, such as furniture, agricultural implements, and food, is also useful, but some material which is similarly generally possessed—clothing, for instance—is of little use because the regional patterns it may once have exhibited have been lost, and regions must be based on material the modern fieldworker can study, as extant publications provide an incomplete and even inaccurate picture.

During the first two centuries of American settlement, there were four major centers of folk cultural dispersal on the East Coast: southern and eastern New England, southeastern Pennsylvania, the area of the Chesapeake Bay, and the coast from southern North Carolina

through Georgia. The characteristics of the regions of the eastern United States are mostly continuations or combinations of, or developments out of, traits found within these seaboard source areas (Figs. 7–9).

The Mid-Atlantic Region

It may be convincingly argued that the area which was most important in the development of the attitudes and ideas which are American popular culture was New England. The Mid-Atlantic, the major region last settled and initially least homogeneous, was, however, the most important of the material folk culture regions, for both the North and the South were influenced by practices which had their New World source in southeastern Pennsylvania.

The Pennsylvania Germans—the people of diverse Central European heritage known popularly and to themselves as the Pennsylvania Dutch—determined much of the character of the Mid-Atlantic region, which includes, in addition to southern and central Pennsylvania, western New Jersey, northern Delaware, central and western Maryland, and the northern part of one Virginia County— Loudoun, east of the Blue Ridge. Many of the region's distinguishing traits have a Continental provenance. In southeastern Pennsylvania can be found examples of a type of reel (Fig. 10), an instrument on which spun yarn is wound up, which are like those found in Germany, Switz-

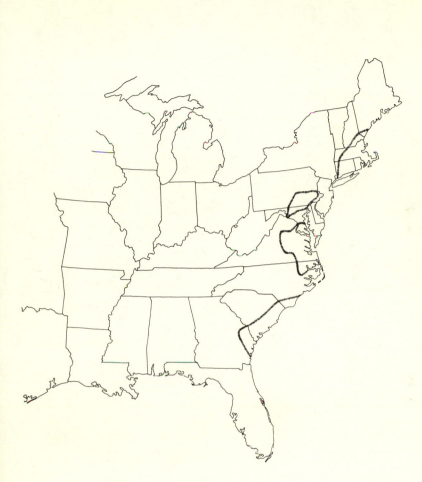

FIGURE 7

THE MAJOR FOLK CULTURAL SOURCE AREAS

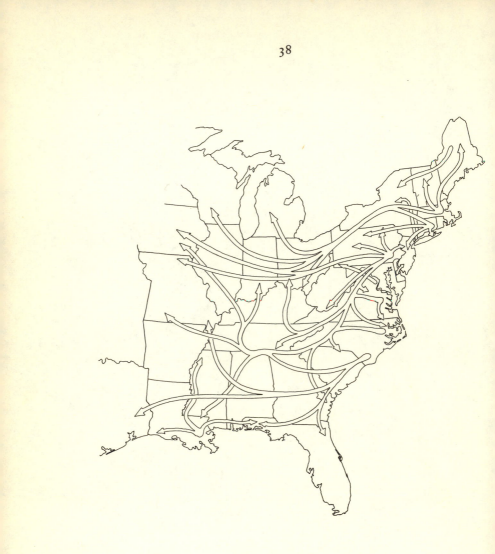

FIGURE 8

THE MOVEMENT OF IDEAS

The arrows give an impression of the directions in which folk cultures were carried out of the source areas by diffusion and migration.

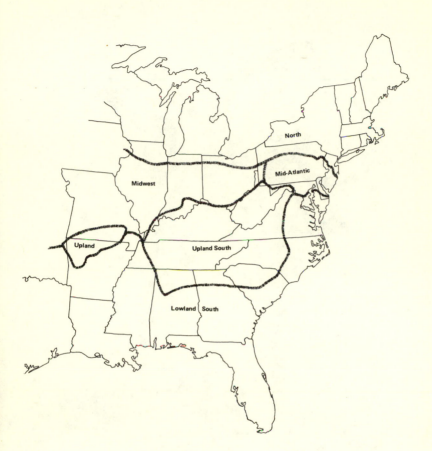

FIGURE 9

MATERIAL FOLK CULTURE REGIONS

Fieldwork clearly reveals the homogeneous source areas (Fig. 7), but the regions have fuzzy, syncretistic borders and any attempt to define them on a map is a process of constant compromise.

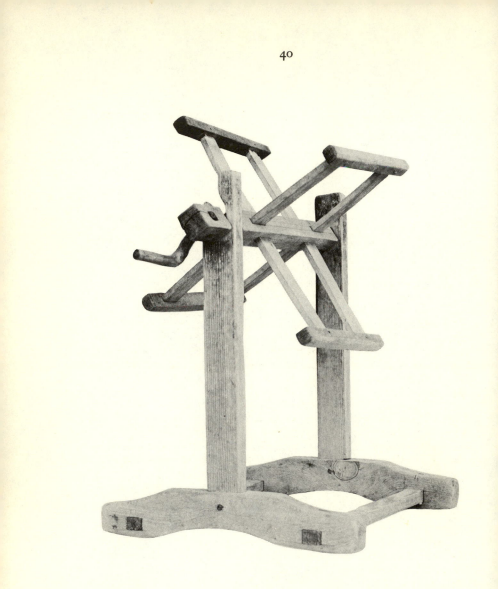

Figure 10

YARN REEL

From near Marietta, Lancaster County, Pennsylvania (March, 1967).

erland, Austria, northern Italy,[48] and French Canada,[49] but
which are different from the windmill-like reels usual in
the British Isles[50] and eastern North America.[51] Pennsyl-
vanians built outdoor bakeovens (Fig. 11)[52] exactly like
those found in Switzerland,[53] and clear Central European

[48]A. Schwarz, "Early Forms of the Reel," *Ciba Review,* 59 (Au-
gust, 1947), pp. 2130–2133; G. B. Thompson, *Spinning Wheels (The
John Horner Collection)* (Belfast, 1964), figs. 33, 42, 51, 57; Max Kislin-
ger, *Alte Bäuerliche Kunst* (Linz, 1963), pp. 192–193.

[49]For examples see these articles in *Canadian Geographical Jour-
nal* by Marius Barbeau: "Isle aux Coudres," XII:4 (April, 1936), p. 209;
"Island of Orleans," V:3 (September, 1932), p. 165.

[50]Arthur Hayden, *Chats on Cottage and Farmhouse Furniture*
(London, 1950), p. 99; Thompson, *Spinning Wheels,* fig. 58. It would
seem that the northern European type is like the British and different
from the Central European type; see Thompson, figs. 31, 47, and Gustav
Brandt, *Bauernkunst in Schleswig-Holstein* (Berlin and Leipzig, n.d.),
plate 24.

[51]Henry H. Taylor, "Some Connecticut Yarn Reels," *Antiques,*
XVII:6 (June, 1930), pp. 538–540; Edward Deming Andrews and Faith
Andrews, *Shaker Furniture* (New York, 1950), plate 24; Dorothy K.
Macdonald, *Fibres, Spindles and Spinning-Wheels* (Royal Ontario Mu-
seum of Archaeology, 1950), pp. 43–44; Audrey Spencer, *Spinning and
Weaving at Upper Canada Village* (Toronto, 1964), p. 21.

[52]Edith M. Thomas, "Old Dutch Bakeovens," *A Collection of
Papers Read Before the Bucks County Historical Society,* IV (1917), pp.
574–576; Frederick B. Jaekel, "Squirrel-Tailed Bakeoven in Bucks
County," pp. 579–586 in the same volume; Jesse Leonard Rosenberger,
The Pennsylvania Germans (Chicago, 1923), pp. 52–53; Amos Long, Jr.,
"Outdoor Bakeovens in Berks," *Historical Review of Berks County,*
XXXVIII:1 (Winter, 1962–1963), pp. 11–14, 31–32; Amos Long, Jr.,
"Bakeovens in the Pennsylvania Folk-Culture," *Pennsylvania Folklife,*
14:2 (December, 1964), pp. 16–29; John Newton Culbertson, "A Penn-
sylvania Boyhood," *American Heritage,* XVIII:1 (December, 1966), p. 83.

[53]P. Zinsli, "Vom Brotbacken in Safien," *Schweizer Volkskunde,*
31:1 (1941), pp. 2–5; Max Währen, "Backen und Backhäuser in Berner
Gebeiten," *Schweizer Volkskunde,* 52:2 (1962), pp. 17–22.

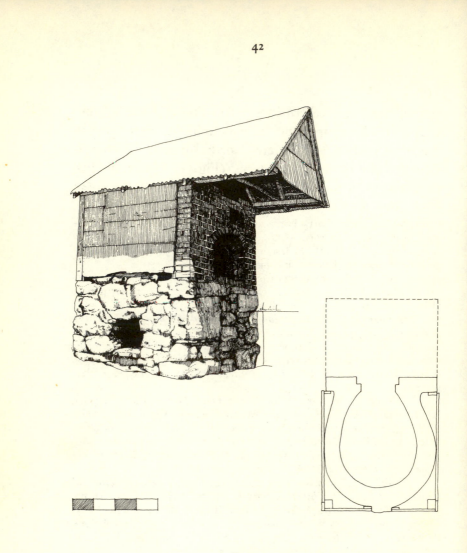

FIGURE 11

OUTDOOR BAKEOVEN

Between Heidlersburg and Biglerville, Adams County, Pennsylvania (May, 1967). This building is located a few steps out the back door of the dwelling. Its oven is a brick dome—"beehive"—the internal dimensions of which are only approximated in the measured plan at the right.

antecedents can be located not only for the rare decorated dower chests[54] and fine *schranks*,[55] but also for the simple softwood blanket chests[56] which sit on stubby turned legs, are fitted inside with a "till" for sundries, painted a solid color or "grained" in half-hearted imitation of some wood finer than pine or poplar, and are found commonly throughout the region (Fig. 12). Birth and baptismal certificates, house blessings (Fig. 13), Bible or hymn texts, religious puzzles and awards for merit, among other things, were drawn up as *fraktur*, a combination of medieval calligraphy and traditional Pennsylvania motifs, such as the tulip and pomegranate, *distelfink* and parrot. Although influenced by German copybooks, *fraktur* is traceable to the folk art of southwestern Germany, Switzerland, and Alsace.[57]

[54]For examples: Frances Lichten, *Folk Art of Rural Pennsylvania* (New York, 1946), pp. 85–109; Henry J. Kauffman, *Pennsylvania Dutch American Folk Art* (New York, 1964), pp. 19–20, 118–121. For examples of the Continental chests which were the forerunners of the Dutch dower chests: Christian Rubi, *Berner Bauernmalerei* (Bern, 1948); Konrad Hahm, *Deutsche Bauernmöbel* (Jena, 1939), plates 68–91.

[55]John Joseph Stoudt, *Early Pennsylvania Arts and Crafts* (New York and London, 1964), pp. 118–120. For Continental antecedents: Helmut Nemec, *Alpenländische Bauernkunst* (Wien, 1966); Annaliese Ohm, *Volkskunst am Unteren Rechten Niederrhein* (Dusseldorf, 1960), pp. 24–51.

[56]The plain blanket chest has not brought high enough prices in antique shops to warrant its inclusion in books on furniture; for its Continental ancestors see: Oskar Seyffert, *Von der Wiege bis zum Grabe: Ein Beitrag zur sächsischen Volkskunst* (Wien, n.d.), pp. 4, 60; F. Rudolf Uebe, *Deutsche Bauernmöbel* (Berlin, 1924), pp. 52, 66; Torsten Gebhard, *Die Volkstümliche Möbelmalerei in Altbayern* (Munich, 1937), plates 106–111.

[57]For *fraktur:* Henry C. Mercer, "The Survival of the Mediae-

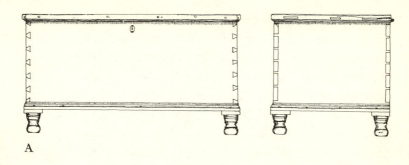

A

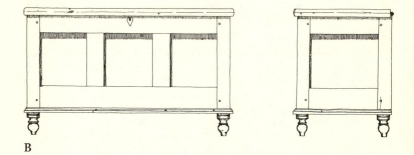

B

FIGURE 12

BLANKET CHESTS

A. Pine blanket chest with sponge-mottled reddish brown paint, from the vicinity of Newville, Cumberland County, Pennsylvania (February, 1967). B. Pine blanket chest with poplar panels and maple escutcheon, painted red, from Millersburg, Dauphin County, Pennsylvania (February, 1967).

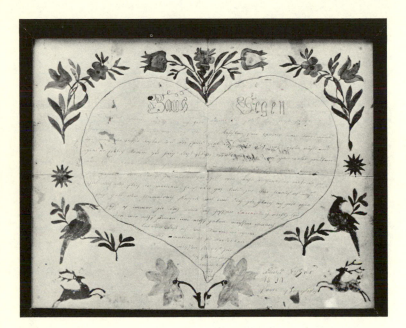

FRAKTUR HAUS SEGEN

House blessing, from Schaefferstown, Lebanon County, Pennsylvania (May, 1967). This *haus segen*, drawn in 1831, is apparently a copy of a form printed at Ephrata, Lancaster County, Pennsylvania, in the early nineteenth century; see Shelley, *The Fraktur-Writings*, ill. 251; John Joseph Stoudt, *Pennsylvania German Folk Art* (Allentown, 1966), p. 204.

Sgraffito, a type of pottery decoration in which a batter-thick slip, liquid clay, is poured over an unfired piece of redware and then incised so that the under color is exposed, flourished only in Pennsylvania. Used primarily for decoration, sgraffito was made in southeastern Pennsylvania as early as 1733 and as late as 1924.[58] Sgraffito was made in several parts of Britain during the colonial period,[59] and that produced in Devon was not only decorated very much like that of Pennsylvania, it was exported to Maryland and Virginia in the later seventeenth century;[60] still, the Central European tradition was much

val Art of Illuminative Writing Among the Pennsylvania Germans," *Proceedings of the American Philosophical Society,* XXXVI (1897), pp. 424–433; Henry S. Borneman, *Pennsylvania German Illuminated Manuscripts* (Norristown, 1937); Alfred L. Shoemaker, *Check List of Pennsylvania Dutch Printed Taufscheins* (Lancaster, 1952); Donald A. Shelley, *The Fraktur-Writings or Illuminated Manuscripts of the Pennsylvania Germans* (Allentown, 1961). *Fraktur* provides an example of a folk tradition which is not only literate—its later examples were mechanically printed.

[58]For Pennsylvania sgraffito: Edwin Atlee Barber, *Tulip Ware of the Pennsylvania-German Potters* (Philadelphia, 1903); John Spargo, *Early American Pottery and China* (New York and London, 1926), chapter VI; Cornelius Weygandt, *The Red Hills* (Philadelphia, 1929), pp. 181–191; John Ramsay, *American Potters and Pottery* (Clinton, 1939), pp. 15, 41–42; Arthur W. Clement, *Our Pioneer Potters* (New York, 1947), pp. 14–16.

[59]L. M. Solon, *The Art of the Old English Potter* (New York, 1886), pp. 82–83; W. B. Honey, *English Pottery and Porcelain* (London, 1933), p. 29; Wolf Mankowitz and Reginald G. Haggar, *The Concise Encyclopedia of English Pottery and Porcelain* (New York, n.d.), p. 199.

[60]C. Malcolm Watkins, "North Devon Pottery and its Export to America in the 17th Century," *Contributions from the Museum of History and Technology,* 225:13 (Washington, 1960), pp. 17–59.

stronger than the English, which seems, in fact, to be Continentally derived, and the sgraffito tradition of southeastern Pennsylvania is owed to the German and Swiss settlers.[61] All of the material manifestations of the folk culture of the Mid-Atlantic region were by no means Continental in origin, however. The decorative ventilator patterning in brick (Fig. 18A) found on barns on both sides of Mason and Dixon's Line, which has been identified as a Pennsylvania Dutch development,[62] is an English contribution, for the same construction was employed on barns in Staffordshire, Cheshire, and Shropshire as early as the fifteenth century.[63] And, the usual Mid-Atlantic pattern consisted of the blending of similar European traditions, the general acceptance and localization of one of the traditions, or the replacement of them all with something new; the result is a culture more Pennsylvanian than English, German, Scotch-Irish, or Welsh. The Conestoga wagon, one of Pennsylvania's proudest products, has antecedents in both Germany and England,[64] and Pennsylvania's famous sweet

[61]For examples of sgraffito remarkably like that of Pennsylvania: Erich Meyer-Heisig, *Deutsche Bauerntöpferei* (Munich, 1955).

[62]Henry J. Kauffman, "Pennsylvania Barns," *The Farm Quarterly*, 9:3 (Autumn, 1954), p. 61; J. William Stair, "Brick-End Decorations," in Alfred L. Shoemaker, ed., *The Pennsylvania Barn* (Kutztown, 1959), pp. 70–86.

[63]Olive Cook and Edwin Smith, *English Cottages and Farmhouses* (New York, 1955), p. 30, plates 92–93, 101, 113; W. M. Ingemann, *The Minor Architecture of Worcestershire* (London, 1938), p. 8.

[64]Frederick Law Olmsted, *Walks and Talks of an American Farmer in England*, I (New York, 1852), pp. 201–202; John Omwake, *The Conestoga Six-Horse Bell Teams of Eastern Pennsylvania* (Cincinnati, 1930), p. 16; Thomas Coulson, "The Conestoga Wagon," *Journal*

cookery is a composite of German, British, and general American traditions.[65]

A variety of house types may be found in the Mid-Atlantic region. Of stone or log, the Pennsylvania Germans built distinctive houses of a type known in the Rhine Valley;[66] these have a central chimney with a single deep fireplace yawning into the kitchen, one or two stories, and a two, usually three, or four-room plan (Fig. 14).[67] There

of the Franklin Institute, 246:3 (September, 1948), pp. 215–222; J. Geraint Jenkins, *The English Farm Wagon* (Reading, 1961), pp. 8–11, 36–37, 57 f.n. 9 (this book is a model material folk culture study); George Shumway, Edward Durell, Howard C. Frey, *Conestoga Wagon, 1750–1850* (York, 1966), chapter 2.

[65]For some material on Pennsylvania sweet cookery see: Edith M. Thomas, *Mary at the Farm and Book of Recipes Compiled During her Visit Among the "Pennsylvania Germans"* (Norristown, 1915), pp. 108–114, 194–208, 307–321, 325–388; J. George Frederick, *The Pennsylvania Dutch and Their Cookery* (New York, 1935), chapters 10, 11, 13, 14; Earl F. Robacker, *Pennsylvania German Cooky Cutters and Cookies* (Plymouth Meeting, 1946); Frederic Klees, *The Pennsylvania Dutch* (New York, 1950), pp. 415–427; Don Yoder, "Schnitz in the Pennsylvania Folk-Culture," *Pennsylvania Folklife*, 12:3 (Fall, 1961), pp. 44–53.

[66]Franz von Pelser-Berensberg, *Mitteilungen über Trachten. Hausrat Wohn- und Lebenweise im Rheinland* (Dusseldorf, 1909), pp. 49–53, plate X; Adolph Spamer, *Hessische Volkskunst* (Jena, 1939), pp. 20, 24–25 (houses of this type constructed as a part of a larger building including the barn).

[67]For examples: Donald Millar, "An Eighteenth Century German House in Pennsylvania," *The Architectural Record*, 63:2 (February, 1928), pp. 161–168; G. Edwin Brumbaugh, *Colonial Architecture of the Pennsylvania Germans* (Lancaster, 1933), pp. 23–47, especially pp. 24, 28–30, 43–47, and plates 2–6, 16–19, 35–39, 43–50; Robert C. Bucher, "The Continental Log House," *Pennsylvania Folklife*, 12:4 (Summer, 1962), pp. 14–19; Henry Glassie, "A Central Chimney Continental Log House," *Pennsylvania Folklife*, XVIII:2 (Winter, 1968–1969), pp. 32–39.

are a few scattered cabins (Fig. 15) of stone, frame or log, with rectangular floor plans and gable-end chimneys, very like the houses found in northern and western Ireland[68] and Wales,[69] and similar to some found in Scotland[70] and England.[71] The English immigrants usually erected I houses—two-story dwellings, one room deep, two or more rooms long, with, in Pennsylvania, internal gable-end chimneys and, typically, blank gable walls. Except for the I house, which continued to be built through the nineteenth century around Philadelphia and which was sporadically built, generally of frame or brick with two front doors, during the more recent two-thirds of the 1800's throughout the region, these Old World folk house types were almost completely replaced after about 1760 by houses influenced by the English two-room deep, two-story

[68]Åke Campbell, "Irish Fields and Houses: A Study of Rural Culture," *Béaloideas*, V:I (1935), pp. 57–74; Åke Campbell, "Notes on the Irish House," *Folkliv*, 1937: 2–3, pp. 205–234; E. Estyn Evans, *Irish Heritage* (Dundalk, 1963), chapter VII; E. Estyn Evans, "The Ulster Farmhouse," *Ulster Folklife*, I (1955), pp. 27–31; Caoimhín O Danachair, "Three House Types," *Ulster Folklife*, 2 (1956), pp. 22–26.

[69]Sir Cyril Fox, "Some South Pembrokeshire Cottages," *Antiquity*, XVI:64 (December, 1942), pp. 307–319; Iowerth C. Peate, *The Welsh House* (Liverpool, 1946), pp. 88–111.

[70]Colin Sinclair, *The Thatched Houses of the Old Highlands* (Edinburgh and London, 1953), "Dailriadic type."

[71]Sidney Oldall Addy, *The Evolution of the English House* (London, 1898), pp. 38–41 (it is interesting that this, the most important early work on English folk architecture, was written by a folklorist); Basil Oliver, *The Cottages of England* (New York and London, 1929), pp. 23–24; W. J. Turner, *Exmoor Village* (London, 1947), pp. 26–29, plus house charts and plates V, 5–8.

A

FIGURE 14

THE PENNSYLVANIA GERMAN
CENTRAL CHIMNEY HOUSE TYPE

A. V-notched log house; east of Palm in Lehigh County, Pennsylvania (April, 1967). B. Plan of A. In the most common plan of a house of this type, the large room to the right of the chimney is partitioned into two rooms; the larger, front room is the parlor; the smaller rear room, a bedroom. The long narrow room, entered through the front door, was the kitchen. C. Stone house, west of Lampeter, southeast of Lancaster, Lancaster County, Pennsylvania (November, 1967). The broken lines show the original positions of missing partitions. The doorways were located by mortises in the floor. This large house had a small room at the rear of the kitchen. The rooms other than the kitchen were heated by stoves. In this age of preservation and restoration, it is a disgrace that this house—the Herr house, built in 1719 and rich in early detail— is being allowed to disintegrate slowly. For pictures of it, see Brumbaugh, *Colonial Architecture of the Pennsylvania Germans,* plates 35-38.

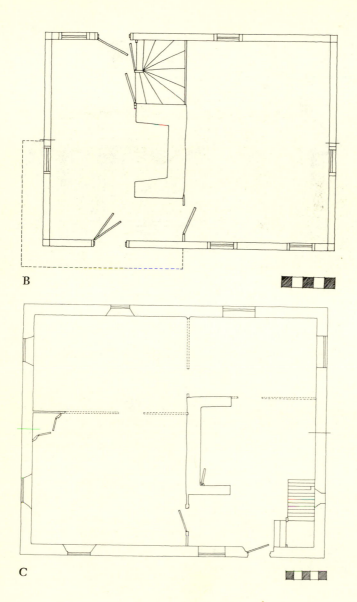

B

C

A

B

FIGURE 15

BRITISH CABINS
IN THE MID-ATLANTIC REGION

A. Stone cabin with front porch, rear kitchen shed, southwest of Kutztown, Berks County, Pennsylvania (March, 1967). B. Plan of A. C. Stone cabin with pent roof on the front, southeast of Honey Brook, Chester County, Pennsylvania (May, 1966). D. Stone cabin, northwest of Frederick, Frederick County, Maryland (June, 1963). With its opposed front and rear doors and internal partition, this provides a good New World example of a northwestern Irish house.

Georgian mode.[72] The classic floor plan of the Georgian type consisted of two rooms on each side of a broad central hall (Fig. 16A). A common subtype in rural Pennsylvania amounted to two-thirds of this plan—a hall with two rooms arranged along one of its sides (Fig. 16B). The Georgian type, the floor plan of which was not dissimilar to that of some Central European house types[73] and some of the Germanic houses of the early Moravian settlements,[74] continued to be built through the nineteenth century, long after it had ceased to be fashionable. The farmhouses most usual in the Mid-Atlantic region, however, combine Georgian with earlier folk features—old Rhineland peasant interiors stuffed into stylish eighteenth century shells. They are two rooms deep, have internal gable-end chimneys, a placement of windows and doors which approximates symmetry, and a low pitched roof like the Georgian houses, but they lack most of the stylish trim, the broad open stair has been replaced by a narrow boxed-in medieval stair which curls up in one corner,[75] the hallway is absent, and the house has a three or four-room Con-

[72]For some examples of Pennsylvania country Georgian: Aymar Embury, II, "Pennsylvania Farmhouses: Examples of Rural Dwellings of a Hundred Years Ago," *The Architectural Record*, XXX:V (November, 1911), pp. 475-485.

[73]C. Gillardon, "Das Safierhaus," *Schweizerisches Archiv für Volkskunde*, 48:4 (1952), pp. 201-232; Max Gschwend, *Schwyzer Bauernhäuser* (Bern, 1957), pp. 20-22, fig. 16.

[74]William J. Murtagh, *Moravian Architecture and Town Planning* (Chapel Hill, 1967), pp. 79-82, 101-104, 124-125.

[75]For examples: Don Blair, *Harmonist Construction* (Indianapolis, 1964), pp. 67-70, plate VI.

tinental plan and often two front doors (Fig. 16C-E, 17).
Like many of the early Pennsylvania German houses, these
houses are frequently built into a bank with a semisubterra-
nean cellar (Fig. 17B). Whether partially above ground or
completely below, the cellar was used for cooking and the
storage of preserved food; it often has the only large open
fireplace in the house. Porches skirting the front, sides and
rear, and kitchen wings off to one end or the rear, which
often have built-in porches and shed roofs, are common
appendages of the usual Mid-Atlantic folk house.

Just as the diverse early dwelling traditions of the
groups which settled in southeastern Pennsylvania gave
way to a new house type less than a century after the
colony was founded, so the small early barn types of Brit-
ain and the Continent (Figs. 26A, 39B) were largely sup-
planted by the late eighteenth century with the two-level
"bank barn." The cattle are stabled in the basement of the
Pennsylvania barn and the upper level, used for hay and
grain storage, is cantilevered over the lower on the barn-
yard side. This overhang, which generally faces the south,
east, or some compass point between, is called an "over-
shot," "foreshoot," or "forebay"—*der forschoos* or *der
forbau* in the Pennsylvania Dutch dialect. The barn is
built into a bank or has a ramp—"barn hill"—or bridge
built up to the side opposite the forebay, so that a vehicle
can be drawn onto the floor of the second level. It is built
of stone or brick, log or frame with a stone basement. The
Pennsylvania barn divides into two basic subtypes: that in
which the forebay is unsupported and that in which it is

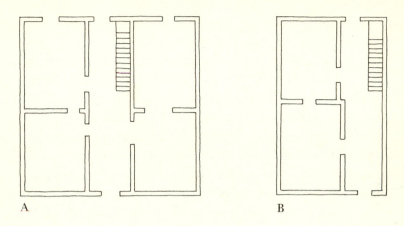

A B

FIGURE 16

MID-ATLANTIC HOUSE PLANS

A. Full Georgian plan; late nineteenth-century brick house, east of Robesonia, Berks County, Pennsylvania (April, 1967). B. Two-thirds Georgian plan; early nineteenth-century stone house, in Bellefonte, Centre County, Pennsylvania (June, 1966). Both A and B had rear appendages which have been removed in the drawing to reveal more clearly the basic type. C. Full-dovetailed log and stone house, south of Cocalico, Lancaster County, Pennsylvania (June, 1967). This house began as a log central chimney Pennsylvania German house (as in Fig. 14); at an early date it was enlarged with the stone walls at the right of the plan and extensively altered to conform externally with the later Mid-Atlantic farmhouses. D. V-notched log house with a one-story ell built of horizontal log tenoned into corner posts, northwest of York Springs, Adams County, Pennsylvania (March, 1968). The plan of this house is exactly that of the early Pennsylvania German type, except that it lacks the central chimney; the deep, straight-sided fireplace for heavy cooking is located in the rear ell instead of in the long narrow kitchen. E. Corner post log house with a one-story brick ell, between Mount Top and Rossville, York County, Pennsylvania (April, 1967). The three-room Continental plan and the balanced windows and doors of this house characterize the most common folk house type of the Mid-Atlantic region. The large cooking fireplace is located in the basement. For no good reason, houses C and E were torn down before 1967 had ended.

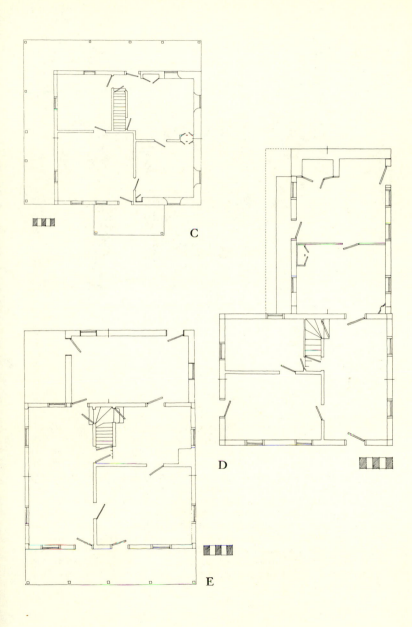

C

D

E

A

FIGURE 17

MID-ATLANTIC FARMHOUSES

A. North of Thurmont, Frederick County, Maryland (March, 1968). B. Southwest of Millersville, Lancaster County, Pennsylvania (July, 1967). A and B represent the usual subtypes of the most common Mid-Atlantic house type: both have four openings on the front of the first story; A has two windows and two doors (as in Fig. 16 E); B has three windows and one door. Both have the small internal gable end chimneys, and the symmetrical arrangement of windows on the ends which are characteristics of the type which includes them. Both also have the window shutters and front porches and B has the partially aboveground basement found on many Mid-Atlantic houses. C. East of Gettysburg, Adams County, Pennsylvania (October, 1967). Basically two houses built end to end, this house has a built-in, two-story porch on the rear of a kind found regularly in south-central Pennsylvania and adjacent Maryland.

B

C

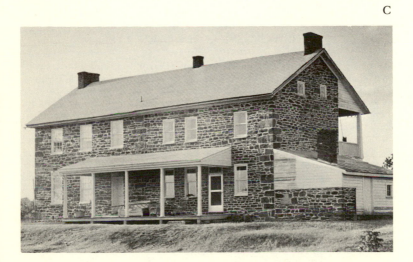

A

THE PENNSYLVANIA BARN TYPE

A. Brick barn with unsupported forebay (Dornbusch and Heyl, *Pennsylvania German Barns*, type F-G), north of Dillsburg, York County, Pennsylvania (July, 1968). B. Stone barn with supported forebay (Dornbusch and Heyl, type H), southeast of Oley, Berks County, Pennsylvania (July, 1963). C. Plan of a log barn with a stone basement and unsupported forebay (Dornbusch and Heyl, type F-G), southeast of Ickesburg, Perry County, Pennsylvania (March, 1967). Log examples of this type, while less rare than the published data would indicate, are less common than examples of frame, brick or stone. A log example was chosen because there was no difference between the form of log and other examples, and the log cribs delineate more clearly the internal divisions of the upper level (the plan above) than a framed example would: the hay mows are separated by a central floor two bays in width; there is a forebay on the front and sheds on the rear for grain bins and the storage of harness. Like many others, this barn incorporates a corncrib and runway at the right end.

B

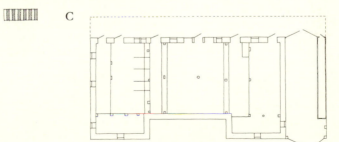

C

supported by an extension of the end walls (Fig. 18).[76] Although the peasant houses of Switzerland[77] and the Black Forest[78] have balconies which suggest the forebay and are often built into a bank with a lower level of stone and a wooden upper level like the usual Pennsylvania barns, and although the two-level barns of northwestern England[79] are built entirely of stone with sheds flanking the ramp like many are in Pennsylvania and are the same as a barn type found occasionally in the Mid-Atlantic region which has a pent roof rather than a forebay over the stabling doors,[80] the fully developed Pennsylvania barn seems not to be a transplant from Europe, but rather an American meshing of similar traditions brought from Britain and Central Europe.

The plain people share in the folk culture of the Mid-Atlantic region. Their houses and barns, for example,

[76]Charles H. Dornbusch and John K. Heyl, *Pennsylvania German Barns* (Allentown, 1958), types F-G and H. Although nothing more than a classification and an imperfect one at that, this is one of the best works on American folk architecture.

[77]An excellent study of Swiss folk architecture which includes many buildings, barns as well as houses, which are reminiscent of Pennsylvania barns is: Richard Weiss, *Häuser und Landschaften der Schweiz* (Erlenbach, Zurich and Stuttgart, 1959).

[78]See Hermann Schilli, *Das Schwarzwaldhaus* (Stuttgart, 1953).

[79]See James Walton, "Upland Houses: The Influence of Mountain Terrain on British Folk Building," *Antiquity*, XXX:119 (1956), pp. 144-147; Cook and Smith, *English Cottages and Farmhouses*, pp. 37-39, plates 154, 170-172, 174, 188.

[80]Dornbusch and Heyl, *Pennsylvania German Barns*, type E.

are basically the same as those of their "gay Dutch" and "English" neighbors, and wherever they have gone—to Maryland, to Nebraska, to Ontario—they have carried elements of southern Pennsylvania's material folk culture. But, they are identified and hedged off from other Pennsylvania Germans by certain traits, especially their dress.[81] Amish men wear lapel-less coats fastened by hook-and-eye and "barn door britches" of black. In the summer they wear hats of braided rye straw with a black or navy blue band; their winter hats are black and broad-brimmed. The older men wear cape coats like those that were fashionable during the first half of the nineteenth century. In cold, stormy weather the women wrap themselves in woolen shawls. Their dresses may be a solid bright color, but are subdued with a black apron. Like the Amish women, lady Mennonites wear bonnets derived, apparently, from Quaker originals and white mesh caps. Within the sects there is much variation in clothing: some Mennonite women dress no differently than other Americans, while

[81]For plain costume: Nelson Lloyd, "Among the Dunkers," *Scribner's Magazine*, XXX:5 (November, 1901), pp. 513–515, 527–528; John Paul Yoder, "Social Isolation Devices in an Amish-Mennonite Community," unpublished master's thesis, Pennsylvania State College (August, 1941), pp. 35–36, 53–57, 80–83; Don Yoder, "The Costumes of the 'Plain People'," in *In the Dutch Country* (Lancaster, n.d.), pp. 9–11; Mary Jane Hershey, "A Study of the Dress of the (Old) Mennonites of the Franconia Conference, 1700–1953," *Pennsylvania Folklife*, 9:3 (Summer, 1958), pp. 24–47; Elmer Lewis Smith, *The Amish People* (New York, 1958), pp. 164–171; Calvin George Bachman, *The Old Order Amish of Lancaster County* (Lancaster, 1961), pp. 89–95, 175–176, 182; John A. Hostetler, *Amish Society* (Baltimore, 1963), pp. 134–138, 236–241, 311.

others wear dresses which, though continually changing in response to the shifts of popular fashion, are stripped of frills and furnished with a modest cape. The distinctive costume of the plain groups was developed in the last century. Although some of its elements—the prayer cap and, conceivably, the broad-brimmed hat—may be traceable to the Continent, most are modifications of the conservative dress of nineteenth century rural Americans from any region, of any religious persuasion.[82] Today, these clothes are available in special department stores (the Amish elders wear expensive Stetson hats), but much of it, the outer garments of the women particularly, is still produced within the community.

The South

In the source area of the Chesapeake Tidewater, running from Baltimore down the coast to North Carolina's Albemarle Sound and rising inland to the foot of the Blue Ridge in Virginia (Fig. 7), the folk house types are one room deep: the most distinctive type—the hall and

[82]Compare, for example: Laura Huyett, "Straw Hat Making Among the Old Order Amish," *Pennsylvania Folklife*, 12:3 (Fall, 1961), pp. 40–41; Lewis R. Bond, "Homemade Straw Hats in Solebury," *A Collection of Papers Read Before the Bucks County Historical Society*, IV (1917), pp. 406–409 (Pennsylvania but not plain); Lora Case, *Hudson of Long Ago* (Hudson, 1963), p. 15 (Connecticut Yankees in Ohio making hats of the same kind).

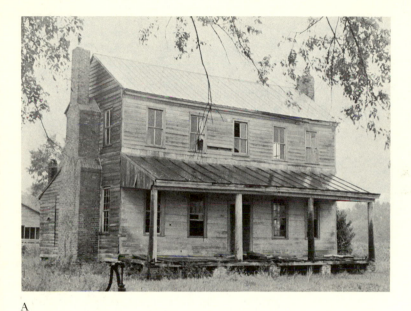

A

Figure 19

SOUTHERN I HOUSES

A. Frame with brick external chimneys, front porch and rear shed, west of Winton, Hertford County, North Carolina (September, 1967). B. Frame with internal gable end stove flues and two-story rear ell, north-west of Culpeper, Culpeper County, Virginia (August, 1964). Both of these houses, which range in date from the late eighteenth to the early twentieth centuries, are of the central hall, Georgian subtype of the I house.

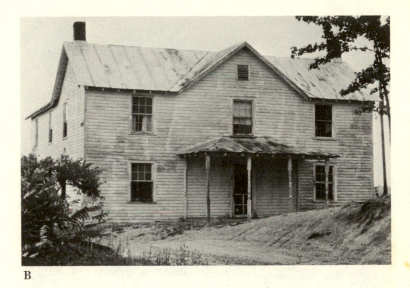

B

parlor house—is one story high (Fig. 22A);[83] the most common type is the two-story I house.[84] Both of these houses were patterned closely after English originals;[85]

[83]Cf. Henry Chandlee Forman, *The Architecture of the Old South* (Cambridge, 1948), pp. 96–97; Marcus Whiffen, *The Eighteenth Century Houses of Williamsburg* (Williamsburg, 1960), p. 44.

[84]The architectural historian has generally ignored the I house; for a few early Tidewater examples, see: Thomas Tileston Waterman and John A. Barrows, *Domestic Colonial Architecture of Tidewater Virginia* (New York, 1932), pp. 10–17, 20–27; Henry Chandlee Forman, *Tidewater Maryland Architecture and Gardens* (New York, 1956), pp. 3–11, 31–36.

[85]M. W. Barley, *The English Farmhouse and Cottage* (London, 1961); and Raymond B. Wood-Jones, *Traditional Domestic Architecture in the Banbury Region* (Manchester, 1963), the two finest recent studies of English domestic architecture, show clearly that one-story, two-room cottages and two-story, one-room-deep I houses were quite common in England during the American colonial period.

both usually have external chimneys at each gable-end, though chimneys built flush within the end walls are also found; and both were originally built with asymmetrical two-room plans (Fig. 20A), but came to be built with a broad central hall after the Georgian fashion (Figs. 19A, 20B). The strong I house tradition west of the Chesapeake includes moderate variation: a house was often built which consisted of two-thirds of the Georgian-influenced I—one room and a hallway long with one end chimney (Fig. 20C)—and from the later nineteenth century well into the twentieth, the central hall I house was built with narrow stove flues which flanked the hall or were located at the ends instead of chimneys (Figs. 19B, 20E). During the movement out of the Tidewater, the number of houses built of brick diminished as did the number built with hip or gambrel rather than gable roofs; the I house, particularly in its central hall subtype,[86] and the external gable-end chimney became even more predominant.

Much of the traditional English cuisine was, like the house types, carried west from the southern coast without great change. Mrs. Alice Poch, a woman in her seventies who was raised on a Virginia Piedmont farm in sight of the Blue Ridge remembers:

Then, they used to go out and shoot birds . . . these little birds. We used to go out—the boys would go out and shoot them, bring in twenty-five and thirty of 'em. And this colored girl we had would pick 'em,

[86]Cf. Thomas Tileston Waterman, *The Mansions of Virginia* (Chapel Hill, 1946), pp. 325–328, 330, 333, 360–363.

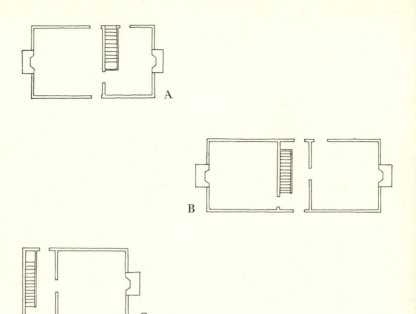

FIGURE 20

SOUTHERN I HOUSE PLANS

A. Two-room plan; frame with brick chimneys, between Waverly and Homeville, Sussex County, Virginia (July, 1963). The early two-room I houses generally have such asymmetrical plans; later examples often have rooms of equal size and occasionally two front doors. B. Central hall, Georgian subtype; frame with stone chimneys, between Madison and Shelby, Madison County, Virginia (July, 1962). C. Two-thirds Georgian subtype; square-notched log with brick chimney, south of Bumpass, Louisa County, Virginia (July, 1963). A, B and C all had rear appendages which have been removed to reveal more clearly the basic I house subtypes. D. Plan of house in Fig. 19 A; central hall I house with front porch and rear shed. The shed is divided into three; the central section, as is not unusual in the Lowland South, was left open to serve as a porch. E. Frame two-thirds Georgian I house subtype with one-story rear kitchen ell and internal stove flues, south of Unionville, Orange County, Virginia (June, 1968).

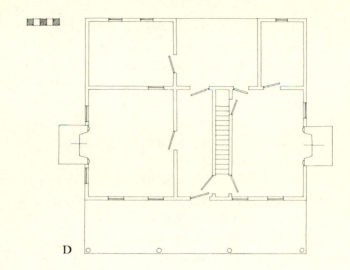

D

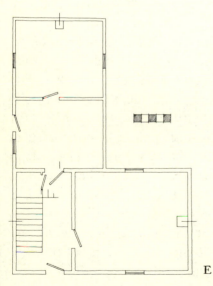

E

make 'em into a pie. And I think they were mostly like snow birds—a little bird like that. And they'd take the feathers 'n' all off. . . . Then, they'd take and put 'em in a pot an' boil them until they were entirely done. [And after they cooked them they'd take a fork, and Mandy used to take some of the bones out of the water, before puttin' 'em in, but often you'd find bones all through the pie.] And then they would take the dough and make it just like you were going to make a regular apple pie or somethin', make a good pie, a good dough. And put the little birds in there. [Then they made a white sauce out of flour and milk and poured the white sauce right over the birds.] Put a top on it, and put it in the stove and cook it just exactly like that. . . . It seemed good; the boys liked it. . . .

And another way they did to kill these little birds: they would take—this was a horrible way—they would take a plank, about, I'll say, twelve inches wide and about four feet long, and, then, put under each side a little thing like they called a 'trigger,' it was nothin' in the world but a stick with a rope tied to it and they would go inside the barn, clean a place off in the snow and put wheat there, a lot of wheat . . . and all under this board. And when those little birds would go there, maybe twenty-five of them at once, starving to death to eat the wheat, they would pull that string and let that thing come down on 'em. . . . And then they would take and pick 'em and take 'em

in to poor old Mandy and she would make the pies
out of them. I've done that a million times and you
know it was really barb'rous.[87]

Pies made of little birds were also enjoyed in the
Tidewater as Minor Wine Thomas, Jr., born and raised
around Williamsburg, Virginia, explains:

You asked earlier about the business of blackbird pie.
This is something that Annabelle and I have made on
several occasions, but the idea was actually suggested
to me by stories that I have heard from older people
than myself about making a pie out of small birds.
Apparently it was the custom for many, many years
in an earlier day to make pies out of robins. And,
apparently robins at one time traveled in great, enor-
mous migratory flocks that used to stop and roost
particularly in cedar groves. . . . This was a regular
spring and fall occurrence: to go out in the cedar
groves where these robins, these migratory flocks of
robins, came. And to go out with torches at night and
find the locations of the robin roosts and then to fire
in them with fine birdshot. And, to just shoot and
shoot and shoot, and they didn't bother even to pick
up the carcasses until the next morning when they

[87]Mrs. Alice C. Poch; tape-recorded interview, August 1, 1965.
Mrs. Poch was raised on "Clearmont," a farm established early in the
eighteenth century by her ancestors, who came from Devon, England.
She left the farm, which is located near New Baltimore, north of
Warrenton, in Fauquier County, Virginia, as a young woman and
makes her home now in Washington, D.C. Her memories of her youth
are unclouded by change and remarkably clear.

could see, and they'd go out and pick these things up by the hundreds. And then they'd make pies out of them. . . . I doubt that it happens anymore, I don't think there are that many robins any more; but, any rate, it did happen. But, although I never ate robins, we did it with blackbirds, and to this day, of course, blackbirds migrate in, again, astonishing numbers, and they settle in the corn, and, where they find them, wheat fields in eastern Virginia; there're not too many wheat fields there anymore—mostly corn fields. . . . Well, the first time that I ever did this I managed to secrete myself in a haystack, and I could see about which way a flock of these birds was rolling towards me. And I got three sora loads in my automatic shot-gun. And the flock came up to me; I stood up suddenly, which, of course, made the whole flock get up at once, and fired right into the mass three times just as fast as I could shoot, and I killed forty-two birds, and went out and picked 'em up.

And they're extremely easy to dress: the skin pulls away from the body with no difficulty whatsoever, you just grab it between your forefingers, like this, and pull, and the skin and everything'll come away. And then you can slip your thumb under the breast bone of the bird and just, literally, pull it away, like so. And you get a chunk of meat which surrounds the wish bone and breast bone, which is, oh, roughly as big around as a fifty cent piece and possibly half an inch thick. The business of dressing out forty-two

blackbirds will take less than forty-two minutes, you can just dress them out about that rapidly. You pay no attention to anything, just the breast meat, and this we parboiled until the meat was soft enough to pull away from the breast bone; then, we just pulled this away. And then, Annabelle fixed it in much the same fashion that you'd fix creamed chicken, for instance, and did it up in a cream sauce. Put it in a pie shell and baked it up. And, it's one of the most delicious things I've ever eaten in my entire life, and having done this once, we hunted them fairly regularly for a number of years after that; I never made as big a kill with three shots again as I did that particular time.[88]

In England small birds have been hunted for food since at least the Middle Ages,[89] and in southwestern England, from whence came many of the Tidewater people, nearly everything edible, including small birds, is stuffed into pies.[90] The popular attitude which would prevent many a modern American from sitting happily down to a dinner of robin, wren, or chickadee, obtained also in the nineteenth century while many southerners were captur-

[88]Minor Wine Thomas, Jr.; tape-recorded interview, August 11, 1966. Mr. Thomas, an unshaken Confederate, is one of America's foremost experts on colonial technology and the chief curator of the Farmers' Museum-Fenimore House-New York State Historical Association complex in Cooperstown, New York.

[89]H. S. Bennett, *Life on the English Manor* (London, 1962), p. 93; E. V. Lucas, *Highways and Byways in Sussex* (London, 1907), pp. 180–183.

[90]A. K. Hamilton Jenkin, *Cornish Homes and Customs* (London and Toronto, 1934), pp. 77–82, 86.

ing songbirds and making them into pies. The editor of the *American Agriculturist*, a guardian of rural morals, placed the following under an engraving of three small boys trying to capture some birds in the snow with a grain sieve propped up by a stick which one of the boys controls with a string.

We don't quite like the looks of those boys trying to catch the innocent little snow birds. . . . Do you quite like the appearance of the boy who holds the string, and is no doubt head of the party?. . . . We think there is a "don't care" look about him that is not very promising. . . . If the truth could be known, perhaps we should find him one who has just left his threshing in the barn . . . and taking the grain screen, he has coaxed the other boys who should be at school, to go out with him to trap the snow-birds. A boy that would trap such innocent little fellows, that do no harm and that are useless when caught, would be likely to do such tricks. Some one should sing to him that sweet little song "Chick-a-dee-dee,"—written by our "Uncle Frank,"—to soften his hard nature a little.[91]

While the Tidewater culture was being carried up into the Virginia Piedmont during the middle two quarters of the eighteenth century, beyond the Blue Ridge, Penn-

[91]*American Agriculturist*, XVIII:2 (February, 1859), p. 57. The aversion to eating songbirds is a good example of a tradition which is not folk. The southern songbird pie is a good example of something which is traditional, nonpopular—folk.

sylvanians of mostly German and Scotch-Irish stock were settling the Valley of Virginia. In the northern Valley they built some central chimney houses of log or stone[92] and the German plan Georgian houses which are usual in southern Pennsylvania and central Maryland, but throughout the rolling Valley the houses are predominantly of the English I type brought over the Blue Ridge from the low country west of the Chesapeake Bay. The older I house was built sometimes of brick but more usually of wood with a hefty limestone chimney at each end and a two-story porch slightly wider than the central hall on the front; later ones lack the chimneys, have long one-story porches, Gothic gables and two-story ells, but their floor plan, broad front with its balanced rhythm of openings, tall gable, and white clapboard siding were the same; to the family who must live and work inside, to the casual viewer from the road they are the same house. The most common barn is the two-level Pennsylvania type with the unsupported forebay, though certain of its features, such as the overhang on the ends and ramp side in addition to the forebay, are, apparently, Virginia localizations.[93] Also characteristic of the Valley is the external chimney (Fig. 21) built with an exterior fireplace used during laundering,

[92]John Water Wayland, *The German Element of the Shenandoah Valley of Virginia* (Charlottesville, 1907), pp. 190–192; Thomas Tileston Waterman, *The Dwellings of Colonial America* (Chapel Hill, 1950), pp. 44–46; Jennie Ann Kerkhoff, *Old Homes of Page County, Virginia* (Luray, 1962), pp. 5–8, 29–32, 37–40, 45–48.

[93]Henry Glassie, "The Pennsylvania Barn in the South," II, *Pennsylvania Folklife*, 15:4 (Summer, 1966), pp. 12–25.

FIGURE 21

CHIMNEY WITH EXTERIOR FIREPLACE

This chimney is on a log two-thirds Georgian I house sub-type with a two story frame end addition making it into a full Georgian I house, located between Mint Spring and Middlebrook, Augusta County, Virginia (July, 1963). Chimneys were built of stone to the shoulders and topped with brick in all of the eastern regions.

butchering, soap and apple butter boiling. While not un-known outside of the Valley (there are examples in west-ern Pennsylvania,[94] central Maryland,[95] and eastern Vir-ginia[96]), it is rare outside of the Valley, as such chores were usually carried out over open fires in the adjacent moun-tains[97] and in separate washhouses or staple-shaped ma-sonry fireplaces in Pennsylvania.[98] Other traits of the ma-terial folk culture of the Valley were transported directly from Pennsylvania: furniture with delicate floral inlay like that done especially in Chester County[99] has been found in the Valley,[100] and Virginia Germans drew up *fraktur* birth and baptismal certificates.[101]

[94]James D. Van Trump and Arthur P. Ziegler, Jr., *Landmark Architecture of Allegheny County, Pennsylvania* (Pittsburgh, 1967), p. 245.

[95]Roger Brooke Farquhar, *Historic Montgomery County, Mary-land, Old Houses and History* (Silver Spring, 1952), p. 104. There is another example near Travilah, Montgomery County (August, 1962).

[96]*The Architectural Record*, 63:6 (June, 1928), p. 590.

[97]Lamont Pugh, "Hog-Killing Day," *Virginia Cavalcade*, VII:3 (Winter, 1957), pp. 41–46.

[98]Laura B. Strawn, "Applebutter Making as Practiced by our Ancestors," *A Collection of Papers Read Before the Bucks County Historical Society*, IV (1917), pp. 331–333; Henry Kinzer Landis, *Early Kitchens of the Pennsylvania Germans* (Norristown, 1939), pp. 29–31, 39–42.

[99]Margaret Berwind Schiffer, *Furniture and Its Makers of Ches-ter County, Pennsylvania* (Philadelphia, 1966), pp. 262–264, plates 119–145, 168.

[100]Ernest Carlyle Lynch, Jr., *Furniture Antiques Found in Vir-ginia* (New York, 1954), pp. 14–15.

[101]Elmer Lewis Smith, John G. Stewart, M. Ellsworth Kyger, *The Pennsylvania Germans of the Shenandoah Valley* (Allentown, 1964), pp. 165–170.

The ridges that rim the Valley and run along the Tennessee-North Carolina border into Georgia are characterized by a syncretism of Tidewater-English and Pennsylvania-German-Scotch-Irish traits: the houses are mainly English types carried up from the Chesapeake Tidewater; most of the predominant barn, outbuilding, and construction types are traceable to Pennsylvania. Along the Virginia Blue Ridge, in an area spilling over eastward into the Piedmont, particularly where Virginia and North Carolina join, and again at the southern tail of the Blue Ridge in Georgia and Alabama, many of the distinctive Tidewater types, such as the hall and parlor house, can be found, translated without formal change from weatherboarded frame and brick into log and stone (Fig. 22). The direct Tidewater influence on the Alleghenies and the North Carolina Blue Ridge and Piedmont was less, and the commonest folk house types in these areas, other than the English I house, are based on the cabin type derived from a Pennsylvania-Ulster and Connaught original, which may be distinguished by its rectangular plan and opposed front and rear doors from the square English-Tidewater cabin found in the Virginia and Georgia Piedmont and Blue Ridge.[102] Frequently the cabin has another added to one of its ends; if the addition is made onto the chimney end, the house is a saddlebag (Fig. 23A, B, E, F);[103] if the addition

[102]Henry Glassie, "The Types of the Southern Mountain Cabin," in Jan H. Brunvand, *The Study of American Folklore* (New York, 1968), pp. 338–370.

[103]For a good example see Francis Benjamin Johnston and Thomas Tileston Waterman, *The Early Architecture of North Carolina* (Chapel Hill, 1947), pp. 8, 16–17.

is built onto the end opposite the chimney, a double-pen with end chimney house results (Fig. 23C, D); both types came to be commonly built in log or frame as one-story houses composed of two equal units with two front doors and one chimney.

The importance of the Pennsylvania German strain in Southern Appalachian culture has been obscured by nonsense about "the purest Anglo-Saxon blood on earth."[104] The log construction which was carried from Central Europe, probably from lands which are now in western Czechoslovakia, via Pennsylvania into the Southern Mountains,[105] is nearly a symbol of the region;[106] it was employed on structures of all types and sizes into our century, and is still used in the construction of minor outbuildings and bridges. The three or four stringed, strummed, or bowed mountain dulcimer (Fig. 24)[107]—

[104]Josiah Henry Combs, *The Kentucky Highlanders from a Native Mountaineer's Viewpoint* (Lexington, 1913), p. 39.

[105]For log construction: Fred Kniffen and Henry Glassie, "Building in Wood in the Eastern United States: A Time-Place Perspective," *The Geographical Review*, LVI:1 (1966), pp. 48–65.

[106]Although most of the areas in which log construction is very common were not surveyed (see, however, the figures for Knott County, Kentucky and Halifax County, Virginia), *The Farm-Housing Survey* (Washington, 1939) presents clearly the contrast of the prevalence of log construction in the southern uplands with its rarity in the North.

[107]For the dulcimer: Charles F. Bryan, "American Folk Instruments: The Appalachian Dulcimer," *Tennessee Folklore Society Bulletin*, XVIII:1 (March, 1952), pp. 1–5; John Putnam, "The Plucked Dulcimer," *Mountain Life and Work*, XXXIV:4 (1958), pp. 7–13; Charles Seeger, "The Appalachian Dulcimer," *Journal of American Folklore*, 71:279 (January–March, 1958), pp. 40–51; Jean Ritchie, *The Dulcimer Book* (New York, 1963); Leonard Glenn, "The Plucked Dulcimer of the

A

FIGURE 22

THE HALL AND PARLOR HOUSE TYPE

A. Frame with brick chimneys, in Port Royal, Caroline County, Virginia (July, 1963). The crooked narrow internal partition is modern and, for comparative purposes, the plan must be read without it. B. Full-

B

dovetailed log with stone chimneys, west of Boonesville, Albemarle
County, Virginia (August, 1964). These houses, one located in the
Tidewater and one in the Blue Ridge, not only have the same form—
are of the same type—but also share some variable details; on both, for
example, the rafters are framed together at the peak in an open mortice
joint (there is no ridge pole) and are tied together with halved in
collar beams. For another example see Fig. 44.

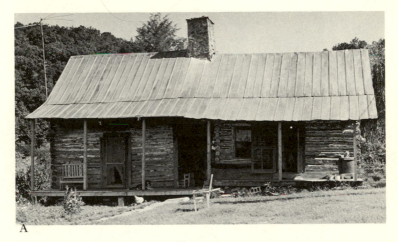

A

FIGURE 23

DOUBLE-PEN HOUSE TYPES
OF THE SOUTHERN UPLANDS

A. V-notch log saddlebag house, east of Danbury, Stokes County, North Carolina (August, 1965). B. Half-dovetail log saddlebag house with stone chimney, Punchbowl Hollow, near Nough, south of Del Rio, Cocke County, Tennessee (May, 1966). The original house, the room at the right, provides an example of a mountain cabin of Scotch-Irish derivation (compare Fig. 15 D). C. Double-pen house with end chimneys; clapboarded rectangular log cabin with porch, frame end and rear additions, stone and brick chimneys, north of Alpharetta, Fulton County, Georgia (November, 1966). D. Double-pen house with end chimney; V-notched rectangular log cabin with frame end and rear additions, and stone chimney, east of Etowah, Henderson County, North Carolina (June, 1963). This form with one end chimney is much more common than the two chimney form of C. E. Saddlebag house; V-notched rectangular log cabin with frame end addition, front porch, and stone chimney, between Hayesville and Franklin, Macon County, North Carolina (June, 1963). F. Saddlebag house; half-dovetailed log with frame ell, front and rear porches, brick chimney, north of Menlo, Chattooga County, Georgia (May, 1964). Unlike A, B, and E, this saddlebag house is not the result of an addition; rather, it was built as a whole.

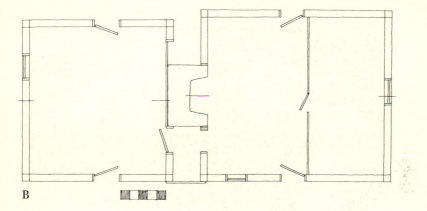

B

C

E

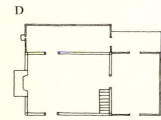

D

F

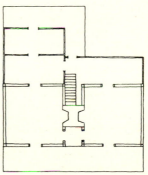

FIGURE 24

THE GLENNS' DULCIMER SHOP

The shop of Leonard and Clifford Glenn is located in front of their house in the mountains west of Sugar Grove, Watauga County, North Carolina (August, 1964). Leonard Glenn has been making banjoes since about 1928 (see Fig. 4). The dulcimers that he and his son, Clifford, make arè patterned after one his uncle, a Kentuckian, gave him to repair about 1958. (The older North Carolina dulcimers tend to be tear drop–rather than guitar-shaped like that pictured here.) The sudden, largely urban, interest in the dulcimer has allowed the Glenns to devote their full time since 1963 to a craft which had been a farmer's sideline for over three decades. The Glenns' dulcimer whether traded locally or shipped to Brooklyn, whether made by the father or the son, is the same instrument.

"dulcimore"—is almost surely a modification of Pennsylvania Dutch instruments of the zither family[108] which have antecedents in Northern and Central Europe.[109] Continental antecedents[110] and a New World source in Pennsylvania[111] can also be discovered for a type of outbuilding found irregularly throughout the Southern Appalachian area, which is built into a bank with a masonry lower level and an upper level of wood (Fig. 25).[112] The Kentucky rifle, developed out of Swiss and German rifles (with some formal direction provided, probably, by British fowling pieces)

Southern Appalachians," *Folkways Monthly*, I:2 (January, 1963), pp. 63–68; Julia Montgomery Street, "Mountain Dulcimer," *North Carolina Folklore*, XIV:2 (November, 1966), pp. 26–30.

[108]See Henry C. Mercer, "The Zithers of the Pennsylvania Germans," *A Collection of Papers Read Before the Bucks County Historical Society*, V (1926), pp. 482–497; R. P. Hommel in *Antiques*, XXII:6 (December, 1932), p. 238; Cornelius Weygandt, *The Dutch Country* (New York and London, 1939), pp. 300–302.

[109]See Hortense Panum, *The Stringed Instruments of the Middle Ages: Their Evolution and Development* (London, n.d.), pp. 263–291; Anthony Baines, *Musical Instruments Through the Ages* (Baltimore, 1961), pp. 210–211.

[110]See Halvor Vreim, "Houses with Gables Looking on the Valley," *Folk-Liv*, 1938:3, pp. 295–315; M. Gschwend, "Schlafhäuser," *Schweizer Volkskunde*, 39:4 (1949), pp. 56–59; Walter Laedrach, *Der Bernische Speicher* (Bern, 1954), p. 110; Josef V. Scheybal, "K Nekterým Otazkám Patrového Stavitelství na Slovensku," *Slovenský Národopis*, VIII:3 (1960), pp. 494–501.

[111]See Robert C. Bucher, "The Cultural Backgrounds of Our Pennsylvania Homesteads," *Bulletin of the Historical Society of Montgomery County, Pennsylvania*, XV:3 (Fall, 1966), p. 26. For examples: Amos Long, Jr., "Springs and Springhouses," *Pennsylvania Folklife*, 11:1 (Spring, 1960), pp. 40–43.

[112]Henry Glassie, "The Smaller Outbuildings of the Southern Mountains," *Mountain Life and Work*, XL:1 (Spring, 1964), pp. 21–25.

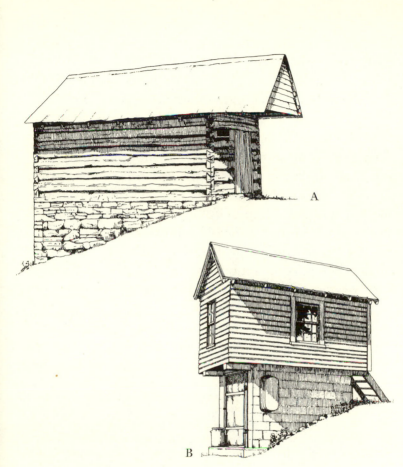

FIGURE 25

THE TWO-LEVEL OUTBUILDING TYPE

A. Half-dovetailed log upper level, limestone lower level, west of Chilhowie in Washington County, Virginia (July, 1964). B. Frame upper level, cinder block lower level, west of Allen Gap, Greene County, Tennessee (May, 1964). While this example is brand new, the idea of having the upper level overhang the lower is old in the mountains and known on the Continent.

during the early eighteenth century in southeastern Pennsylvania,[113] has been made very recently in the mountains,[114] and is kept freshed out and in repair to appear on occasion at target matches because a modern firearm accurate enough to compete with the old locally made percussion rifles costs more than most mountain farmers can muster. The rifle made in the mountains in the past half century exhibits about the same form as an early nineteenth century Pennsylvania-made Kentucky—its barrel is long, its bore is small, and there is a noticeable drop in the stock—but it may be easily distinguished by its thin wrist, thick forestock, (low price in antique gun catalogues), and the absence of ornamental inlays and patchbox.

The southern Tennessee Valley and the hills around it comprised a dynamic area at the beginning of the nineteenth century, for it was here that, in what was apparently a brief period, the transverse-crib barn and

[113]John G. W. Dillin, *The Kentucky Rifle* (Washington, 1924); Henry Kinzer Landis and George Diller Landis, "Lancaster Rifles," *The Pennsylvania German Folklore Society*, VII (1942), pp. 107–157; Henry J. Kauffman, *The Pennsylvania–Kentucky Rifle* (Harrisburg, 1960); Joe Kindig, Jr., *Thoughts on the Kentucky Rifle in its Golden Age* (York, 1960).

[114]Robert Lindsay Mason, *The Lure of the Great Smokies* (Boston and New York, 1927), chapter X; Arthur Isaac Kendall, "Rifle Making in the Great Smokies," *The Regional Review*, VI:1,2 (January-February, 1941), pp. 20–31; Walter M. Cline, *The Muzzle-Loading Rifle . . . Then and Now* (Huntington, 1942), pp. 17–22, 70, 77–94, 112–117; Ned H. Roberts, *The Muzzle-Loading Cap Lock Rifle* (Harrisburg, 1958), chapter X; Eldon G. Wolff, "Wyatt Atkinson, Riflesmith," *Lore*, 14:2 (Spring, 1964), pp. 38–52.

dogtrot house were developed. The Tennessee Valley farmer found himself in need of a large barn. The Pennsylvania barn would have served him, but he seems not to have known it; he did, however, know the double-crib barn, a type found in Central Europe and with regularity from south central Pennsylvania down the Alleghenies of Virginia, West Virginia, and Kentucky, and through the Blue Ridge of North Carolina and Tennessee.[115] He built a pair of double-crib barns facing each other, roofed the whole, and had a four-crib barn. As it was built, the four-crib barn developed its own symmetry, one of its two passageways was blocked off to provide additional stabling, and this painfully neat evolutionary sequence resulted in the transverse-crib barn (Fig. 26).[116] At about the same time, say 1825, the dogtrot house, loved by writers of local color and travel literature, arose. This one-story house, composed of two equal units separated by a broad open central hall and joined by a common roof (Fig. 27), has been attributed to Scandinavian influence and pioneer ingenuity[117]—that logical collision of environment and genius to which the unenergetic scholar ascribes many American cultural phenomena. The dogtrot house is, actually, a subtype of the old hall and parlor house built

[115]Henry Glassie, "The Pennsylvania Barn in the South," I, *Pennsylvania Folklife*, 15:2 (Winter, 1965–66), pp. 12–19.

[116]Cf. Kniffen, "Folk Housing," pp. 563–565, 566.

[117]Martin Wright, "The Antecedents of the Double-Pen House Type," *Annals of the Association of American Geographers*, 48:2 (June, 1958), pp. 109–117.

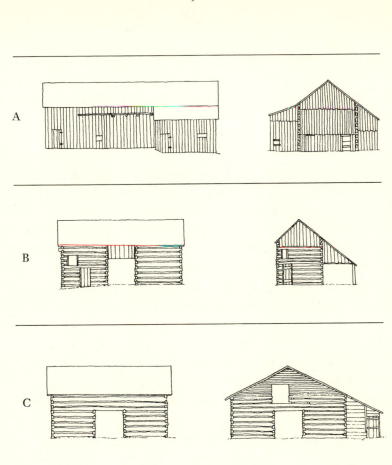

FIGURE 26

THE DOUBLE-CRIB TO
TRANSVERSE CRIB-BARN SEQUENCE

A. Double-crib barn, west of Mann's Choice, Bedford County, Pennsylvania (August, 1963). B. Double-crib barn, southwest of Crandon, Bland County, Virginia (July, 1964). Both of these double-crib barns are of

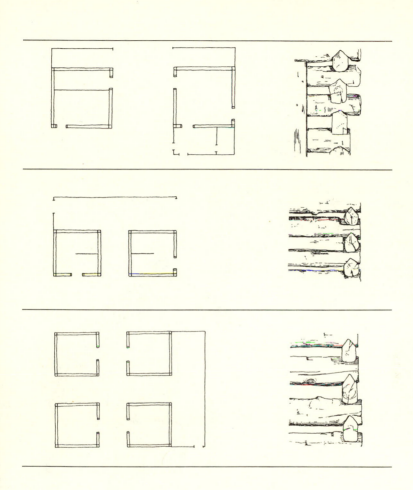

the subtype II; see *Pennsylvania Folklife*, 15:2 (Winter 1965–1966), pp. 14–15. C. Four-crib barn, between Tuscaloosa and Oakman, Tuscaloosa County, Alabama (July, 1964). D. Transverse-crib barn, northeast of Eutaw, Greene County, Alabama (May, 1964). E. Transverse-crib barn, near Hickory Flat, Forsyth County, Georgia (November, 1966). All of

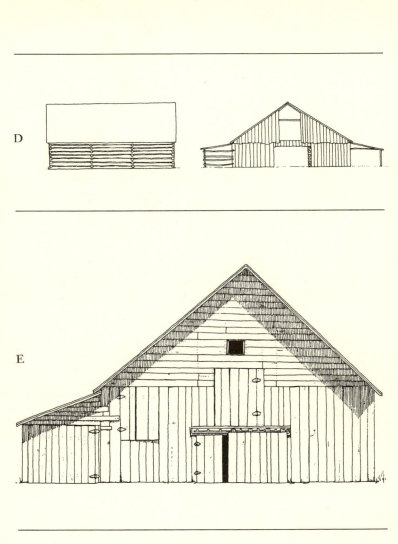

these barns have stabling on the ground level with a hay loft above. All also have shed additions for storage, particularly of vehicles. A through D were built of log. The right hand column consists of details of their corner-timbering; A through C are V-notched; D is saddle-notched.

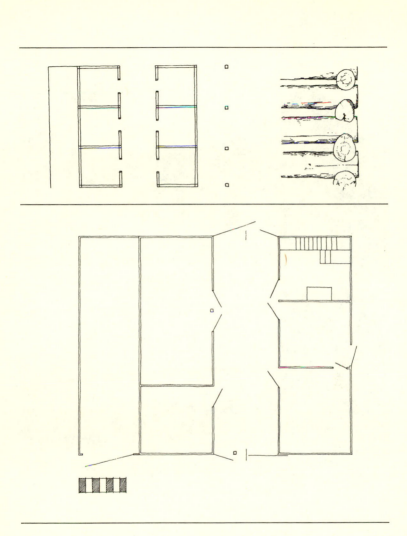

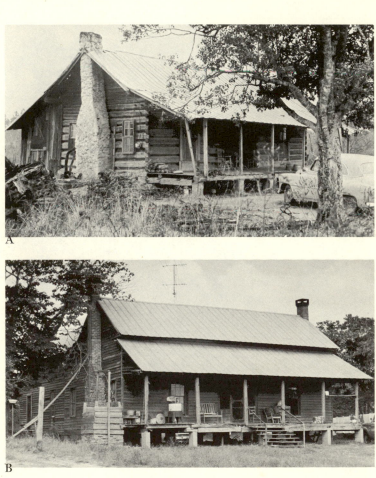

FIGURE 27

THE DOGTROT HOUSE TYPE

A. Half-dovetailed log dogtrot house with front porch, rear shed addition, near Energy, Clarke County, Mississippi (November, 1962). B. Frame dogtrot house with front porch, rear ell, west of Johnson Cor-

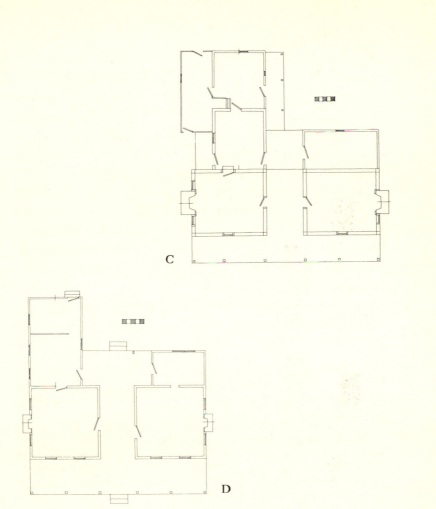

C

D

ner, Toombs County, Georgia (September, 1967). The trot is screened in. C. Plan of a V-notched log dogtrot house with stone chimneys, front and rear porches, rear shed and ell of frame, west of Russellville, Franklin County, Alabama (December, 1962). D. Plan of a clapboarded frame dogtrot house with brick chimneys, front and rear porches, rear shed and ell, near Ralph, Tuscaloosa County, Alabama (July, 1964).

symmetrically with a central hall (Fig. 28),[118] one of the most common house types in the Southern Tidewater source area from Pamlico Sound in North Carolina through eastern Georgia. This central-hall, one-story house, one room in depth, was supported by the adoption of its form by some Greek Revival architects,[119] but most extant examples were built plainly of frame with a brick chimney at each end, a porch on the front, and additions on the rear. In the western areas of higher elevation, these houses were built, when built of log, in two separate units because logs the length of a central hall house—about forty feet—would have been difficult to obtain and work. In western Virginia, the halls of the rare log central hall houses—I houses more often than houses of one story[120]— were usually framed in or blocked off from the beginning by cantilevered logs. But in the warmer Tennessee Valley

[118]For examples of dogtrot-like Tidewater houses see: Whiffen, *Eighteenth Century Houses of Williamsburg*, p. 120; Carl Julien and Chlothilde R. Martin, *Sea Islands to Sand Hills* (Columbia, 1954), pp. 45, 112.

[119]Houses of dogtrot proportions were planned and erected widely but thinly by Greek Revival architects, being, probably, adaptations from the I house in the North and from the hall and parlor house in the South; for an example see Rexford Newcomb, *Old Kentucky Architecture* (New York, 1940), plate 89.

[120]For I houses see: Robert A. Lancaster, Jr., *Historic Virginia Homes and Churches* (Philadelphia and London, 1915), p. 467; Frances J. Niederer, *The Town of Fincastle, Virginia* (Charlottesville, 1966), pp. 5, 7–8, 9, 11, 13, 14. Two-story log central hall houses are still occasionally encountered in southwestern Virginia. One-story examples are very rare; there is one south of Markham, Fauquier County, Virginia (August, 1964), however, and another between Covington and Jordan Mines, Allegheny County, Virginia (July, 1964).

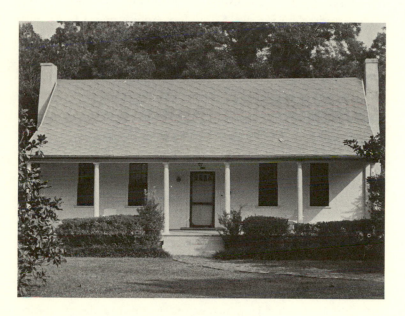

FIGURE 28

HALL AND PARLOR HOUSE
WITH CENTRAL HALL

This house is clapboarded except for the area under the porch on the front which is covered by flush horizontal boards. The chimneys, set slightly away from the gable at the top as is typical of the southern coast, are of brick. It is located in Sandersville, Washington County, Georgia (September, 1967).

some clever individual(s) hit upon the idea of leaving the
hall open to the evening breezes. The trot is generally
called a "hall" by dogtrot house inhabitants and that is
how it is used: it is always floored and may be comforta-
bly screened and furnished in the summer with table,
chairs, and television set. Some late houses were built with
the trot sealed off, and the open hall of most of the old
houses is now boarded up, less as a result of climatic than
social change. By no means are all houses with open pas-
sageways dogtrot houses: many are unrelated,[121] and the
open central hall was borrowed for use in other types,
such as the recent bungalow[122] and the I house.[123]

[121]The term "dogtrot"—also "possum trot," "turkey trot"—has
been promiscuously used, probably because of its down-home ring. The
problem is that, if a type is incompletely described, it will attract to it
unrelated examples. The open hall is not the lone definitive characteris-
tic of the dogtrot house: a house with a wing added to the rear or end
with a breezeway left between has an open passageway, but the parts it
separates are not of equal size and symmetrical relationship. The
breezeway was known in England and is rare in neither Pennsylvania
nor the eastern South; see: Forman, *Architecture of the Old South*, pp.
64, 78–79, 154–155, 180–181; Stotz, *Early Architecture of Western Penn-
sylvania*, pp. 34–35, 36, 38, 42. A pair of cabins built close together and
unattached, or attached by a roof lower than that of the two cabins
(there is such a house in Calvary Community, Halifax County, Virginia
[July, 1963]) are also false dogtrots. Two cabins built side by side with
a narrow unfloored passage between are not dogtrot houses either; an
example is found in Laura Thornborough, *The Great Smoky Mountains*
(Knoxville, 1962), p. 96, facing p. 157. (Once the form was established,
extant cabins were, of course, added to with dogtrot house results.)
Other varieties of nondogtrots can be found in Sibyl Moholy-Nagy,
Native Genius in Anonymous Architecture (New York, 1957), pp.
107–108, and in many cities where open passageways separate row
houses, as in Fig. 62B.
 [122]There is a bungalow with an open hall running from gable to

The dogtrot house and transverse-crib barn tie the material culture regions of the South together. They were carried northward so that transverse-crib barns can be found throughout the Southern Appalachians and dogtrot houses in the Cumberlands and the northern North Carolina Piedmont. Both were built throughout the Tennessee Valley and up through Tennessee[124] into Kentucky;[125] the northern distribution of the barn, though, is broader and more intense than that of the house. In the low plateaus, the Bluegrass, the typical dwelling is the I house, brought across the mountains and connoting, wherever built, agrarian stability; it was the home of the middle-class farmer who carried much of the predominantly English folk culture of the eastern South. His I house was often superficially fashionable and built of brick or stone as well as log or frame,[126] and he had his slaves lay up limestone walls with upright diagonal capping stones (Fig. 29)[127] like

gable near Red Bay, Itawamba County, Mississippi (December, 1962).

[123]For a good example see: *Historic American Buildings Survey Catalog of the Measured Drawings and Photographs of the Survey in the Library of Congress* (Washington, 1941), pp. 343-344.

[124]See Edna Scofield, "The Evolution and Development of Tennessee Houses," *Journal of the Tennessee Academy of Science*, XI:4 (October, 1936), pp. 229-240 (Fig. 2 is, naturally, not a dogtrot house).

[125]See Gordon Wilson, *Folkways of the Mammoth Cave Region* (Bowling Green and Mammoth Cave, 1962), p. 30.

[126]For good I houses: Clay Lancaster, *Ante Bellum Houses of the Bluegrass* (Lexington, 1961), pp. 6-7, 10 (log), 12-13 (frame), 16-28 (stone), 32-33 (brick), 90-91 (Greek Revival), 131 (Gothic Revival).

[127]Cf. James Lane Allen, "The Blue-Grass Region of Kentucky," *Harper's New Monthly Magazine*, LXXII:429 (February, 1886), p. 375.

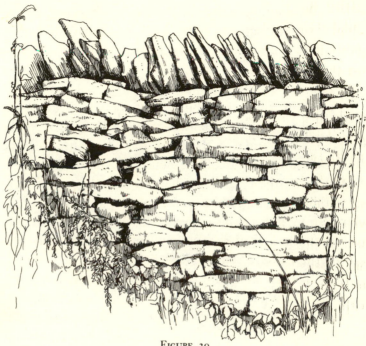

FIGURE 29

BLUEGRASS STONEWALL

This wall runs near Lawrenceburg, Anderson County, Kentucky (September, 1963). Wherever limestone outcroppings occur—in central New York, southern Pennsylvania, the Valley of Virginia, the Tennessee Valley, the Bluegrass, southern Indiana, eastern Kansas, southern Wisconsin—the stone is extensively used in traditional masonry. Soft and easily workable, in its natural state limestone often lends itself to rough coursing (see also Figs. 21, 25A). Not everywhere that limestone, or any other stone, is found abundantly, however, does one find stonewalls; in rocky New England stonewalls are common—in the rocky Southern Mountains they are not. Walls exactly like this one can be found not only in Kentucky and southern Indiana, but also in upstate New York and the northeastern neck of West Virginia.

those his English ancestors built.[128] But, his assemblage is trans-Appalachian and is also likely to include a spring or smokehouse with a projecting roof of the Continental-Pennsylvania-Southern Mountain type (Fig. 1), and a transverse-crib barn framed with skinned poles planted in the earth.

The farm of the Deep South is a seemingly pattern-less composite of many separate buildings, each with its special use; frequently such a farm is organized about a dogtrot house lying parallel to the road with a transverse-crib barn behind it and off to one side. In addition to the transverse-crib, the farm often includes a small single-crib barn—a corncrib of log or vertical board flanked by sheds —a type found the length of the Blue Ridge and down to the Coast in Virginia. If the house is not a dogtrot (dog-trot houses, however, are much more common in the low country from Georgia to Texas[129] than they are from the Tennessee north), it might be a cabin of one room fitted

[128]Arthur Raistrick, *Pennine Walls* (Cross Hills, 1961); J. Geraint Jenkins, *Traditional Country Craftsmen* (London, 1965), pp. 169–171, 227.

[129]Wilbur Zelinsky, "The Log House in Georgia," *The Geographical Review*, XLIII:2 (April, 1953), pp. 175, 178, 179; Fred R. Cotten, "Log Cabins of the Parker County Region," *West Texas Historical Association Year Book*, XXIX (October, 1953), pp. 99–102. Good descriptions of Alabama dogtrots may be found in these very different but very important works: James Agee and Walker Evans, *Let Us Now Praise Famous Men* (New York, 1966), pp. 123–167, 360–361; Mitchell B. Garrett, *Horse and Buggy Days on Hatchet Creek* (University, 1957), pp. 4, 102–105.

with a shed on the rear for a kitchen (Fig. 59),[130] but it probably is a one-story two-room house with two front doors and a chimney in the center or on one end (Fig. 30).[131] This pair of two-room types—two distinct types dependent upon the placement of the chimney—was evolved from cabins in the mountains and on the Coast; they were carried south and westward into the Deep South, and from the South to the Rocky Mountains.[132] The two-room single chimney types are particularly common in the Southern Tidewater where several serve on the same farm as quarters,[133] or where they are lined up in unpainted rows in the Negro sections of the small towns. Farther inland, their form is the same, but they are larger and they sit on a small holding, a rambling semicircle of outbuildings around them. In such houses, built generally of frame but sometimes of light pine logs, the family sits down today to a noontime dinner of field peas cooked

[130]Cf. Clifton Johnson, *Highways and Byways of the South* (New York, 1904), pp. 334–336.

[131]For a full description of the house of a Georgia farmer—an example of what is apparently one of those two house types with, as is common, a front porch, rear shed addition and separate kitchen—see this intriguing book: Stephen Powers, *Afoot and Alone; A Walk from Sea to Sea by the Southern Route* (Hartford, 1872), pp. 56–58. For an example of a Deep South saddlebag: William H. Davidson, *Pine Log and Greek Revival* (Alexander City, 1965), p. 301.

[132]See Austin E. Fife, "Folklore of Material Culture on the Rocky Mountain Frontier," *Arizona Quarterly*, 13:2 (Summer, 1957), p. 104.

[133]Good examples: Orrin Sage Wightman and Margaret Davis Cate, *Early Days of Coastal Georgia* (St. Simons Island, 1955), pp. 58–59, 78–79.

FIGURE 30

DOUBLE-PEN HOUSES
OF THE LOWLAND SOUTH

A. Southeast of Preston, Kemper County, Mississippi (November, 1963). B. Near Old Town Creek, Lawrence County, Alabama (December, 1962). C. East of Callahan, Nassau County, Florida (September,

G

J

H

K

I

L

1967). This house is unusual in that it has a loft, the stair to which is entered through a door in the front. D. West of Fair Bluff, Columbus County, North Carolina (September, 1967). E. East of Altamaha, Tattnall County, Georgia (September, 1967). F. North of Woodstock, Cherokee County, Georgia (November, 1966). G. East of Philadelphia, Neshoba County, Mississippi (November, 1963). H. Northwest of Hamilton, Marion County, Alabama (September, 1967). I. Between Jewell

M

P

N

Q

O

R

and Sparta, Hancock County, Georgia (September, 1967). J. West of Norwood, Warren County, Georgia (September, 1967). Houses A through J illustrate some of the variations in the two (central or end chimney) double-pen house types. Front porches have been omitted to make these variations more visible. The most common examples have two front doors and one chimney (houses A, B, F, G, H). K. Southeast of Eutaw, Greene County, Alabama (September, 1967). L. Between

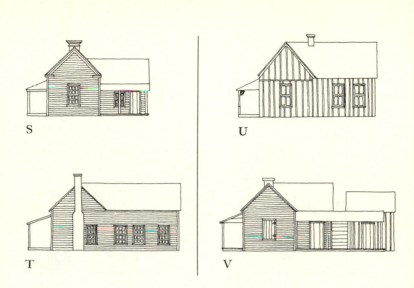

S U

T V

Racepond and Folkston, Brantley County, Georgia (September, 1967). M. Near Lombardy, Bolivar County, Mississippi (December, 1962). N. East of Altamaha, Tattnall County, Georgia (September, 1967). O. East of Gretna, Gadsden County, Florida (September, 1967). P. Near Energy, Clarke County, Mississippi (November, 1962). Q. South of Soperton, Treutlin County, Georgia (September, 1967). R. South of Blackshear, Pierce County, Georgia (September, 1967). S. In Marion, Marion County, South Carolina (September, 1967). T. East of Madison, Madison County, Florida (September, 1967). U. In Fernwood, Pike County, Mississippi (September, 1967). This house illustrates a not unusual feature of houses of the Deep South: rather than being on the end or in the middle of the house, the chimney is placed at the junction of the main house and the rear ell. V. Between Saluda and McCormick, Edgefield County, South Carolina (September, 1967). On houses K through V can be seen some of the common appendages of double-pen houses in the Lowland South: the front porch (all but L), the rear shed (L through R), the semi-detached kitchen (Q, R, V), and the rear ell (S through V). All of these houses are frame, except G which is half-dovetailed log. All have brick chimneys, except A, B, and P, the chimneys of which are stone.

with fat meat and sprinkled with "pepper sauce" from a 7-Up bottle filled with vinegar and sun-dried peppers. Depending upon how long it has been since hog-killing, there might be a pork chop, some ham, bacon, or sausage on the side of the plate. To sop the juices there are buttermilk biscuits thickly spread with butter which the lady of the house churned while she rocked, and afterward there is cornbread soaked in syrup. Whether made from sugar cane or sorghum, syrup is manufactured in the same way, with the same devices (Fig. 31), on small farms throughout the South. The butt ends of the cane are fed into the syrup mill powered by a mule walking a slow circle. The juice crushed out of the cane is caught in a tub, poured into a pan over a wood fire, boiled down to syrup, strained through a cloth, and put up in jugs, jars or cans.[134]

The I house, the most common folk type of the Upland South, is found only sporadically south of the

[134]H. W. Wiley, "Table Sirups," *Yearbook of the United States Department of Agriculture: 1905* (Washington, 1906), pp. 241–248; Marion Nicholl Rawson, *Little Old Mills* (New York, 1935), chapter XVI; H. C. Nixon, *Lower Piedmont Country* (New York, 1946), pp. 112–114; J. R. Webb, "Syrup Making," *North Carolina Folklore*, I:1 (June, 1948), p. 17; Floyd C. Watkins and Charles Hubert Watkins, *Yesterday in the Hills* (Chicago, 1963), pp. 76, 78–79; Martin J. Dain, *Faulkner's County: Yoknapatawpha* (New York, 1964), pp. 128–130; Yvonne Phillips, "The Syrup Mill," *Louisiana Studies*, IV:4 (Winter, 1965), pp. 354–356; Bobby G. Carter, "Folk Methods of Preserving and Processing Food," in Thomas G. Burton and Ambrose N. Manning, *A Collection of Folklore by Undergraduates of East Tennessee State University* (Johnson City, 1966), p. 29. The cane sugar technology on the big antebellum plantation was basically the same; see: J. Carlyle Sitterson, *Sugar Country* (Lexington, 1953), chapter VII.

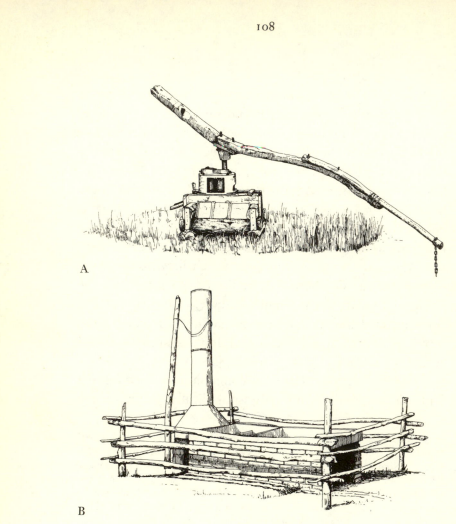

A

B

FIGURE 31

SOUTHERN SYRUP MAKING MACHINERY

A. Cane or syrup mill, west of Allen Gap, Greene County, Tennessee
(May, 1966). The mill proper is usually factory-made; it is set up and
used, however, in a traditional way. B. Evaporator in which the juice is
boiled down to syrup, Pine Hill, near Enterprise, Clarke County, Mis-
sissippi (November, 1962).

hilly portions of Georgia and Alabama, and then mostly in town. The middle-class farmhouses of the Deep South, which play the role the two-story I house does in the up-country, are consistent with the houses of the Southern Tidewater source area: they have one story, generally ceiled with no loft above. Some successful southern farmers built dogtrot houses: many frame ones feature jigsaw trim and at least one was built solidly of brick;[135] the comfortable slaveholders Huck Finn encounters in Mark Twain's novel live in log dogtrot houses.[136] But the most usual home on the big farm and on the right side of the tracks in the small towns is a type which arose early on the Carolina-Georgia coast (Fig. 32). It has a full classic Georgian plan—two rooms on each side of a broad central hall which was rarely left open dogtrot style.[137] Typically, it has a pair of internal brick chimneys with a tiny shallow fireplace for each room; rarely it has four external chimneys, two on each gable end. It is a house of one story with high ceilings; the pie-slice shaped area under the roof was generally left unused. Inside, its details (or, the absence of the details which tickle the architectural historian) are typical of the Lowland South: whitewashed

[135]South of Center Point, Howard County, Arkansas (March, 1964).

[136]Mark Twain, *The Adventures of Huckleberry Finn*, chapters 16, 17, 32.

[137]Examples: Frederick Doveton Nichols and Francis Benjamin Johnston, *The Early Architecture of Georgia* (Chapel Hill, 1957), pp. 121–122, 186; near Sucarnochee, Kemper County, Mississippi (August, 1963).

A

FIGURE 32

THE GEORGIAN PLAN, ONE STORY HOUSE TYPE

A. In Blackville, Barnwell County, South Carolina (September, 1967). B. In Sandersville, Washington County, Georgia (September, 1967). C. Plan of a one story frame house with a gable roof, northwest of Kelly, Bladen County, North Carolina (September, 1967).

B

C

walls with dark frank woodwork, the frequent substitution of horizontal boards for plaster, the ceiling and the walls for two or three feet below it painted white when the lower walls are a darker color, and the panels or battens a color different from the remainder of the door. The exterior of the older houses was unadorned, symmetrical, and topped with a gable or hip roof; later nineteenth and twentieth century ones were built usually with steep hip or towering pyramidal roofs and a variety of porches, odd gables, and decorative gewgaws which disguised its unchanging mid-eighteenth century plan.

The flatlands of Arkansas and southern Missouri exhibit the same Lowland South characteristics found across the river in Mississippi and Tennessee; the mountainous sections of these states, however, which have been attracting folkloristic attention since the 1920's, comprise with the hilly parts of adjacent Oklahoma a separate subregion. The Ozarks were settled partially by people from the Southern Mountains, but the culture there has not been simply transplanted from the Appalachians, for some of it was brought from the North and much of it is more typical of the Lowland South than it is of the Southern Mountains. The dogtrot house, for example, rare and late in the Blue Ridge, is not unusual in the Ozarks.[138] The log construction of the Missouri and Arkansas mountains is like that of the Tennessee-North Carolina Blue Ridge: the

[138]Carl O. Sauer, *The Geography of the Ozark Highlands of Missouri* (Chicago, 1920), p. 115; Guy Howard, *Walkin' Preacher of the Ozarks* (New York and London, 1944), pp. 56, 59–62.

logs are planked—hewn inside and out to a rectangular section, say, 6 inches by 16 inches—and neatly corner-timbered, usually with a half-dovetail joint (Fig. 45B). Log "bee gums"—hives made out of a short section of a log—like those known in southern Switzerland,[139] on the eastern frontiers during the early nineteenth century,[140] and in the Southern Mountains to the present,[141] are still occasionally found in the Ozark province.[142] Perhaps the only place in the New World where the catted chimney remains common is in the Ouachita Mountains of Arkansas (Fig. 33). This type of clay and slat chimney construction was employed in England,[143] Wales,[144] and Ireland.[145] Catted chimneys were built during the colonial period in New England[146] and the seaboard South[147] and a few examples are still scattered throughout the Deep South.[148]

[139]Melchior Sooder, "Die Alten Bienenwohnungen der Schweiz," *Schweizerisches Archiv für Volkskunde*, 43(1946), pp. 589–596.

[140]Jared van Wagenen, *The Golden Age of Homespun* (New York, 1963), pp. 174–179.

[141]Joseph S. Hall, *Smoky Mountain Folks and Their Lore* (Asheville, 1964), pp. 30, 33, 59.

[142]Vance Randolph, *The Ozarks: An American Survival of Primitive Society* (New York, 1931), p. 33.

[143]Nathaniel Lloyd, *A History of the English House* (London and New York, 1931), p. 347, figs. 558–561.

[144]Peate, *The Welsh House*, pp. 92–93, 123, plates 81–85.

[145]Caoimhín Ó Danachair, "Hearth and Chimney in the Irish House," *Béaloideas*, XVI:I-II (1946), pp. 91–104; Desmond McCourt, "Weaver's Houses Around South-West Lough Neagh," *Ulster Folklife*, 8 (1962), pp. 48–49, 54, plates II-IV, VIII, fig. 3.

[146]Abigail Fithian Halsey, *In Old Southampton* (New York, 1952), p. 77; Henry Chandlee Forman, *Early Nantucket and its Whale Houses* (New York, 1966), pp. 97–99.

[147]Henry Chandlee Forman, *Virginia Architecture in the Seven-*

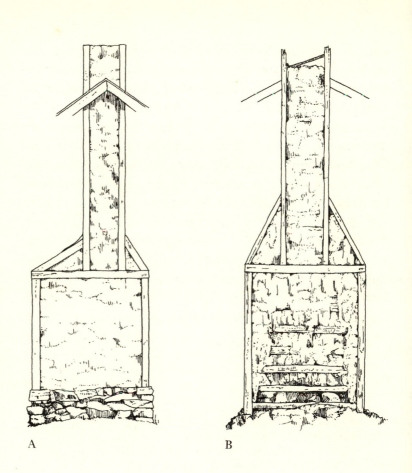

A B

FIGURE 33

CATTED CHIMNEYS

A. Newly constructed chimney on a half-dovetail log square cabin, east of Newhope, Pike County, Arkansas (March, 1964). B. On a V-notched round log cabin, south of Athens, Howard County, Arkansas (March, 1964).

There are cultural traits which distinguish the southern Negro—the cultural Negro, not the merely racial one—from his white neighbor; some white southerners might point to the Negro's traditional fondness for possum,[149] for instance, and the corner stores in the black sections of the northern cities stock the ingredients for folk dishes never tasted by most urban whites but frequently enjoyed by not-necessarily-recent immigrants from the southern countryside. However, in most respects the Negro has been culturally—if not socially—integrated: the traditional foods—"heavy suppers of black-eyed peas and turnip greens, cracklin' bread and buttermilk, lemonade and sweet potato cobbler"[150]—on which creative Negroes thrive in a metropolitan environment are also sustenance to the white southern farmer. And, predominantly Negro areas in the Deep South are character-

teenth Century (Williamsburg, 1957), pp. 33–34. For an example: John Mead Howells, *Lost Examples of Colonial Architecture* (New York, 1963), plate 130.

[148]For the catted chimney in the Deep South: Robert Sears, *A Pictorial Description of the United States* (New York, 1855), p. 348; Frederic Ramsey, Jr., *Been Here and Gone* (London, 1960), pp. 19–20, 24; Everett Dick, *The Dixie Frontier* (New York, 1964), p. 28; Guy and Candie Carawan and Robert Yellin, *Ain't You Got a Right to the Tree of Life?* (New York, 1966), p. 28.

[149]Rev. Peter Randolph, *From Slave Cabin to Pulpit* (Boston, 1893), p. 158; Mrs. James H. Dooley, *Dem Good Ole Times* (New York, 1906), pp. 67–73; Dorothy Scarborough, *From a Southern Porch* (New York and London, 1919), pp. 243–245; B. A. Botkin, *Lay My Burden Down* (Chicago, 1961), pp. 90, 202.

[150]Ralph Ellison, *Shadow and Act* (New York, 1966), p. 191, also 199. See too: Charles Keil, *Urban Blues* (Chicago and London, 1966), pp. 168–169, 186.

ized by the same low houses with the same gardens, clusters of unpainted outbuildings, paling fences, and dangling gourd (or plastic Clorox bottle) bird houses that the white farmer owns.[151] Although much of the Negro's folk culture is European in origin, some of it is undeniably African and much of it has been enriched by an Afro-American texture—an animated style and uninhibited handling of material which seem foreign to the Anglo-American. Obviously, more African elements survive in musical, social, or kinesthetic traditions than in material culture; still, the Negro's African heritage is probably reflected in some of the elements of the Deep South's material folk culture. In his hunt for African survivals, Melville J. Herskovits flushed the mortar and pestle used in the Sea Islands to pound rice prior to winnowing.[152] These implements were, indeed, used in Africa and by Negroes in the South, but they were also used in Switzerland and Germany,[153] in Russia,[154] aboriginally by the American Indians,[155] and by Anglo-Americans on the early frontier

[151]Cf. Arthur F. Raper, *Preface to Peasantry* (Chapel Hill, 1936), p. 62.

[152]Melville J. Herskovits, *The Myth of the Negro Past* (Boston, 1964), p. 147.

[153]Robert Wildhaber, "Gerstenmörser, Gerstenstampfe, Gerstenwalze," *Schweizerisches Archiv für Volkskunde*, 45:3 (1948), pp. 177–208; Reinhard Peesch, *Holzgerät in seinen Urformen* (Berlin, 1966), pp. 49–51.

[154]Dimitrij Zelenin, *Russische (Ostslavische) Volkskunde* (Berlin and Leipzig, 1927), pp. 84–86.

[155]John R. Swanton, *Indian Tribes of the Lower Mississippi Valley and Adjacent Coast of the Gulf of Mexico* (Washington, 1911), pp. 67, 347, plate 21.

in western Virginia,[156] Kentucky,[157] and Ohio.[158] The use of hoes in the Sea Islands where a plow would be expected,[159] might be tallied up as an Africanism, but hoes were also extensively used in English agriculture: the Pilgrims used hoes instead of plows during the initial years of New England farming.[160] This is not to say that there are no African traits preserved in the material folk culture of the South—old Negro ladies still wear headkerchiefs which hide the brow, and the banjo is played by both white and black southerners—but rather, that African practices and material with non-African analogs stood a better chance of survival than did that which would have appeared totally alien to old marster.

In Illinois and Missouri, French settlers of Norman-Canadian background built hip-roofed houses of vertical posts tamped in a trench or set up on a sill and infilled with mud and straw or mortared stone.[161] Today the ma-

[156]Henry Howe, *Historical Collections of the Great West*, I (New York, 1857), p. 195.

[157]Daniel Drake and Emmet Field Horine, ed., *Pioneer Life in Kentucky, 1785–1800* (New York, 1948), pp. 57–58.

[158]I. T. Frary, *Ohio in Homespun and Calico* (Richmond, 1942), pp. 24, 28.

[159]Carl Kelsey, *The Negro Farmer* (Chicago, 1903), p. 40; Guion Griffis Johnson, *A Social History of the Sea Islands* (Chapel Hill, 1930), pp. 48, 83.

[160]Albert Bushnell Hart, ed., *Commonwealth History of Massachusetts*, I (New York, 1927), p. 423.

[161]Ward Allison Dorrance, *The Survival of French in the Old District of Sainte Genevieve* (University of Missouri, 1935), pp. 15–16,

terial vestiges of the French in the Mississippi Valley form
tiny foreign pockets—except at its southern end where the
Louisiana French have produced a small, but significant
material folk culture subregion. The Cajun's barns are bas-
ically the same as those of other southerners, but it was
not until the late nineteenth century that the strong
French tradition of wattle and daubed or brick nogged
half-timber was supplanted by frame construction of the
Anglo-American type.[162] And that constructional change
did not alter the Louisiana French house types, which are
distinctively different from the English-derived southern
ones. The most typical of these is the Creole house (Fig.
34) with its inset porch, paired front doors, and central
chimney, which seems to look to western France, Canada,
and the West Indies for formative influences.[163] Like the
farms of early medieval France,[164] Newfoundland,[165]

44; Charles E. Peterson, "Early Ste. Genevieve and its Architecture,"
The Missouri Historical Review, XXXV:2 (January, 1941), pp. 207–232;
Charles E. Peterson, "The Houses of French St. Louis," in John Francis
McDermott, ed., *The French in the Mississippi Valley* (Urbana, 1965),
pp. 17–40.

[162]Corinne L. Saucier, *Traditions de la Paroisse des Avoyelles en
Louisiane* (Philadelphia, 1956), pp. 87–90; Yvonne Phillips, "The Bousil-
lage House," *Louisiana Studies*, III:1 (Spring, 1964), pp. 155–158;
George F. Reinecke, ed., "Early Louisiana French Life and Folklore,"
Louisiana Folklore Miscellany, II:3 (May, 1966), pp. 24–26.

[163]For this type see: Fred B. Kniffen, "Louisiana House Types,"
in Philip L. Wagner and Marvin W. Mikesell, eds., *Readings in Cul-
tural Geography* (Chicago, 1962), pp. 157–169, which is the great, origi-
nal geographic study of folk architecture.

[164]Allen D. Edwards, "Types of Rural Communities," in Marvin

Prince Edward Island,[166] and Quebec,[167] the Louisiana French holdings, which are measured in a system of *arpents*, stretch back in narrow bands from the waterways on which the houses front and along which they string, not only in the eastern bayou country, but also, where possible, in the southwestern prairies.[168] The water orientation of the French led to the development of the folk boat complex which separates southern and Anglo Louisiana. The Cajun's most characteristic boat was the pirogue, a modification of the Indian dugout canoe. During the last century, pirogues plied the Mississippi, the Ohio, and inland waterways throughout the South,[169] but their modern

B. Sussman, ed., *Community Structure and Analysis* (New York, 1959), p. 53.

[165]John Szwed, *Private Cultures and Public Imagery: Interpersonal Relations in a Newfoundland Peasant Society* (St. John's, 1966), p. 17.

[166]Andrew Hill Clark, *Three Centuries and the Island* (University of Toronto, 1959), p. 68.

[167]Horace Miner, *St. Denis: A French-Canadian Parish* (Chicago, 1939), pp. 6, 45–48.

[168]William O. Scroggs, "Rural Life in the Lower Mississippi Valley About 1803," *Proceedings of the Mississippi Valley Historical Association*, VIII (1914–1915), pp. 271–272; Lauren C. Post, *Cajun Sketches From the Prairies of Southwest Louisiana* (Baton Rouge, 1962), chapter 6.

[169]Clifton Johnson, *Highways and Byways of the Mississippi Valley* (New York, 1906), p. 73, facing p. 64; Frank K. Swain, "Making a Dugout Boat in Mississippi," *A Collection of Papers Read Before the Bucks County Historical Society*, V (1926), pp. 87–89; Leland D. Baldwin, *The Keelboat Age on Western Waters* (Pittsburgh, 1941), p. 41; Edouard A. Stackpole, *Small Craft at Mystic Seaport* (Mystic, 1959), p. 62.

A

FIGURE 34

THE CREOLE HOUSE TYPE

A. East of Port Vincent, Livingston Parish, Louisiana (September, 1967). B. Near Convent, St. James Parish, Louisiana (March, 1964). C. Plan of a Creole house with a rear shed and an attached rear kitchen, the ridge of which runs parallel to the ridge of the main house (as in A), west of Lutcher, St. James Parish, Louisiana (September, 1967). Next to the kitchen in the rear is the cypress cistern in which rainwater is collected.

B

C

A

FIGURE 35

A PIROGUE BEING BUILT

Ebdon Alleman and Fred Guitry of Bayou Pierre Port, Louisiana, making a pirogue out of a cypress log. In A, Guitry is smoothing the sides of the pirogue with a foot adze after having roughed it out with a broad axe. In B, Alleman, his hand adze resting in the boat, judges the thickness of the sides. In C, a final coat of shellac is brushed on. (photographs courtesy of Standard Oil Co. of New Jersey)

B

C

distribution is limited to southern Louisiana. The early ones were sometimes thirty feet long and used for transport; the twentieth century pirogue is about fourteen feet long and used mainly in trapping, fishing, and hunting; it is designed for one man who paddles or poles it from the stern, leaving the bow empty for cargo. In southeastern Louisiana they are still occasionally adzed out of half a cypress log (Fig. 35); through the balance of the Cajun country the dugout form is reproduced in plank—two or three planks for the bottom and one for each side—or, more recently, plywood.[170]

The North

The seventeenth century New England houses were as firmly founded on English traditions as those of the Chesapeake Tidewater were. The I house appears in Massachusetts, Rhode Island, and Connecticut, too, although there the chimney stack squats near the house's center (Fig. 36A),[171] and it very often has a characteristi-

[170]William B. Knipmeyer, "Settlement Succession in Eastern French Louisiana," unpublished doctoral dissertation, Louisiana State University (August, 1956), pp. 147–162; H. F. Gregory, "The Pirogue-Builder: A Vanishing Craftsman," *Louisiana Studies*, III:3 (Fall, 1964), pp. 316–318.

[171]For an example, see: Antoinette F. Downing and Vincent J. Scully, *The Architectural Heritage of Newport, Rhode Island, 1640–1915* (New York, 1967), plates 29–36. For this type in England, see: Harry Forrester, *The Timber-Framed Houses of Essex* (Chelmsford, 1965), pp. 12–16.

cally British[172] shed or lean-to addition on the rear with which the house, called, then, a saltbox, came to be consistently built (Fig.36B).[173] The renaissance ideals embedded in the Georgian era caused the saltbox to be built with a symmetrical gable; the resultant two-story, two-room deep, central chimney house type (Fig. 36C) remains a regular feature of New England's landscape.[174] Many an eighteenth century New Englander desired a still more fashionable dwelling. Some remodeled the central chimney to a central hall plan (Melville's "I and My Chimney"—Freudian interpretations notwithstanding—records such an alteration); others constructed, instead, houses with a central hall, double pile plan, similar to those being built at the same time in Pennsylvania (Fig. 16A), except that the New England chimneys are as often paired on the ridge (Fig. 36D, the plan is basically the same as that in Fig. 32) as they are located in the gable ends.[175]

[172]For the English antecedents of the saltbox house, see: Ralph Nevill, *Old Cottages and Domestic Architecture in South-West Surrey* (Guildford, 1889), pp. 13, 58; W. Galsworthy Davie and W. Curtis Green, *Old Cottages and Farmhouses in Surrey* (London, 1908), p. 16, plate XL.

[173]For examples: Harold Donaldson Eberlein, "The Seventeenth Century Connecticut House," *The White Pine Series of Architectural Monographs*, V:1 (February, 1919), pp. 2–13.

[174]Examples: M. S. Franklin, "Houses and Villages of North Smithfield, Rhode Island," *Monograph Series*, XXI:4, *Pencil Points* (August, 1935), pp. 431–446.

[175]The most important work on New England's houses is J. Frederick Kelly, *The Early Domestic Architecture of Connecticut* (New York, 1963, reprint of 1924). You should also be aware of Anthony N. B. Garvan, *Architecture and Town Planning in Colonial Connecticut* (New Haven, 1951), with his harsh but accurate criticism

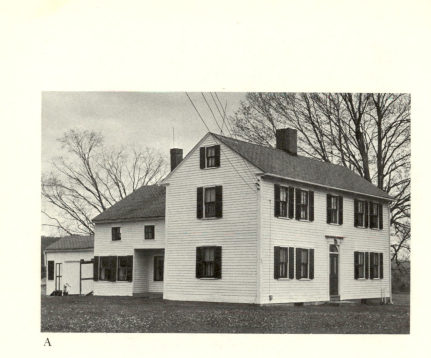

A

FIGURE 36

NEW ENGLAND HOUSES

A. I house with central chimney, east of Hampden, Hampden County, Massachusetts (October, 1964). B. Saltbox house, Newington, New Hampshire; Historic American Buildings Survey photograph by L. C. Durette (October, 1936). The usefulness of the H. A. B. S., which is housed at the Library of Congress, varies according to the district officer and/or photographer. For example, the student of folk architecture will find the New Hampshire material of more value than that of Maine or Vermont, and within the New Hampshire material, that accumulated during the Survey's first phase—the 1930's—will be found more useful than that of the second phase—the 1950's and '60's. C. House with saltbox plan and symmetrical gable, in Gilead, Tolland County, Connecticut (August, 1966). D. Georgian house, in Clinton, Middlesex County, Connecticut (August, 1966).

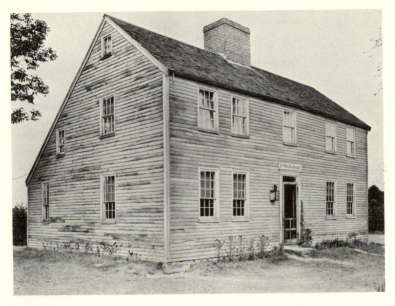

B

C

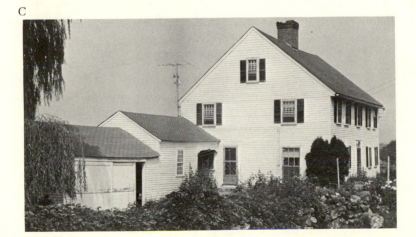

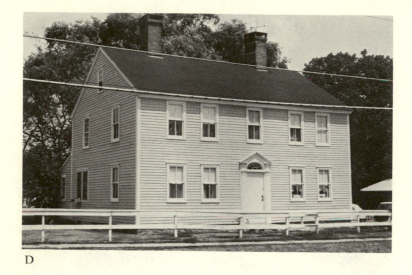

D

In the later eighteenth and early nineteenth centuries, an early, low one-story house with a symmetrical gable, central chimney, and saltbox floor plan flourished in New England. In the areas where it is most common, such as Cape Cod,[176] where the type picked up its name, and eastern Long Island, it is found in a limited variety of subtypes: houses with one large, one large and one small, or two large front rooms. The Cape Cod house is not, how-

of Kelly (pp. 104, 119); Norman M. Isham and Albert F. Brown, *Early Connecticut Houses* (New York, 1965); and Antoinette Forrester Downing, *Early Homes of Rhode Island* (Richmond, 1937).

[176]Ernest Allen Connally, "The Cape Cod House: an Introductory Study," *Journal of the Society of Architectural Historians*, XIX:2 (May, 1960), pp. 47–56.

ever, restricted to the coastal Northeast: in its most usual form—two large front rooms with a chimney between and three or more back rooms (Fig. 37A)—it is found throughout New England.[177]

In the movement westward the New England houses felt strongly the influence of the successive popular styles. The I house reappeared in the early 1800's, but its central chimney had yielded to a central hall and internal end chimneys, and its exterior was trimmed with whatever happened to be in vogue.[178] From New England through central New York and south around the Great Lakes, a descendent of the Cape Cod house was built during and after the Greek Revival period; its central chimney had given way to gable-end flues for stoves, the pitch of its roof had become shallower, its loft was higher so that small rectangular windows could peep out from under its eaves, its facade was classically graced, but its traditional floor plan—its folk essence—had been left largely intact (Fig. 37B). During the second quarter of the nineteenth century, the New Englanders' western settlements began to be characterized by a new nonfolk, Greek Revival form typified by a door in the gable and one or two low wings off to the side (Fig. 38). This temple form house became the predominant type through the North and out into the

[177]A New Hampshire example is described in Cornelius Weygandt, *The White Hills* (New York, 1934), pp. 213–219.
[178]An example: Cameron Clark, "Houses of Bennington, Vermont, and Vicinity," *The White Pine Series of Architectural Monographs*, VIII:5 (October, 1922), p. 6.

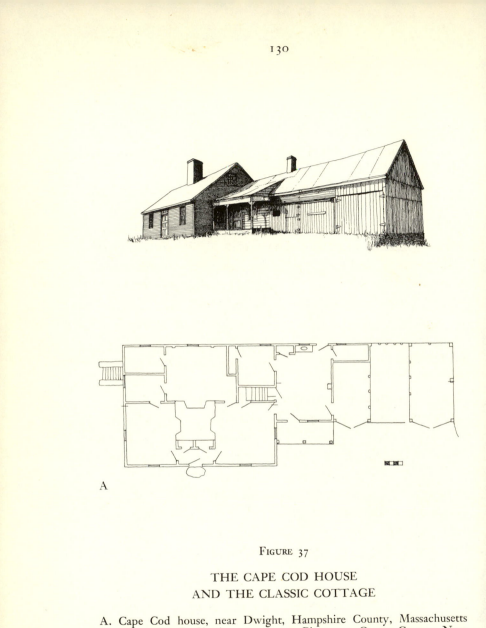

A

FIGURE 37

THE CAPE COD HOUSE
AND THE CLASSIC COTTAGE

A. Cape Cod house, near Dwight, Hampshire County, Massachusetts (August, 1966). B. Classic cottage, near Pierstown, Otsego County, New York (August, 1966). These houses have the same basic plan: two large front rooms, and a large central room in the rear, used originally in A

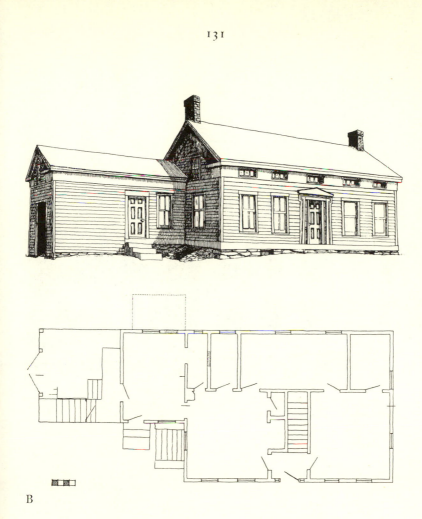

B

as a kitchen, in B as a bedroom. The attic of A has only one small finished room; the second story of B is finished and divided into bedrooms, but the family sleeps on the first floor. Both houses have wings extending from one gable end. In the York State example these rooms, right to left, are a kitchen (with a blocked off door and missing porch on the rear) and a woodshed with the stairs leading to a bedroom for transient hop pickers. The rooms of the wing off the Massachusetts house from left to right are: kitchen with a porch on the front, woodshed with a pantry at the rear, and two bays for vehicles.

A

FIGURE 38

THE TEMPLE FORM HOUSE TYPE

A. Between Edmeston and New Berlin, Otsego County, New York
(February, 1965). B. Genoa, De Kalb County, Illinois; Historic Ameri-
can Buildings Survey photograph by Chester Hart (February, 1934).
The Midwestern and Northeastern temple houses are similar; both may
have one or two story main sections, and one or two wings, although
the two story height and single wing form become increasingly domi-
nant with western movement. In the Northeast, the main door of the
house is in the gable end; in the Midwest, the door in the wing (the
door most commonly used in many Northeastern temple houses) be-
comes the front door, and the door through the gable is frequently
omitted.

B

Great Lakes area,[179] where it continued to be built after the Greek Revival had run its course; examples built after the mid-nineteenth century, when the architects' fancies had turned from Greek to Gothic, can be classed as folk.

All along the eastern coast, farmers and carpenters of English extraction built the same tripartite, side-opening barns they had been accustomed to in Britain.[180] In Eng-

[179]See Howard Major, *The Domestic Architecture of the Early American Republic: The Greek Revival* (Philadelphia and London, 1926), pp. 91–96, plates 38, 73, 88, 93, 95; Talbot Hamlin, *Greek Revival Architecture in America* (New York, 1964), pp. 266, 293, 297–298, 305, 306, plates LXXIX, LXXXVI.

[180]Little has been published on British barns other than the early tithe and manorial barns. For Welsh barns similar to those in America, see this excellent study: Sir Cyril Fox and Lord Raglan, *Monmouth-*

land this barn was generally used for hay and grain storage, the stock being stabled separately or in attached sheds.[181] In the eastern South, the bays on each side of the central floor are used for stabling and have over them lofty hay mows (Fig. 39A). Examples built in the Mid-Atlantic region are arranged like those of the South[182] or have one bay for stabling over which there is a cantilevered hay loft; the bay across the central floor is entered through large doors and shelters farm vehicles and machinery (Fig. 39B). The Yankee barn typically has one bay

shire Houses, I (Cardiff, 1951), pp. 56–67, plates VIIID, XII; II (Cardiff, 1953), pp. 77–81, plates XIII, XV, XXIIB; III (Cardiff, 1954), p. 123, plate XXV. Much has recently been written on the magnificent medieval barns of England; this has dealt primarily with framing but has revealed that these enormous barns are of essentially the same type as the English barns of the East Coast; for examples see these articles published in *Journal of the Society of Architectural Historians:* Walter Horn and F. W. B. Charles, "The Cruck-built Barn of Middle Littleton in Worcestershire, England," XXV:4 (December, 1966), pp. 221–239; Cecil A. Hewett, "The Barns at Cressing Temple, Essex, and Their Significance in the History of English Carpentry," XXVI:1 (March, 1967), pp. 48–70.

[181]See the definitions in these English-oriented American publications: Samuel Deane, *The New England Farmer* (Worcester, 1797), p. 21: "Barn, a sort of house used for storing unthreshed grain, hay and straw, and all kinds of fodder. But the other uses of barns in this country, are to lodge and feed beasts in, to thresh grain, dress flax &c." And, Cuthbert W. Johnson, *The Farmer's Encyclopaedia, and Dictionary of Rural Affairs* (Philadelphia, 1844), p. 145: "Barn. A covered building, constructed for the purpose of laying up grain, &c." See, too, these descriptions: Clifton Johnson, *Among English Hedgerows* (New York, 1900), pp. 69–70; Gertrude Jekyll, *Old West Surrey* (New York, 1904), pp. 22–24; George Ewart Evans, *Ask the Fellows Who Cut the Hay* (London, 1962), pp. 92–94.

[182]Dornbusch and Heyl, *Pennsylvania German Barns*, type D.

for stabling; the other, larger bay is used as a hay mow; the central floor has large doors on each end and is used for threshing and the storage of implements (Fig. 39C). In southern Pennsylvania this type was largely replaced by two-level barns, and it merged in the movement westward through the Southern Appalachians with the closely related double-crib barn (Fig. 26A, B), but in New England the Yankee or English or Connecticut barn remains the most common type. And, New Englanders carried it west with them so that it may be found through New York, northern Pennsylvania, Ohio, northern Indiana and Illinois, up into Michigan and Wisconsin, and out to Iowa, Kansas, Nebraska, and beyond.[183] It is not the only barn type in the Northeast, however, for northerners also built two-level "basement barns" with the stabling below and the hay storage above. From the Berkshires west, two-level barns predominate. Similarly arranged barns were built in Cumberland, Lancashire, and Westmoreland,[184] so that the northern barns could be a continuation of a British tradition. They could represent a response to a stimulus diffusion from Pennsylvania, as there were connections between upstate New York and southern Pennsylvania along the Susquehanna—the New York State rifle developed out of the Pennsylvania-made Kentucky, for instance, and the low-back Windsor chair was made during the eighteenth

[183]For a New England derived barn in Oregon, see Philip Dole, "The Calef Farm: Region and Style in Oregon," *Journal of the Society of Architectural Historians*, XXIII:4 (December, 1964), pp. 200–209.

[184]See footnote 79.

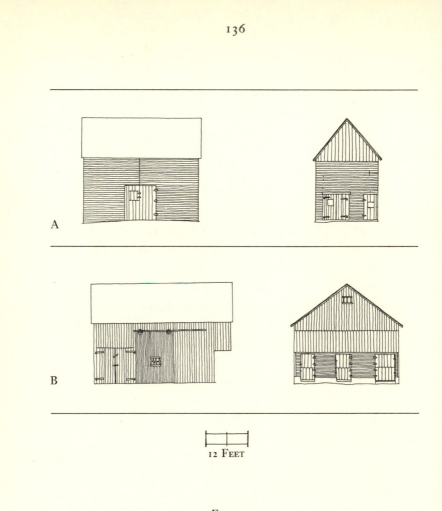

FIGURE 39

THE ONE-LEVEL, SIDE-OPENING (ENGLISH)
BARN AND THE NORTHERN TWO-LEVEL BARN

A. One-level, three bay, side-opening barn, west of Gum Spring in Goochland County, Virginia (August, 1966). B. One-level, three bay, side-opening barn, near Uniontown, southwest of Dillsburg, York County, Pennsylvania (January, 1967). C. One-level, three bay, side-opening barn, north of Fly Creek, Otsego County, New York (July,

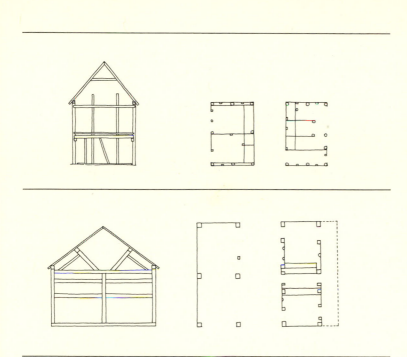

1966). D. Two-level, three bay, side-opening barn, south of Phoenix Mills, Otsego County, New York (January, 1965). The cross-section through each barn revealing the face of one bent—the major framing element—is given because the bent is the diagnostic feature of frame construction, just as corner-timbering is the diagnostic feature of log construction (see Fig. 26). The frames of the two northern barns (C and D) are the same constructional type. The southern frame, dependent upon major vertical framing elements planted sill-less in the earth and collar beams instead of purlins, is very different from the framing types of the Mid-Atlantic and the North, which are similar.

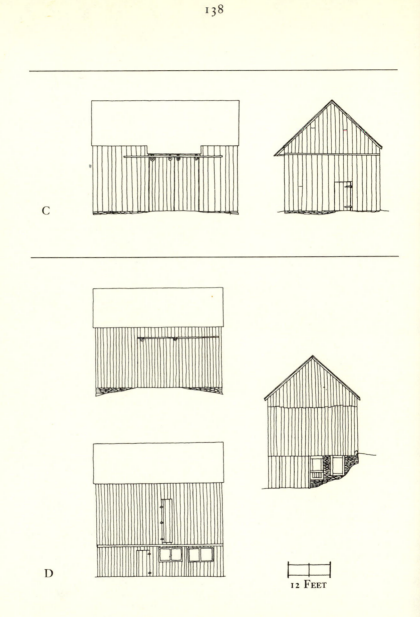

C

D

12 FEET

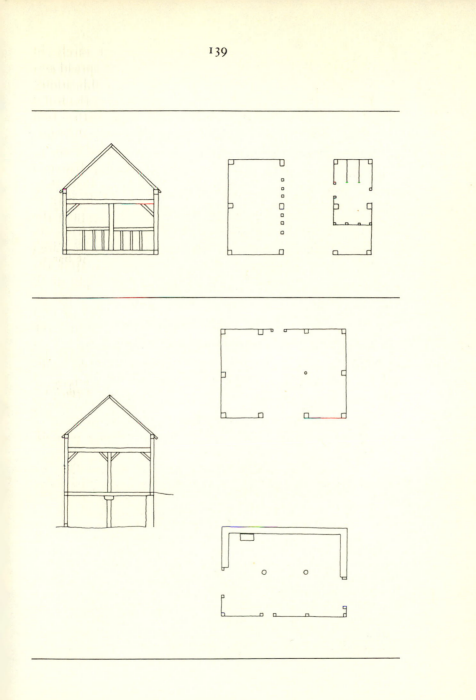

century in Pennsylvania and New York but rarely in New England.[185] But, the major cause for their spread and popularity seems to have been agricultural publications. The nineteenth and early twentieth century agricultural writers were pleased with the Pennsylvania barn's two levels, which they felt would prove handy in the shift from diversified agriculture to dairying, but they seem to have seen little reason for the forebay, and they frowned on the idea of building the barn into a bank—that, they wrote, was dark, dusty, and bred bacteria.[186] Primarily at the suggestion of print, the northern farmer accepted the two-level notion and began building his one-level type up on a basement. The upper level of the older barns found through most of the North is patterned closely after the old English barn built flat on the ground. In contrast to the barns of southeastern Pennsylvania (Fig. 18), it has no forebay, the central threshing floor is one instead of two bays long, and it lacks the line of doors opening into the

[185]Wallace Nutting, *A Windsor Handbook* (Saugus, 1917), pp. 170–171; Thomas H. Ormsbee, *The Windsor Chair* (New York, 1962), pp. 38–40.

[186]See George E. Harney, *Barns, Outbuildings, and Fences* (New York, 1870), plates 22, 30–31; *How to Build, Furnish and Decorate* (New York, 1883), pp. 2–18; Byron David Halsted, *Barn Plans and Outbuildings* (New York, 1881, 1891, 1906, 1909), barns are taken up first in this very influential book; T. B. Terry, *Our Farming* (Philadelphia, 1893), chapter XXIX; *Farm Buildings* (Chicago, 1907), pp. 17–41; William A. Radford, *Radford's Practical Barn Plans* (New York, 1909), especially pp. 115–116. By the decade preceding the Civil War, the prize-winning northern barns had basements; see: Charles L. Flint, *The Agriculture of Massachusetts As Shown in the Returns of the Agricultural Societies, 1854* (Boston, 1855), pp. 24–25, 241–244, 249–250, 491.

barnyard from the basement (Fig. 39D). After the Civil War, in the midst of agrarian prosperity, the northern farmer began copying plans from books and magazines and built grand popular barns based ultimately but very loosely on Pennsylvania traditions. Since World War I, the farmer from New England through the north Middle West has usually erected a low gambrel building of tin, cement block, and prefabricated truss which bears no relation to northern tradition; even that form is now out of favor, as a still more nondescript sheet metal rectangle is gaining popular acceptance; however, a few conservative farmers continue to build the two-level barns of the Victorian era.

The usual gravestone art, such as the willow and urn chiseled out in the shadow Washington's death cast across the early nineteenth century, provides good examples of popular as opposed to folk expression.[187] But, in the burying grounds of New England, stones ranging in date from the mid-seventeenth century to the early nineteenth can be found which have peering from them ornamentally geometric angels and winged death's heads (Fig. 40).[188]

[187]Popular rather than folk artistic motifs can be found in Phil R. Jack, "Gravestone Symbols of Western Pennsylvania," in Kenneth S. Goldstein and Robert H. Byington, eds., *Two Penny Ballads and Four Dollar Whiskey* (Hatboro, Pa., 1966), pp. 165–173.

[188]See Erich A. O'D. Taylor, "The Slate Gravestones of New England," *Old-Time New England*, XV:2 (October, 1924), pp. 58–67; Harriette Merrifield Forbes, *Gravestones of Early New England and*

The style of these motifs has its source in the gravestone art of England[189] and close analogs in the few examples of nonfunery seventeenth century New England stone carving which have been discovered.[190]

As characteristic of the folk culture of the Northeast as these abstract flying heads are some elements of Yankee diet. Long after the medieval flail[191] had given way to mechanical means of threshing grain, it was used in the Northeast,[192] as in England,[193] for threshing out beans. On Saturdays, these were baked with molasses, salt, fat pork, and an onion in a bean pot or in a kettle set down into a

the Men Who Made Them (Boston, 1927); Mason Philip Smith, "Burial Ground Art," *Down East*, XII:4 (November, 1965), pp. 16–19; Edmund Vincent Gillon, *Early New England Gravestone Rubbings* (New York, 1966); Allan I. Ludwig, *Graven Images: New England Stonecarving and its Symbols, 1650–1815* (Middletown, 1966); James Deetz and Edwin S. Dethlefsen, "Death's Head, Cherub, Urn and Willow," *Natural History*, LXXVI:3 (March, 1967), pp. 28–37.

[189]See Innes Hart, "Rude Forefathers," *The Architectural Review*, LXXXVI:516 (November, 1939), pp. 185–188.

[190]See Lura Woodside Watkins, "The Byfield Stones—Our Earliest American Sculpture?" *Antiques*, LXXXIV:4 (October, 1963), pp. 420–423.

[191]E. M. Jope, "Agricultural Implements," in Singer, Holmyard Hall and Williams, *A History of Technology*, II (1957), p. 97.

[192]Clarence Albert Day, *A History of Maine Agriculture* (Orono, Me., 1954), p. 274. A little on New England flails can be found in Walter Needham and Barrows Mussey, *A Book of Country Things* (Brattleboro, Vt., 1965), pp. 31–32; for some more on flails: Henry C. Mercer, "Ancient Methods of Threshing in Bucks County," *A Collection of Papers Read Before the Bucks County Historical Society*, V (1926), pp. 316–320.

[193]N. A. Hudleston, *Lore and Laughter of South Cambridgeshire* (Cambridge, n.d.), pp. 11–12; Evans, *Ask the Fellows Who Cut the Hay*, p. 96.

FIGURE 40

NEW ENGLAND GRAVESTONE CARVING

A. Death's head, graveyard in Newport, Newport County, Rhode Island (July, 1967). The stone reads: "Here Lyes Ye Body/ of Peter Easton/ Juner Aged 32 Years/ Deceased Ye 17th/ of December/ J690."
B. Cherub, graveyard, north of Stafford Springs, Tolland County, Connecticut (August, 1966). The stone reads: "In Memory of/ Mrs. Patience Bloss/ Wife of/ Mr. Samuel Bloss/ who died/ June 29, 1815:/ in the 62th year/ of her age/ Thy flight has filled our/ hearts with pain,/ Whilst thou dost reap eternal/ gain." This pair of examples accurately represents the chronological sequence of winged heads in New England's cemeteries: the cherub replaced the death's head during the eighteenth century.

stone-lined pit in the ground.[194] The New England bean pots, which appeared in the nineteenth century, were like most pottery forms made first of redware and later of stoneware;[195] they were simultaneously turned out in traditional one-family potteries with a locally consumed output and large factories employing mass-production methods.[196]

The Northeast, while exhibiting basically English patterns, did receive an early Continental infusion. Northern New England is lightly sprinkled with manifestations of French Canadian culture, such as log construction in which the horizontal logs are fitted into corner posts instead of being notched together,[197] and a distinctive sala-

[194]Robert P. Tristram Coffin, *Mainstays of Maine* (New York, 1944), pp. 103–112; Cornelius Weygandt, *The Heart of New Hampshire* (New York, 1944), pp. 135–136; John Gould, *The House That Jacob Built* (New York, 1947), pp. 104–111; R. E. Gould, *Yankee Boyhood* (New York, 1950), pp. 169–173, 203.

[195]Lura Woodside Watkins, *Early New England Potters and Their Wares* (Cambridge, 1950), p. 234.

[196]For some information on the operation of northern potteries: Leonard F. Burbank, "Lyndeboro Pottery," *Antiques*, XIII:2 (February, 1928), pp. 124–126; these articles written or coauthored by F. H. Norton in *Antiques:* "The Osborne Pottery at Gonic, New Hampshire," XIX:2 (February, 1931); "The Crafts Pottery in Nashua, New Hampshire," XIX:4 (April, 1931), pp. 304–305; "The Exeter Pottery Works," XXII:1 (July, 1932), pp. 22–25; and C. Dean Blair, *The Potters and Potteries of Summit County* (Akron, 1965).

[197]Richard W. Hale, Jr., "The French Side of the 'Log Cabin Myth'," *Proceedings of the Massachusetts Historical Society*, LXXII (October, 1957-December, 1960), pp. 118–125.

mander-slat-back chair with relieved arms (Fig. 41),[198] a
type found in several French provinces, though the chairs
most like those in the New World seem to be from Nor-
mandy and Touraine.[199] In the Hudson Valley, the Dutch
built characteristic homes[200] and hung their clothes in a
massive paneled piece of furniture called a *kas*,[201] which is
related to the Pennsylvania German *schrank;* the form of
the *kas* was brought without change from Holland.[202] The
most distinctive material feature of the Dutch folk culture,
and that which achieved the greatest distribution, being
found deeply into central New York, was the Dutch barn
(Fig. 42).[203] Based on structures which sheltered both the

[198] Jean Palardy, *Les Meubles Anciens du Canada Français* (Paris,
1963), p. 227, plate 322; Wallace Nutting, *Furniture Treasury*, II (New
York, 1948), nos. 1888 and, particularly, 1889; Henry Lionel Williams,
Country Furniture of Early America (New York, 1963), p. 39; Carl W.
Drepperd and Lurelle Van Arsdale Guild, *New Geography of Ameri-
can Antiques* (New York and London, 1967), pp. 82, 84–86.

[199] Émile Bayard, *Les Meubles Rustiques Régionaux de la France*
(Paris, 1925), especially pp. 83, 88, 146, 183–185, 235; Mabel M. Swan,
"French Provincial Chairs," *Antiques*, XVIII:4 (October, 1930), pp.
312–317.

[200] For Dutch-American domestic architecture: Harold Donald-
son Eberlein, *The Manors and Historic Houses of the Hudson Valley*
(Philadelphia and London, 1924); Helen Wilkinson Reynolds, *Dutch
Houses in the Hudson Valley Before 1776* (New York, 1965); Rosalie
Fellows Bailey, *Pre-Revolutionary Dutch Houses and Families* (New
York, 1936); Maud Esther Dilliard, *Old Dutch Houses of Brooklyn*
(New York, 1945).

[201] Esther Singleton, *The Furniture of Our Forefathers*, IV (New
York, 1901), pp. 264–267.

[202] See C. H. DeJonge and W. Vogelsang, *Holländische Möbel
und Raumkunst von 1650–1750* (Stuttgart, 1922), pp. 75–100.

[203] An early discussion and overestimation of the importance of

farmer and his stock from Holland through southern Denmark into northern Germany,[204] the Dutch barn is typified by doors in the gable ends and a roughly square floorplan. Features of its construction differed from the northern norm: it is sided with very wide weatherboards of exactly the type found in northern Holland,[205] and it is framed with a mortise and tenon joint in which the tenon protrudes through the vertical post (Fig. 42C), a form employed from Holland through northern Germany.[206] In New Jersey, on Long Island (where the Dutch *kas* is also common), and in the Hudson and Mohawk Valleys of New York (where the Dutch barn is most usual), a Dutch

the Dutch barn is M. D. Learned, "The German Barn in America," *University Lectures Delivered by Members of the Faculty in the Free Public Lecture Course, 1913–1914* (Philadelphia, 1915), pp. 342–343, 345–346.

[204]The Dutch barn is a descendent of the Saxon house on which a great deal has been written; for example: R. Mejborg, *Nordiske Bøndergaarde*, I (Copenhagen, 1892), pp. 3–42; Paul Klopfer, *Das deutsche Bauern- und Bürgerhaus* (Leipzig, 1915), pp. 18–35; Jos. Schrijnen, *Nederlandsche Volkskunde*, I (Zutphen, 1930), pp. 42–55; Johann Ulrich Folkers, "Die Schichtenfolge im alten Bestand niedersächsischer Bauernhäuser Mecklenburgs," in *Festschrift Richard Wossildo* (Neumünster, 1939), pp. 112–128.

[205]See Charles Holme, *Old Houses in Holland* (New York, 1913), p. 80. The overlapped, horizontal siding—weatherboarding or clapboarding—found through most of the United States derives from the English tradition which is strongest in Kent, Sussex, and Essex; see: Harry Batsford and Charles Fry, *The English Cottage* (London, 1950), pp. 82–83.

[206]See Karl Baumgarten, "Probleme mecklenburgischer Niedersachsenhausforschung," *Deutsches Jahrbuch Für Volkskunde* (1955), p. 173; *Driemaandelijkse Bladen*, II:2 (1959), p. 53.

FIGURE 41

SALAMANDER SLAT-BACK CHAIR
FROM NEW HAMPSHIRE

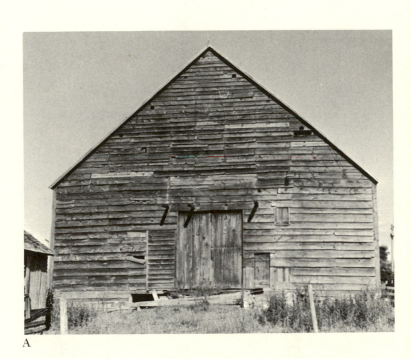

A

FIGURE 42

THE DUTCH BARN TYPE

A. North of Stone Arabia, Montgomery County, New York (July, 1966). B. Plan of a Dutch barn, between Kerhonksen and Accord, Ulster County, New York (June, 1966). Originally, horses were stabled in the aisle to the right of the broad central floor, and cows in that to the left. C. Mortise and tenon joint from a Dutch barn, east of Sharon, Schoharie County, New York (June, 1965). D. Strap hinge from the stable door of a Dutch barn, south of Pluckemin, Somerset County, New Jersey (August, 1966).

B

C

D

type of strap hinge may also be found (Fig. 42D).[207] The Mohawk Valley was the home of an early group of Palatine Germans whose material vestiges include a pair of single-stilted wooden wheel plows (Fig. 43). The wheel plow may date to the Iron Age in the Jutland peninsula,[208] and plows similar to the Mohawk Valley German ones were in use commonly from the late Middle Ages into the nineteenth century on the Continent[209] and in England,[210] but they are rare in the New World.[211]

The Dutch settled in New Jersey and many of their homes remain in the northern part of the state, but the material folk culture there is predominantly English. In southern New Jersey, I and hall and parlor houses were built like some in England, extreme southeastern Pennsylvania, and the Delmarva peninsula, of intricately laid brick

[207]See Albert H. Sonn, *Early American Wrought Iron*, II (New York, 1928), pp. 36–37 (fig. 1), 48–49 (fig. 4), 58–59 (fig. 4), 62–63.

[208]Axel Steensberg, "North West European Plough-Types of Prehistoric Times and the Middle Ages," *Acta Archaeologica*, VII (1936), pp. 252–255.

[209]Paul Leser, *Entstehung und Verbreitung des Pfluges* (Münster, 1931), sections I, II; Peter Michelsen, *Danish Wheel Ploughs* (Copenhagen, 1959).

[210]Samuel Copland, *Agriculture Ancient and Modern*, I (London, 1866), pp. 577–578; G. E. Fussell, *The Farmer's Tools: A. D. 1500–1900* (London, 1952), pp. 35–37.

[211]Wheel plows were used in the Hudson and Mohawk Valleys by the Dutch: Francis W. Halsey, ed., *A Tour of Four Great Rivers: The Hudson, Mohawk, Susquehanna and Delaware in 1769* (Port Washington, 1964), pp. 10–11, 21.

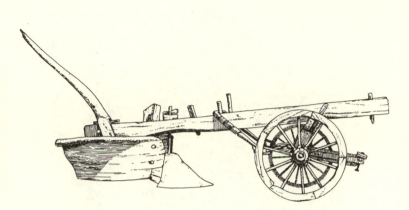

FIGURE 43

WHEEL PLOW

Found in a barn near Palatine Bridge, Montgomery County, New York, this plow now rests at the Farmers' Museum, Cooperstown, New York. Its label dates it to the 1750's and states that it is typical of the plows used by the Germans in the Mohawk Valley. A very similar plow, which still has its coulter in place, is on exhibit in the Museum of History and Technology of the Smithsonian Institution, Washington, D.C. It is dated 1769 and "was made for Henry Klock at Palatine, a German community in New York's Mohawk Valley."

through which burned headers trace diamond or vertical zig-zag patterns, dates, or initials (Fig. 44).[212] Northwestern Jersey fits with northern Pennsylvania into the region of the North; there, for example, the usual northern base-

[212]Joseph S. Sickler, *The Old Houses of Salem County* (Salem, 1949); Paul Love, "Patterned Brickwork in Southern New Jersey," *Proceedings of the New Jersey Historical Society*, LXXIII:3 (July 1955), pp. 182–208.

A

FIGURE 44

BRICK HALL AND PARLOR HOUSE
FROM SOUTHERN NEW JERSEY

This house, located west of Hancock's Bridge on Alloway Creek, Salem County, New Jersey (February, 1968), is one of several gambrel roofed hall and parlor houses built for the Oakford family along Alloway Creek. The vitrified headers accent the Flemish bond of the lower part of the wall and provide the date, 1764, and the initials of the owners at the top of the end wall. A. End View. B Plan.

B

ment barn appears commonly. The architecture in the west is closely related to that which characterizes the landscape across the Delaware; the typical farm has an I house of stone or frame and a Pennsylvania two-level barn. Much of the central part of the state is a cultural island— an island because any significant westward movement was blocked by or filtered through Pennsylvania—which seems to have been influenced by New England and is characterized by shingled or clapboarded Georgian form houses and large English barns.[213]

[213]Cf. Alan Gowans, *Architecture in New Jersey* (Princeton, 1964), pp. 14–18, 43–45.

The regions of the North, the Mid-Atlantic, and the Upland South extend, overlap, and mingle in the Midwest; west of New York and Pennsylvania and north of the Ohio the patterns are not neat. Through the northern Midwest, north of old Route Forty, the material traits are mostly New England-York State derived: Greek Revival house types and Yankee barns, built, generally, larger than those in New England, are regularly found there. The old Middle West is spotted with Mid-Atlantic pockets; the Pennsylvania bank barn (usually with the forebay filled in and a straw shed on the rear like those in southwestern Pennsylvania) is found in many parts of Ohio (Fig. 45A)[214] and with decreasing frequency into Wisconsin[215] and Nebraska.[216] Also in Ohio, Pennsylvanians produced *fraktur*,[217] and the Amish built Pennsylvania style banked

[214]One of the many pockets of Pennsylvania barns in Ohio is described in William I. Schreiber, "The Pennsylvania Dutch Bank Barn in Ohio," *Journal of the Ohio Folklore Society*, II:1 (Spring, 1967), pp. 15–28.

[215]Richard W. E. Perrin, *Historic Wisconsin Buildings: A Survey of Pioneer Architecture* (Milwaukee, 1962), pp. 39, 43, 44. The forebay-less, two-level "Swiss" barns in M. Walter Dundore, "The Saga of the Pennsylvania Germans in Wisconsin," *The Pennsylvania German Folklore Society*, XIX (1954), pp. 84–86, may or may not be from Pennsylvania.

[216]G. M. Ludwig, "The Influence of the Pennsylvania Dutch in the Middle West," *The Pennsylvania German Folklore Society*, X (1945), pp. 71–74.

[217]Olive G. Zehner, "Ohio Fractur," *The Dutchman*, 6:3 (Winter, 1954–1955), pp. 13–15.

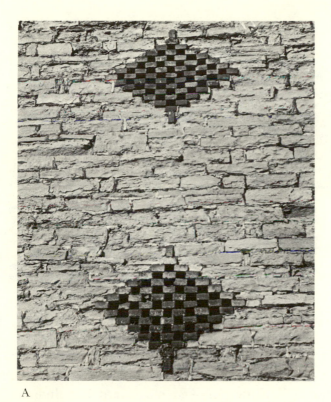

A

FIGURE 45

DETAILS OF MIDWESTERN CONSTRUCTION

A. Brick ventilators in the gable end of a stone Pennsylvania two-level
barn (Dornbusch and Heyl, *Pennsylvania German Barns*, type H),
southern outskirts of Delaware, Delaware County, Ohio (December,
1966). This kind of ventilator is particularly common in the general
area of Lehigh County, Pennsylvania. B. Half-dovetail corner-timbering
on a log cabin, between Hartsville and Newbern, Bartholomew County,
Indiana (August, 1963). The half-dovetailing and the plate set forward
on the cantilevered extension of logs in the end walls are both typical
of the Upland South.

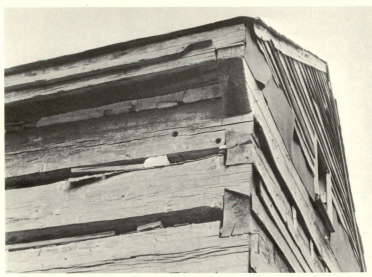

B

farmhouses.[218] Southern influence is felt in southern Ohio with the appearance of I houses (a type also carried west from New York and conceivably from southeastern Pennsylvania), and a few log cabins with external gable-end chimneys.[219] Settlers moved northward into Indiana and Illinois, so that machinery for making sorghum into syrup,[220] half-dovetailed log construction (Fig. 45B), I

[218]William I. Schreiber, *Our Amish Neighbors* (Chicago, 1962), p. 44.

[219]There is a V-notched square cabin with a brick external gable-end chimney southwest of Yellow Springs, Greene County, Ohio (August, 1963).

[220]The acceptance of Chinese sugar cane (sorghum) in climes in which sugar cane could not be grown—Ohio, Indiana, and Illinois included—and the application of traditional southern sugar cane ma-

houses,[221] and transverse-[222] and single-crib barns may be found in the southern halves of those states, parts of which, as a result, fit loosely with the Tennessee Valley and Bluegrass into the region of the Upland South.

The Midwestern wedge was inserted between the North and the Upland South. Its eastern point penetrates Pennsylvania and is characterized by the irregularity of the cultural landscape; today's traveler, by noticing barns and farm layout in particular, becomes aware of a confusing patchwork of small Yankee, Southern, and Mid-Atlantic areas. In the west, at first, northerners and southerners cut their corn with different kinds of knives and splintered their light eastern plows on the sod, but the flat, fertile land presented new problems and possibilities.[223] On the prairies, progressive farming was feasible and necessary; it was accepted before the diverse old traditions had

chinery to processing the new crop can be clearly seen in "Sorghum Canes: Condensed Correspondence," *Report of the Commissioner of Patents for the Year 1857: Agriculture* (Washington, 1858), pp. 181–226. Northern farmers were told in Charles W. Dickerman's handbook, *How to Make the Farm Pay* (Philadelphia, Cincinnati, Chicago, St. Louis, and Springfield, 1871), pp. 239–240, that the pans and techniques used in boiling down maple sap could be used in the treatment of the juice pressed out of the sorghum cane.

[221]For Indiana I houses, not all of which reflect definite southern influence, see: Wilbur D. Peat, *Indiana Houses of the Nineteenth Century* (Indianapolis, 1962), plates 4–6, 23, 33, 58, 59, 97, 98.

[222]An example: Patrick Horsbrugh, "Barns in Central Illinois," *Landscape*, 8:3 (Spring, 1959), p. 113.

[223]See this fine book: Allan G. Bogue, *From Prairie to Corn Belt* (Chicago and London, 1963), particularly pp. 5, 24–26, 70–73, 133, 148, 237–240, and chapters VIII, X.

time to shake down into folk cultural homogeneity, and up-to-date material culture instead of localizations and syntheses of Old World traditions came to typify the Middle West. On the map, the Midwest is the easternmost projection of the West rather than the westernmost extension of the East.

 ### Patterns within regions

The broad regions of the eastern United States can be subdivided by a closer analysis of the possessions and products of the general farmer. These subregions—less intriguing but less simplistic and, perhaps, more useful to the worker with specific folk cultural problems than the broad regions—may be established by plotting the distributions of traits restricted to but not found throughout the region, by a quantification of traits found throughout the region, or by an examination of the significance assigned by individuals in different locales to traits found throughout the region. The Mid-Atlantic region is roughly bisected by the Susquehanna: east of the river can be found more houses with central chimneys, west of it more washhouses with external chimneys; in the east there is an emphasis—displayed more clearly at firemen's festivals and country fairs catered by farm women's organizations than in the homes—on chicken corn soup, while in the west the emphasis is on bean soup. The subregion east of the Susque-

hanna may be further subdivided into north and south on the basis of the tools used to dig irrigation ditches, the subtype of two-level barn which predominates, and the presence or absence of geometric designs painted on barns and sheds. And, the area of decorated barns can be carved up into areas (sub-sub-subregions they would be) where a specific form of barn sign, such as the Cocalico star, is the only decoration, where the masons all bind their scaffolds with hickory thongs and dress building stones in the same way, where the women use the same amount of saffron in baking cakes and the same amount of bacon grease in salad dressing—little batches of creek valleys, ridges, knobs, and meadows where single families hold certain art and craft specialties, where movement is limited, contact direct, and where the apparent likeness is absolutely real.

The southern limits of the region of the North are easily recognizable, but because there were no physical barriers to westward movement out of New England comparable to the Appalachian chain, and because, again in contrast to the South, the routes westward were consistent and the population moving along them relatively homogeneous, no positive western boundary can be drawn for the Northeast. Still, the distributions of northern traits suggest a series of overlapping subregions, each with its eastern limits at the Atlantic and its western limits successively farther from the Coast. Generally, as the distance of the western border from the seaboard increases, the distinctive traits of the subregion become more modern and

less characteristic of the New England source area. Gambrel roofs[224] and shingle siding are not found far off the Coast. A type of gable-opening two-level barn type was built frequently in Massachusetts (Fig. 46), but was not carried beyond the Berkshires. Many of the distinctive New England traits, such as the town plan with the open central green,[225] central chimney houses, and air-borne heads on gravestones, appear occasionally in central New York and rarely farther west. The Yankee barn and temple form house are found from the fishing villages of the Connecticut coast to the level country around the Great Lakes.

Subregions can also be suggested by studies of the material culture of specialty crops; for example, tobacco—the tools used to plant and cultivate it, the vehicles used to transport it, and the buildings in which it is cured—can be employed in the demarkation of some of the South's subregions. Tidewater Maryland and Middle Virginia are connected by air-cured tobacco barns patterned after the English barn (Fig. 39). The Piedmont of southern Virginia and northern North Carolina and the southern Tidewater from North Carolina into northern Florida are joined together and separated from the Blue Ridge by the common appearance of flue-cured tobacco barns built of

[224]Cf. Alan Gowans, "New England Architecture in Nova Scotia," *The Art Quarterly*, XXV:1 (Spring, 1962), p. 10.

[225]Conrad M. Arensberg and Solon T. Kimball, *Culture and Community* (New York, 1965), pp. 103–104.

FIGURE 46

TWO-LEVEL, END-OPENING BARN

This barn stands east of Hampden, Hampden County, Massachusetts
(October, 1964).

frame, mud-plastered log or, lately, cinder block.[226] Parts
of central New York can be cut out of the Northeast and
drawn together on the basis of the hops grown there from

[226]See John Fraser Hart and Eugene Cotton Mather, "The Char-
acter of Tobacco Barns and Their Role in the Tobacco Economy of
the United States," *Annals of the Association of American Geogra-
phers*, 51:3 (September, 1961), pp. 274–293.

the early nineteenth to the early twentieth centuries.[227]
The large hop houses which were based on the English
oast houses[228] and have a plastered or tightly boarded kiln
at one end where the hops were dried, are the most obvi-
ous indicators of New York's hop-growing areas (Fig.
47). In barns, sheds, and the memories of old men, other
of the material elements of hop culture may be discovered:
the "dibble" with which the roots of the previous year's
growth were planted, the "hop poles" up which the hop
vines wound, the knives used to cut the hops, the "hop
boxes" into which the picked hops were put, the "hop
shades" which sheltered the box tenders from the late sum-
mer sun, the hanging kettles in which sticks of brimstone
were heated to dry the hops, the "hop shovels" used to
move the dried hops off the slatted, burlap-covered kiln
floor, and the presses in which the hops were baled on a

[227]For New York hop culture: "Hops—Otsego County, N.Y."
The Northern Farmer, II:10 (October, 1855), p. 457; L. T. Marshall,
"Hop Culture," *Report of the Commissioner of Patents for the Year
1861: Agriculture* (Washington, 1862), pp. 289–293; Marion Nicholl
Rawson, *Of the Earth Earthy* (New York, 1937), chapter X; Gary S.
Dunbar, "Hop Growing in Franklin County," *North Country Life*, 8:4
(Fall, 1954), pp. 21–23; W. A. Anderson, *Social Change in a Central
New York Community* (Ithaca, 1954), pp. 18–27; Henry Glassie, "The
Wedderspoon Farm," *New York Folklore Quarterly*, XXII:3 (Septem-
ber, 1966), pp. 169–171, 176–177, 184–185.
[228]For the oast house: Rowland C. Hunter, *Old Houses in Eng-
land* (New York and London, 1930), plates 59–60; Sydney R. Jones,
English Village Homes and Country Buildings (London, 1947), pp. 47,
72, figs. 43, 82; Martin S. Briggs, *The English Farmhouse* (London,
1953), pp. 99, 107–108, 111, 205, 215–216; Cook and Smith, *English
Cottages and Farmhouses*, pp. 31–32, plates 20, 103–105.

damp autumn day. "It was quite a lot of fun," reminisced Jesse Wells, a York State farmer who picked hops as a teenager over half a century ago, "and quite a lot of hard work. I used to tend box some, an' I had a pole puller to pull the poles with 'cause they was in the ground so tight I couldn't pull 'em without havin' this thing to pull 'em with. And, then maybe at night we'd have a dance. Old fellow had a violin, he'd play a few pieces for us. We'd dance a little, have a little good time."[229]

The nonagricultural groups which exist within the agricultural regions can both reinforce and disturb the basic patterns. Because they followed the same westerly routes that the agricultural settlers took, the northern lumbermen strengthened the connections between New England, northern Pennsylvania, and the Great Lakes area. In the North, the lumbermen often transported logs on the

[229] Jesse Wells, farmer, who lives near Toddsville, Otsego County, New York; tape-recorded interview, January 11, 1965. Although he knows a few songs—the pop tunes of his mother's girlhood—Mr. Wells' great value as an informant is that he has worked the same 140-acre farm all his life, his family had lived in the immediate vicinity for five generations before him, he has been married to the same woman and a member of the same Grange hall for over fifty years, and he is, therefore, able to supply some information on nearly every facet of life in his community.

A

FIGURE 47

HOP HOUSES

A. South of Munnsville, Madison County, New York (July, 1965).
With its round stone kiln and frame hop shed, this early hop house is
very like the oast houses found in Kent. B. Between Oaksville and
Hartwick, Otsego County, New York (July, 1965). The ventilator on the
ridge marks the position of the kiln. C. Longitudinal section through a
frame hop house; south of East Springfield, Otsego County, New York
(July, 1962). The kiln is located to the left. The hop furnace was posi-
tioned on the first floor of the kiln; the hops were spread out on the floor
above to dry. The shed to the right of the kiln was used to store hops
and equipment. D. Plan of C.

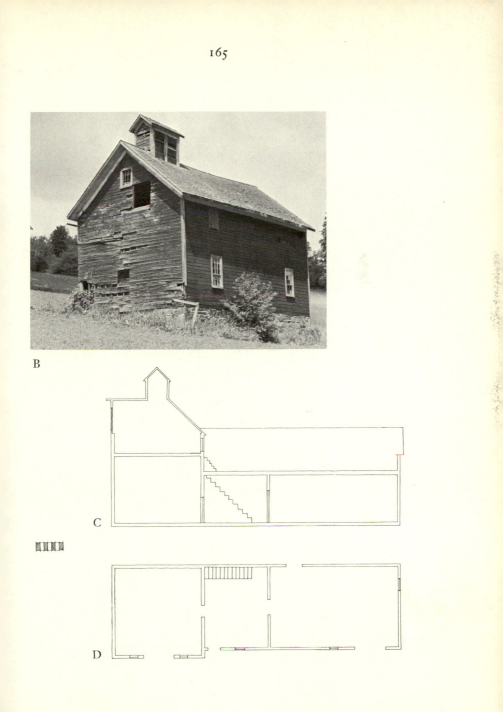

B

C

D

same bobsled type (Fig. 48A)[230] the northern farmer used in the collecting of maple sap; the farmer, also, placed two of them in a line under a box for general winter work, and, when he hauled logs for firewood or the construction of a new building he used two bobsleds tandem (Fig. 48B) or the forward bob alone, just as the lumberjacks did. The great southern forests attracted lumbermen from the North, who brought along their Yankee tools, which were subsequently adopted by many a southern farmer. The peavey, a combination jam pike and cant hook used in the handling of logs, which was invented about 1858 by one Joseph Peavey, Maine blacksmith,[231] is found, now, not only in the North and far West, but in the Deep South, too.

Frequently, the American farmer or rural tradesman is secondarily a hunter, trapper, or fisherman, and his

[230]See John S. Springer, *Forest Life and Forest Trees* (New York, 1851), pp. 94-97; Ralph Clement Bryant, *Logging* (New York and London, 1913), pp. 155-159; Alexander Michael Koroleff and Ralph C. Bryant, *The Transportation of Logs on Sleds* (New Haven, 1925); Nelson Cortlandt Brown, *Logging* (New York and London, 1949), pp. 142-143.

[231]Stewart H. Holbrook, *The American Lumberjack* (New York, 1962), pp. 33-34; Robert E. Pike, *Tall Trees, Tough Men* (New York, 1967), p. 106; Lore A. Rogers and Caleb W. Scribner, "The Peavey Cant-Dog," *The Chronicle of the Early American Industries Association*, XX:2 (June, 1967), pp. 17-21. The peavey is incorrectly ascribed to John Peavey of Bolivar, New York, about 1870, in Henry C. Mercer, *Ancient Carpenters' Tools* (Doylestown, 1960), pp. 44-46; and Ivan C. Crowell, "The Little Old Mills of New Brunswick," *Collections of the New Brunswick Historical Society*, 19 (1966), p. 85; both, still, of course, contain useful information on the implement.

A

B

FIGURE 48

BOBSLEDS

A. Bobsled, southwest of Hartwick, Otsego County, New York (February, 1965). B. Tandem bobs, north of Hartleton, Union County, Pennsylvania (March, 1967).

possessions include the implements necessary for the pursuit of the local fauna. On the swampy waterways of Mississippi he "hangs" fish by setting several fishing poles into the bank at dusk and leaving them overnight. The Ozark hunter uses a "blowing horn," made of a cow's horn boiled to remove the pith and fitted with a mouthpiece carved from the horn's tip, while he is running game with dogs.[232] Some Tidewater farmers grow bamboo which they cut and hang weighted with a stone from a tree; when dry, the bamboo is made into fishing poles. Many Piedmont Virginians maintain a line of homemade rabbit traps—"rabbit gums" (Fig. 49) or snares[233]— around their gardens, both to protect their vegetables and to provide meat for the pot. Back in the hills of central Pennsylvania, fish were "stung"—a fact to which this interview is a testament:

> Ralph Wagner: Well, when I was a kid and used to skate in the winter, why my dad used to ask me whether I'd ever see any big fish, an' I told him I did. And then he asked me whether I ever heard of stingin' fish. I says, "No." So, he showed me how to make a wooden mallet out of a piece of green wood with a handle in it—a good solid piece of wood. Then he said, "You just skate around and when you see a fish down in the

[232]Fred High, *It Happened in the Ozarks* (Berryville, n.d.), p. 39.

[233]See P. A. L. Smith, *Boyhood Memories of Fauquier* (Richmond, 1926), pp. 130–132.

FIGURE 49

RABBIT GUM

This box trap was set at the edge of a garden west of Gum Spring, Louisa County, Virginia (August, 1966).

clear ice, whamo! You give him a good one and cut the ice out and get the fish." So I used to do that quite a bit off and on. I didn't make a business of it, or nothing like that, I was too lazy I guess, or something, but that's the whole thing in a nut shell.

H. G.: How thick was the ice?

Ralph Wagner: Oh, two to three, four inches. You didn't want the ice to get too thick because the thicker it got the harder it was to cut out.

H. G.: What did you cut it out with?

Ralph Wagner: An axe. A little single-bitted axe.

H. G.: Where was this?

Ralph Wagner: This was on Beaver Creek in the Middle Creek. Right around Beaver Springs there. Down in the old canal, the artificially dug canal that was right back in there.

H. G.: How long was the mallet?

Ralph Wagner: Oh, the handle was about two and a half, three feet—a hickory handle usually.

H. G.: How did you get the handle out, did you shave it down?

Ralph Wagner: Yeah, I shaved it down; just cut a split up piece of hickory and shaved it down with a drawing knife, round it off and drill a hole in it. Club her in.

H. G.: What kind of fish did you get mostly?

Ralph Wagner: Pike. See, they come to the surface more than any other fish in the winter. In fact,

FISH STINGING MALLET

This sketch was made by Ralph Wagner who described its use in July, 1967. The original drawing was one and seven-tenths inches long.

during the summer they'll lay out along the bank close to the surface.

H. G.: Tell about your grandfather's, what it was like.

Ralph Wagner: My grandfather also had one of these hammers and I think his was just a regular wedge-driving hammer like they used in the woods to split rails and logs and things like that 'cause his had a steel band around each end of the hammer head, but that's the only thing that was different. But I think his was just a wedge-drivin' hammer and he used to sting fish too. And then I always left the bark on mine because that eventually dried out and would peel off and fly off by itself.

H. G.: What kind of wood did you use for the hammer part? Hickory?

Ralph Wagner: No, a piece of green maple for the hammer part—maple or anything that was good and hard. Green maple's about as tough as you can get (Fig. 50).[234]

On the blue Juniata in Pennsylvania, fish and eels were caught on long lines, staked to the bank at one end and weighted at the other, from which strands with baited hooks were suspended at about eighteen-inch intervals.[235] This method—"outline fishing"—is traditional in Britain[236] and off the northeastern coast;[237] the gentlemanly angler of the nineteenth century considered outline fishing "a very dirty, laborious, unscientific, and unsporting mode of

[234]Ralph Wagner; tape-recorded interview, July 27, 1967. Mr. Wagner was born and raised around McClure, Snyder County, Pennsylvania, and now lives in Harrisburg. A man in his forties, he is a fine craftsman—a woodworker and builder of custom rifles—who puts much of his spare time into hunting and fishing. Listening to the tape being played back, Dick Getz, Ralph's buddy, fellow Snyder Countian and outdoorsman, said that he used to buy sweet-smelling hair tonic at traveling medicine shows and pour it into the water. He would set a striped pole up on the bank, and, when the fish came up for a haircut, he would club them. Ralph and Dick then swapped lies about steep hills and plentiful game, but stinging fish is not a tall tale; for a description from eastern Pennsylvania, see: Warren Fretz, "Old Methods of Taking Fish," *A Collection of Papers Read Before the Bucks County Historical Society,* V (1926), p. 364.

[235]E. J. Stackpole, *Tales of My Boyhood* (Harrisburg, 1921), pp. 44–45.

[236]Peter F. Anson, *Fishermen and Fishing Ways* (London, Bombay and Sydney, 1932), chapter VIII.

[237]Frederick Peterson, "The Fishermen of Gloucester," *Americana,* XXXI:3 (July, 1937), pp. 475–476.

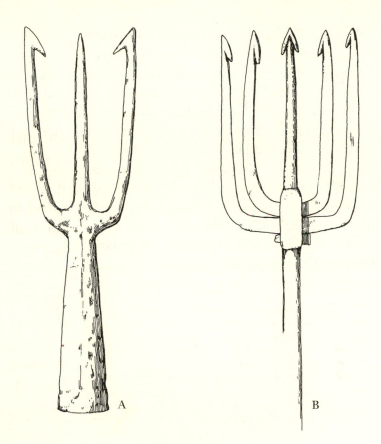

A B

FIGURE 51

LONG ISLAND EEL SPEARS

Both of these spears are from the collection of the Nassau County
Historical Museum. B represents the more usual form of the eel spears
found widely in the East. A similar spear can be seen in use in William
Sidney Mount's "Eel-Spearing at Setauket." The genre paintings of
Mount (1807–1868) provide an invaluable source for the study of folk-
life on Long Island.

killing fish."[238] Long Island eels were impaled on hand-forged spears (Fig. 51) which closely followed an ancient European pattern.[239] New Englanders,[240] like their English ancestors,[241] caught eels in conical basketry traps. And, on the lakes of upstate New York, farmers, sports, and small-time commercial fishermen jig for fish in an area they mark with buoys and keep constantly baited.[242]

There are also some who depend on hunting or fishing for their livelihood; like other occupational groups, these affect the regions in which they operate. Because they often depend on certain types of game and terrain, hunters and fishermen may remain sedentary and contribute toward the delineation of a subregion. Since 1880, the Black River which flows through east central Louisiana

[238]Henry William Herbert, *Frank Forester's Fish and Fishing of the United States and British Provinces of North America* (New York, 1851), p. 73 of supplement.

[239]See Håkan Fernholm, "Ljusterfiske," *Folk-Liv*, VI (1942), pp. 50–72; Arthur E. J. Went, "Irish Fishing Spears," *The Journal of the Royal Society of Antiquaries of Ireland*, LXXXII (1952), pp. 109–134; Sybil Marshall, *Fenland Chronicle* (London, 1967), p. 121.

[240]Jennie F. Copeland, *Every Day But Sunday* (Brattleboro, Vt., 1936), pp. 99–100; Mary Earle Gould, *Early American Wooden Ware and Other Kitchen Utensils* (Springfield, 1942), p. 211.

[241]Dorothy Hartley, *Made in England* (London, 1951), pp. 96–100.

[242]S. R. Stoddard, *The Adirondacks: Illustrated* (Glens Falls, N.Y., 1881), p. 207; Per Guldbeck, "By-Gone Fishing Techniques," *The Chronicle of the Early American Industries Association*, XIII:4 (December, 1960), pp. 44–45; Edmund E. Lynch, "Fishing on Otsego Lake," unpublished master's thesis, Cooperstown Program, State University of New York College at Oneonta (May, 1965), pp. 51–74. Like the unpublished theses of William Knipmeyer and John Vincent, Lynch's study deserves publication.

has provided many with a living from commercial fishing. The white fishermen of the Black River have a material folk culture which separates them from their agricultural neighbors: instead of barns and farm implements, they make flat-bottomed "bateaus" and fishing tackle, such as the hoop net which consists of home "knitted" netting hung on draw-shaved white oak, or, more recently, cut and hammered steel hoops.[243]

The farmsteads in the Adirondack valleys are composed of the same architectural types that most New York farms are, but the material folk culture of the influential guides—the men who led the city parties to game and gorgeous views—distinguishes the Adirondacks from the remainder of the North. The guides and some local farmers pounded out black ash splints and wove the Adirondack pack basket (Fig. 52), a type which seems to have been developed in the Adirondacks out of similar Iroquoian and eastern Algonkian carrying baskets during the early nineteenth century.[244] The guides also developed the

[243]Hiram F. Gregory, Jr., "The Black River Commercial Fisheries: A Study in Cultural Geography," *Louisiana Studies*, V:1 (Spring, 1966), pp. 3–36.

[244]See S. Newhouse, *The Trapper's Guide* (New York, 1869), p. 86; H. G. Wilson, "The Adirondack Pack-Basket," *Fur News and Outdoor World*, XXXIII:4 (April, 1921), p. 22; Roland B. Miller, "The Adirondack Pack-basket," *The New York State Conservationist*, 3:1 (August-September, 1948), pp. 8–9; Henry Glassie, "William Houck, Maker of Pounded Ash Adirondack Pack-Baskets," *Keystone Folklore Quarterly*, XII:1 (Spring, 1967), pp. 23–54.

A

B

FIGURE 52

THE ADIRONDACK PACK BASKET

A. William Houck (1884–1967) at work on a pack basket in his shop near Vernon Center, Oneida County, New York (July, 1965). B. Pounded ash pack basket made by Mr. Houck.

swift, light "guide boat"—"carry boat" or "Saranac Lake boat"—which came to be a major means of transportation for all Adirondack people. The first one was apparently built in 1842. After a quick series of modifications the guide boat type had been set (Fig. 53): it has an identically pointed stem and stern, no thwarts, oars which overlap at the fists, and a wooden yoke for carrying; it has a tapered white pine bottom board and its sides are a smooth single layer of beveled cedar or pine boards attached to each other with copper tacks and to the naturally curved spruce root ribs with brass screws; its finish was blue paint or, later, oil, shellac, and varnish with the bright heads of the tacks and screws forming a consciously decorative pattern.[245]

The sharpie, a flat-bottomed skiff, began to replace the dugout canoes of the Connecticut shore for use in oyster tonging in the 1840's. From its area of origin around New Haven it spread rapidly: modifications of the sharpie were sporadically distributed as far south as the Florida Keys by the close of the nineteenth century.[246]

[245]Much has been written on the guide boat; see: Alfred L. Donaldson, *A History of the Adirondacks*, I (New York, 1921), pp. 305–306; II, pp. 79–80; Joseph F. Grady, *The Adirondacks Fulton Chain-Big Moose Region* (Little Falls, 1933), pp. 211–217; William Chapman White, *Adirondack Country* (New York and Boston, 1954), pp. 156–158; Frank Boone, "The Adirondack Guide Boat," *North Country Life*, 12:1 (Winter, 1958), pp. 26–28; Kenneth Durant, ed., *Guide-Boat Days and Ways* (Blue Mountain Lake, 1963), pp. 25–26, 166, 208–237, 251–252.

[246]Howard I. Chapelle, "The Migrations of an American Boat Type," *Contributions from the Museum of History and Technology*, 228:25 (Washington, 1961), pp. 134–154.

FIGURE 53

THE ADIRONDACK GUIDE BOAT

These early photographs are from the extensive collection of the Adirondack Museum, Blue Mountain Lake, New York. A. Guide boat pulled up on shore near the foot of Long Lake in 1888. B. Guide holding the boat in carry position while a pair of young sports pose for a local, late nineteenth-century photographer. Note the pack basket.

While the kind of communication did exist between Atlantic fishing communities which could allow for the swift diffusion of a piece of culture like the sharpie's form, most of the fisherman's traditional material can be ordered into coastal subregions of the basic material folk culture regions. The lobster pot composed of slats nailed over three spruce arches with ends of tarred net and its modern equivalent which is weighted by a blob of cement instead of a flat rock and is made by tacking slats over three framed squares (Fig. 54),[247] have antecedents in Ireland, Scotland, and England,[248] and are among the traits of the coastal subregion of the Northeast which stretches from the Maritimes through Long Island. The folk boat types of the East Coast often reflect a deep provincialism, an adaptation of tradition to local needs. The Cape Cod cat, a localized variant of a type of centerboard sailboat found along the northern shores, was developed in the 1870's. With almost no change in form, even when a motor was added, it continued to be built for lobstering and hand-line fishing well into this century and is still in service as a pleasure boat.[249] From southern Barnegat Bay to the Dela-

[247]See Robert P. Tristram Coffin, *Yankee Coast* (New York, 1947), pp. 120–124, 128–130; Alta Ashley, "Trap Day on Monhegan," *Down East*, XIII:5 (January, 1967), pp. 16–19.

[248]See E. Estyn Evans, *Irish Folk Ways* (New York, 1957), pp. 230–231 (Professor Evans' book is the best introduction to folklife in English); I. F. Grant, *Highland Folk Ways* (London, 1961), pp. 267–268; Barrie Farnill, *Robin Hood's Bay: The Story of a Yorkshire Community* (Clapham, 1966), facing pp. 25, 40.

[249]Edwin J. Schoettle, ed., *Sailing Craft* (New York, 1928), pp. 87–108; Howard I. Chapelle, *American Sailing Craft* (New York, 1936), chapter 4.

LOBSTER POT.

A

FIGURE 54

LOBSTER POTS

A. From Samuel Adams Drake, *Nooks and Corners of the New England Coast* (New York, 1875), p. 85. While this lobster pot, like the boat, is apparently somewhat inaccurately drawn, it does present the older trap's rounded form. B. Completed rectangular lobster pot with parts ready for use in the construction of new traps, in the village of Stonington, New London County, Connecticut (July, 1967).

B

ware along the Jersey shore, a scow called a garvey was used for a variety of purposes: rowed garveys were used on inland waters for fishing, oyster tonging, and transporting farm freight; small rigged garveys were used for gunning, larger ones for tonging, fishing and clamming in the Bay, and the largest class of this type of sailing scow was used for transport and dredging oysters.[250] In the Chesapeake Bay, the log canoe, which seems to have been developed out of the Indian dugout, served as a work boat. Three different modes of canoe construction were employed on the Bay; in all of them carefully selected pine

[250]Howard I. Chapelle, *American Small Sailing Craft* (New York, 1951), pp. 53–67, 336–338.

logs, usually three or five in number, were hewn and adzed, pinned together, spliced with short pieces of wood, and planed and painted into a graceful craft. The earliest canoes were rowed; since about 1850, they have been fitted with sails in generally some variety of leg of mutton rig.[251]

The nineteenth century seaman filled the monotonous intervals at the fo'c'sle with scrimshawing as well as song. Scrimshaw was produced by sailors and the land people with whom they traded in many parts of the world, but most of it was developed and made on the whalers which put out from the northeastern ports. Although a variety of items carefully made from a variety of materials can be termed scrimshaw, the classic piece was the tooth extracted from the lower jaw of a sperm whale, smoothed down, and engraved (Fig. 55). Whether the subject was a traditional motif, such as the full-rigged ship, or a popular one copied from *Godey's Lady's Book*, the engraving techniques and tools were traditional. The lines were incised with jackknives or—to use Melville's phrase —"dentistical-looking implements"[252] cobbled out of sail

[251]M. V. Brewington, *Chesapeake Bay Log Canoes*, 2 parts (Newport News, 1937); Chapelle, *American Small Sailing Craft*, pp. 291–304. For the leg of mutton rig: E. P. Morris, *The Fore-and-Aft Rig in America* (New Haven, 1927), chapter VI; Richard LeBaron Bowen, Jr., "The Origins of Fore-and-Aft Rigs, Part I," *The American Neptune*, XIX:3 (July, 1959), pp. 165–177.

[252]*Moby Dick*, chapter 57.

FIGURE 55

SCRIMSHAW

This piece is from the collection of the Marine Historical Association, Mystic, Connecticut.

needles and shipboard scraps; ink, lampblack, or some substitute was rubbed into the lines when the composition was completed.[253] This technique was probably transferred from the engraving done traditionally on powder horns in many parts of Europe and in America, particularly in Pennsylvania and the Northeast, during the colonial

[253]For scrimshaw: John R. Spears, *The Story of the New England Whalers* (New York, 1910), pp. 282–283; Clifford W. Ashley, *The Yankee Whaler* (Boston and New York, 1926), chapter XI, and pp. 303–323; Marius Barbeau, "'All Hands Aboard Scrimshawing,'" *The American Neptune*, XII:2 (April, 1952), pp. 99–122; Walter K. Earle, *Scrimshaw: Folk Art of the Whalers* (Cold Spring Harbor, 1957); Edouard A. Stackpole, *Scrimshaw at Mystic Seaport* (Mystic, 1958).

period:[254] long before the whaleman started scrimshawing, powder horns engraved with nautical motifs were being made and used on board British and American ships.[255]

 THE CAUSES OF REGIONAL PATTERNS

The traits of the material folk culture regions of the eastern United States are the results of historic accident: the fact that the New England I house has a central chimney where the Chesapeake Tidewater I house has external gable-end chimneys is a result of the fact that most of the New England people came from eastern England where the houses were usually built with central chimneys, while most of the Chesapeake Tidewater people came from western England where the houses were often built with external gable-end chimneys.[256] Influences other than settlement history did work upon the formation of

[254]For engraved powder horns: W. M. Beauchamp, "Rhymes from Old Powder-Horns," *Journal of American Folk-Lore*, II (1889), pp. 117–122; V (1892), pp. 284–290; Charles Winthrop Sawyer, "The Why and How of Engraved Powder Horns," *Antiques*, XVI:4 (October, 1929), pp. 283–285; Henry Kinzer Landis and George Diller Landis, "Lancaster Rifle Accessories," *The Pennsylvania German Folklore Society*, IX (1944), pp. 159–165; Steven V. Grancsay, *American Engraved Powder Horns* (New York, 1946).

[255]See in Grancsay's fine book, p. 4 f.n. 18, and, for examples, these numbers in his check list, pp. 40–81:7 (1757), 10, 29, 52 (1774), 58, 92 (1760), 108 (whaling ship—1836), 140, 189, 212, 242 (1758), 245, 450 (1762), 528, 583, 705, 928 (1757), 1014 (1774).

[256]Cf. Barley, *The English Farmhouse and Cottage*, pp. 144–145.

the regions, but, although these are frequently assigned creative roles, in the United States they served much less to cause the invention of a new element than to indicate which of a number of traditional possibilities should be chosen and, then, to reinforce the tradition of the chosen element.

From south central Massachusetts up through Maine, less commonly in other parts of New England, and very rarely in north central New York, the barn is often connected to the house by a service wing (Fig. 56).[257] Although the connected farm plan is generally counted as a Yankee invention mothered by climate,[258] comparable practices were known in the British Isles. The Welsh long house,[259] the Yorkshire laithe-house,[260] and many of the

[257]Wilbur Zelinsky, "The New England Connecting Barn," *The Geographical Review*, XLVIII:4 (October, 1958), pp. 540–553. For descriptions: Russell V. Keune and James Replogle, "Two Maine Farm Houses," *Journal of the Society of Architectural Historians*, XX:1 (March, 1961), pp. 38–39; Helen V. Taylor, *A Time to Recall: The Delights of a Maine Childhood* (New York, 1963), pp. 11–13, 21–22, 24–25, 34, 116–117, 152–153.

[258]For example: Eric Sloane, *An Age of Barns* (New York, n.d.), p. 46. The books of Eric Sloane are much more artistic than accurate.

[259]Peate, *The Welsh House*, pp. 51–84.

[260]P. Smith, "The Long-House and Laithe-House: A Study of the House-and-Byre Homestead in Wales and the West Riding," in I. Ll. Foster and L. Alcock, *Culture and Environment* (London, 1963), pp. 415–437; Christopher Stell, "Pennine Houses: An Introduction," *Folk Life*, 3 (1965), pp. 16, 20–21. It is probably this type which is described in Rev. J. C. Atkinson, *Forty Years in a Moorland Parish* (London, 1891), p. 19.

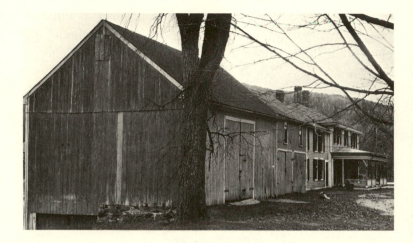

FIGURE 56

CONNECTED FARM PLAN

This farm is located in Hampden, Hampden County, Massachusetts (October, 1964). The barn is a typical, early northern two-level barn; compare with Fig. 39D.

oldest dwellings of Devonshire, [261] Scotland,[262] and northern and western Ireland[263] housed at one end the farmer and at

[261]Barley, *The English Farmhouse and Cottage*, pp. 110–112.

[262]Alan Gailey, "The Peasant Houses of the South-west Highlands of Scotland," *Gwerin*, III:5 (1962), pp. 4–6, 9. For a description: George MacDonald, *Peasant Life* (London, 1871) pp. XV–XVI, 193.

[263]Caoimhín Ó Danachair, "The Combined Byre-and-Dwelling in Ireland," *Folk Life*, II (1964), pp. 58–75.

the other his stock. Through much of England farmhouses were incorporated into a range of buildings including the stables up to the end of the sixteenth century;[264] these plans, in which the barn is attached to the house New England fashion, continued to be built in upland areas, such as Cumberland, Yorkshire,[265] and northern Wales,[266] into the last century. The connected form of farm layout was archaic in the areas from which the New Englanders came, yet many surely brought some knowledge of it with them and were, thus, able to revive it in the face of the bitter New England winters. While not all agricultural engineers approved of the plan,[267] its practicality for the Northeast caused it to be recommended in some publications,[268] built through the nineteenth century, and used to the present in the areas in which it is traditional—not necessarily the coldest parts of New England.

Topography is one of several factors in the physical environment which can affect tradition.[269] In the

[264]Joscelyne Finberg, *Exploring Villages* (London, 1958), pp. 66–67, 131–132.

[265]M. E. Seebohm, *The Evolution of the English Farm* (Cambridge, 1927), pp. 282, 328.

[266]Alwyn D. Rees, *Life in a Welsh Countryside* (Cardiff, 1950) pp. 47–51.

[267]Thomas G. Fessenden, *The Complete Farmer and Rural Economist* (Boston and Philadelphia, 1840), p. 71.

[268]*American Agriculturist*, XXXIX:2 (February, 1880), p. 54; L. H. Bailey, ed., *Cyclopedia of American Agriculture*, I (New York and London, 1907), pp. 38, 148–149.

[269]See this study: E. J. Wilhelm, Jr., "Folk Settlement Types in the Blue Ridge Mountains," *Keystone Folklore Quarterly*, XII:3 (Fall, 1967), pp. 158–170.

mountainous sections of the Continent,[270] of England,[271] Scotland,[272] Wales,[273] Ireland,[274] and the southern United States[275] sleds—sledges, slides, slipes—are used in all seasons more often than wheeled vehicles, which prove impractical in rough and rocky terrain.

The three major folk cultural divisions of the eastern United States were characterized by different agricultural systems during the last half of the eighteenth century and the first half of the nineteenth—the century during which the regions were formed. These systems supported and were supported by the early predominance of popular over folk culture in the North, the selective conservatism of the Mid-Atlantic region, and the persistence of traditional patterns in the South. That is, economics, with its social and educational dependents, can help to maintain regional distinctions. This would seem to be particularly true in material matters, for material culture is largely the accumulation of traditional solutions to practical problems, such as keeping warm. Much of the means of economics is

[270]Gösta Berg, *Sledges and Wheeled Vehicles* (Stockholm, 1935), pp. 63–64, 77–78.

[271]Gertrude Jekyll, *Old English Household Life* (London, 1925), p. 109; Freda Derrick, *Country Craftsmen* (London, 1947), p. 63; J. Geraint Jenkins, "Agricultural Vehicles," in Singer, Holmyard and Hall, *A History of Technology*, III (1957), pp. 140–141.

[272]Grant, *Highland Folk Ways*, p. 281.

[273]Cyril Fox, "Sleds, Carts and Waggons," *Antiquity*, V:18 (June, 1931), pp. 186–187; J. Geraint Jenkins, *Agricultural Transport in Wales* (Cardiff, 1962), pp. 13–18.

[274]G. B. Thompson, *Primitive Land Transport of Ulster* (Belfast, 1958).

[275]Cf. Kephart, *Our Southern Highlanders* (1926), p. 42.

material culture; much of the function of material culture is economic.

The nineteenth century traveler commented upon the literate northerner:

You can hardly find a dwelling in New England, be it a framed house or a log cabin, in which some periodical print is not taken. The newspapers of the day are scattered far beyond the route of the mails, and the region of passable roads. The lonely settler will weekly emerge from his distant home in the woods, to get his newspaper.[276]

His reading was for more than pleasure. His farm was large and geared to profit. He was dependent upon agricultural publications for his knowledge of the latest scientific practices and improvements which made possible the size and success of his farm.[277]

On this topic the editor of *The Northern Farmer* wrote, in 1855, a little morality worthy of televised production. The narrator begins:

The present is an age of progress and improvement —not only in the arts and sciences, but in all that pertains to agriculture. We have improved implements of all descriptions, and improved stock for our

[276]Jacob Abbott, *New England and Her Institutions* (Boston, 1835), p. 25. The same theme of universal northern education is found through the four volumes of Timothy Dwight, *Travels in New-England and New-York* (London, 1823); for example: IV, pp. 284, 287–288.

[277]Cf. Paul Wallace Gates, "Large-Scale Farming in Illinois, 1850–1870," *Agricultural History*, VI:1 (January, 1932), p. 16. See Anne Gertrude Sneller, *A Vanished World* (Syracuse, 1964), p. 144.

farms. Instead of the old, unpainted dwellings of by-gone days, the majority of farmers live in neat, and commodious dwellings. Every thing looks tidy and thrifty around them. Their buildings are well painted, their implements are well housed, and they live on the fat of the land. . . . The *majority* of farmers are thus situated [but] . . . the other side of the picture is dark and forbidding.

The other side of the picture is one old John Slack, a central New York State farmer, a parsimonious individual who resides in a rickety house built by his father "no one knows *when.*" An agent for *The Northern Farmer* calls on Slack to solicit a subscription for his paper, whereupon Slack attempts to strike him with his cane. The agent retreats, upsetting Mrs. Slack who is churning by the door. Time passes. In a conversation with neighbor Jones, Slack asks him how he comes to be so rich. Replies Jones:

"I'll tell you how it is, friend Slack. I have kept up with the times in all the useful farm improvements. You know that I have all the new and valuable implements that are in use to save labor, and I think that I can perform more labor and raise larger crops with my two hired men than some farmers that I know can do with their five and six men who drudge along in the old way."

A discourse in agricultural specifics follows during which Jones' successes and Slack's failures are contrasted. Slack is saved:

"I now want *information.* I have lived sixty-five

years with my eyes shut to the 'improvements' going on, as you call them, having refused to admit a publication of any kind to enter my doors, except the almanac. . . . I don't believe that I should have taken such a course, had not my father always taught me to believe that '*book farming*' was a humbug, them papers what you call the 'Albany *Cultivation*,' '*Genesis* Farmer,' '*Roaring* New Yorker,' '*Northwest* Farmer,' &c."

Patronizingly, Jones returns:

"Neighbor Slack, I am very sorry that you have so long shut your eyes and ears to such a vast field of useful knowledge, as is contained in the publications to which you refer, but have made a slight mistake in the titles. I have them all from the commencement, and all nicely bound, and I say in candor, that I believe if I had taken none of them I should have been to-day a *poor* man.—Through them I have been led, step by step, to obtain the best breed of cattle, swine, sheep, &c.—to construct the most economical fences, with durability combined; to manufacture, and husband my manures; to apply them at a proper time, and in the best manner; to obtain the best seed grain, &c.; to adopt a systematic rotation of crops; to prevent the destruction of crops by worms, and other insects; to procure labor-saving farm implements; to cure my stock when diseased, and to learn many other useful hints which together have, in my opinion, put thousands of dollars into my pocket."

Jones puts the cap on the stack by showing Slack how reading the agricultural papers will not only make him rich, it will make his marriageable daughters more attractive. Slack vows to "subscribe to a few of the best ones immediately," to raze his ramshackle (folk) buildings, to erect modern (popular) structures in their steads, and never again to drive from his door a man who asks him to subscribe to an agricultural paper.[278]

There were and always will be folk facets of northern culture, but in many areas, particularly west of the Hudson and out into the upper Middle West, the northern farmer was not only influenced by popular culture, he was popular culture's agrarian exponent. His buildings and tools were up to date even where traditional ones would have been as practical.

Traditionally the farms of southeastern Pennsylvania are moderately large: "many a farmer has 50 or 100 and even 200–400 acres of land, laid out in orchards, meadows, fields, and woods," wrote an eighteenth century German traveler surprised at the rural wealth he found in the New World.[279] The prosperity of the Mid-Atlantic farmer, while comparable to that the northern farmer enjoyed, was owed not to complete agricultural modernity

[278]T. B. Miner, "Progress of the Age," *The Northern Farmer*, II:3 (March, 1855), pp. 115–117.

[279]Carl Theo. Eben, trans., *Gottlieb Mittelberger's Journey to Pennsylvania and Return to Germany in the Year 1754* (Philadelphia, 1898), p. 76. Much on agriculture and farm size also appears in Rayner Wickersham Kelsey, ed., *Cazenove Journal, 1794* (Haverford, 1922).

but to slowly but constantly changing, intensive farming methods applied to fertile land. He was a careful animal husbandman and made extensive use of animal manure for fertilizer. He irrigated his meadows and employed a system of crop rotation in which clover was alternated with grain to restore the soil, or, earlier, a field was allowed to lie fallow every two to four years.[280] The quality of traditional agriculture buttressed a conservative attitude; a mid-nineteenth century writer noted:

> Farming is, in fact, throughout Pennsylvania, little less than systematic labor—well organized, it is true; but still only a monotonous routine of physical toil, too seldom relieved by mental exercise or enjoyment. This is unfortunate. It is the result of old established prejudices, deeply-rooted in our German population, who, resisting every modern innovation, hold fast to the time-honored principles, precepts and examples of their forefathers, and regard it as a moral and social duty to "follow in their footsteps." They, therefore, plough, plant, and reap, pretty much in the old way, without deviating to the right or left, but by industry, frugality, and close attention to their affairs, gen-

[280]Walter M. Kollmorgen, "The Pennsylvania German Farmer," in Ralph Wood, ed., *The Pennsylvania Germans* (Princeton, 1942), pp. 27–55; Carlton O. Wittlinger, "Early Manufacturing in Lancaster County, Pennsylvania, 1710–1840," unpublished doctoral thesis, University of Pennsylvania (1953), chapter II; Leo A. Bressler, "Agriculture Among the Germans in Pennsylvania During the Eighteenth Century," *Pennsylvania History*, XXII:2 (April, 1955), pp. 102–133.

erally gather a competency, which is finally distributed amongst their children, who in turn travel over the same beaten track of agricultural life.[281]

British and German Pennsylvanians seem to have farmed in much the same manner;[282] the characteristic combination of prosperity and conservatism, however, is constantly ascribed to the Pennsylvania Dutch and its source may lie with the immigrants from the Continent, for the Palatine Germans who settled in New York's Mohawk Valley presented the same face to the visitor from the outside:

> The level region called the *German Flats*, famous for its fertility[, is in the Mohawk Valley]. The inhabitants, who are almost all of German extraction, still preserve their language, and many of the customs of their ancestors, and though often laborious and provident farmers, are little inclined to those improvements in learning or the useful arts, which distinguish so large a portion of the state.[283]

As a practical matter, however, the Mid-Atlantic farmer could not reject all progress. His big farm was operated by his family and practices which could reduce

[281]Eli Bowen, *The Pictorial Sketch-Book of Pennsylvania* (Philadelphia, 1852), p. 33 in the "Locomotive Sketches" section. See also: Phebe Earle Gibbons, *"Pennsylvania Dutch" and Other Essays* (Philadelphia, 1882), p. 34.

[282]James T. Lemon, "The Agricultural Practices of National Groups in Eighteenth-Century Southeastern Pennsylvania," *The Geographical Review*, LVI:4 (October, 1966), pp. 467–496.

[283]*The Northern Traveller and Northern Tour* (New York, 1830), p. 62.

the work load had to be tested. The conservatism of the Mid-Atlantic farmer was tempered by success. Only where it continued to be practical did his material remain traditional.

The most common of the southern agricultural systems during period of regional formation allowed material traditions to persist with a minimum of change;[284] these were the small independent farm found most usually in the Upland South[285] and the farm of the middle-class slaveholder found predominantly in the lowland areas.[286] The continuation of pioneer conditions on the small nearly self-sufficient holding left a man standing up against the folk end of the folk-nonfolk continuum, economically and physically isolated from progress, and reliant upon tradition. A contemporary described the backwoods Kentucky farmer of the nineteenth century in these terms:

The farmer . . . makes almost every thing that he uses. Besides clearing the land, building houses, and

[284]Ronald J. Slay, *The Development of the Teaching of Agriculture in Mississippi* (New York, 1928), pp. 17–18, considers both of these systems a detriment to agricultural progress.

[285]For the small Upland South farm: John C. Campbell, *The Southern Highlander and His Homeland* (New York, 1921), pp. 251–259; James Watt Raine, *The Land of Saddle-bags* (New York, 1924), pp. 226–228; Blanche Henry Clark, *The Tennessee Yeoman, 1840–1860* (Nashville, 1942), pp. 7, 54. Not all such small holdings were in the mountains, though, see: T. J. Woofter, *Black Yeomanry* (New York, 1930), chapters VI–VII.

[286]See Lewis Cecil Gray, *History of Agriculture in the Southern United States to 1860*, I (Washington, 1933), pp. 488–492; Herbert Weaver, *Mississippi Farmers, 1850–1860* (Nashville, 1945), pp. 42–43, 124–125.

making fences, he stocks his own plough, mends his wagon, makes his ox-yokes and harness, and learns to supply nearly all his wants from the forest. The tables, bedsteads, and seats in his house, are of his own rude workmanship. . . . There are thousands scattered over the west, who continue, to this day, to make all the shoes that are worn in their families. They universally raise cotton, and often cultivate, also hemp, and flax; the spinning-wheel and the loom, are common articles of furniture; and the whole farming and hunting population, are clad in fabrics of household manufacture.[287]

Folk culture is almost obviously fostered by the independent holding where the nuclear family raises, hunts, and makes what it needs while maintaining a cash crop only large enough to get them the necessities which cannot be produced at home. The farm of the owner of several slaves was also basically traditional—not as a result of the farmer's isolation, ignorance, or any lack of capital,

[287]James Hall, *Sketches of History, Life, and Manners in the West*, II (Philadelphia, 1835), pp. 68–69. It might be necessary to emphasize that our pioneer was reliant not on an idiosyncratic, rootless self, but on collective traditions brought from across the Atlantic. The combinations were new and distinctively American, but the components have their Old World antecedents. It is a characteristic of American historical scholars that they are aware of the traditional strain in colonial New England but miss it on the frontier—they recognize the clapboarded saltbox but not the log cabin as a folk structure; for perhaps the least objectionable statement see Lewis Mumford's readable *Sticks and Stones* (New York, 1955), pp. 13–31, 83–84.

but because he controlled so much manpower that there was little reason for him to adopt labor-saving devices.[288] About the owner of an antebellum Alabama plantation it has been written:

> After obtaining new information on the most approved methods of farming he often reverted to old, customary, time-worn practices. . . . For example, although he seemed to have developed an interest in labor-saving machinery he always depended on manual labor. In April 1849, he bought a corn sheller, but afterwards never referred to its use. Rather the work was done by hand by his slaves.[289]

The southern farmer held to his traditional material despite progress.

The mid-nineteenth century era of industrialization and war wrought changes in the rural economics of the regions which led to the development of the modern agricultural systems. Agriculture within the different cultural regions and environmental zones is more alike in the twentieth century than it was in the nineteenth, but the regional differences have not yet been completely erased. Scientifically based and educationally endorsed, progressive agriculture has continued to be the northern norm.

[288]Cf. Alexander Fenton, "Material Culture as an Aid to Local History Studies in Scotland," *Journal of the Folklore Institute*, II:3 (December, 1965), p. 334.

[289]Weymouth T. Jordan, *Hugh Davis and his Alabama Plantation* (University, 1948), p. 27.

The midwestern farmer of Yankee heritage has for a century or more embraced modernity for its own sake.[290] However, a complicated set of causes including crop failure, western competition, and the fact that the most modern machinery was ill suited to rolling rocky country, led to a depression in parts of northern New England[291] and upstate New York at the end of the nineteenth and beginning of the twentieth centuries. In these areas, as a result, elements of later nineteenth century popular culture have been stabilized, passed on, and elevated to folk status.

The Mid-Atlantic farmer has remained frugal, hard working, and selectively conservative, but swift change in the mid-nineteenth century and again in the early twentieth, and constant slow change have modernized him nearly completely. He has retained those aspects of his folk culture which do not block his progress, so that until World War I the buildings he planned were still traditional and today he is apt to hold beliefs about planting and treat the weather proverbially, but his tools and buildings are now as modern as those of the northern farmer.[292] The rift between the plain and other Pennsylvania farmers has widened in the past century, as the plain farmer has adopted popular agricultural practices at an increasingly slower rate. The Amishman, for example, accepted a tight

[290]Horace Miner, *Culture and Agriculture* (Ann Arbor, 1949), pp. 17–24.
[291]Harold Fisher Wilson, *The Hill Country of Northern New England* (New York, 1936), chapters V–VI.
[292]See Stevenson Whitcomb Fletcher, *Pennsylvania Agriculture and Country Life, 1840–1940* (Harrisburg, 1955).

four-year plan of crop rotation early in the nineteenth century, about when other Pennsylvania farmers did, but because that plan has kept the land fertile he has been reluctant to try the modern soil conservation methods his worldly neighbors employ.[293] He farms today much as most Americans north of the Potomac did at the turn of the century.

The progressive northern style farm has been added to the southern agricultural scene, but, despite the efforts of editors and educators, it did not make its entrance until our century and it still is not predominant.[294] The Civil War affected the slaveholder's unprogressive farm but it has its lineal descendents in the contemporary share-cropping and tenant farm operations.[295] The new planta-tion—its base still a multitude of tools, mules, and hands instead of a lone man astride an expensive machine—provides a congenial setting for material traditions, and often it fragments into one mule—one cow—garden patch holdings. The small nearly self-sufficient farm remains in the South, in the mountains, and in the piney woods sec-

[293]Walter M. Kollmorgen, *Culture of a Contemporary Rural Community: The Old Order Amish of Lancaster County, Pennsylvania* (Washington, 1942), pp. 15–16, 41.

[294]Willard Range, *A Century of Georgia Agriculture, 1850–1950* (Athens, 1954), pp. 118–119, 134–135, 152–153, 224, and chapter 15.

[295]W. E. Burghardt DuBois, "The Negro Landholder in Georgia," *Bulletin of the Department of Labor,* 35 (July, 1901), pp. 667–669; Rupert B. Vance, *Human Factors in Cotton Culture* (Chapel Hill, 1929), an excellent book, see particularly pp. 31–77; Arthur Raper, *Tenants of the Almighty* (New York, 1943), pp. 77–79, 88–90, 325–334, 369–370.

tions, where as a form it is far from moribund. On the small southern holding, material folk culture survives best —survives not as an irrational vestige, but because it is what the farmer is accustomed to and works best with, and because it continues to make sense in a setting where, though money is scarce, people are not desperately poor. Many a southern farmer—black or white, from hills or low country—still uses an A harrow to "scratch up" his land after it has been plowed (Fig. 57). These triangular harrows were known in the Middle Ages[296] and have been used to the present in odd corners of Western Europe.[297] They were still being employed by progressive American farmers at the beginning of the nineteenth century,[298] but, with the admission that the harrow "is an imperfect machine in any form of which we can construct it,"[299] the agricultural engineers experimented with improvements on the old harrow type in the first half of the 1800's[300] and after the

[296]G. W. B. Huntingford, "Ancient Agriculture," *Antiquity*, VI:23 (1932), p. 334.

[297]Ian Whitaker, "The Harrow in Scotland," *Scottish Studies*, 2:2 (1958), pp. 157–158; Paul Scheuermeier, *Bauernwerk in Italien, der Italienischen und Rätoromanischen Schweiz* (Erlenbach and Zurich, 1943), pp. 93, 249.

[298]R. K. Meade, "Mode of Cultivating Indian Corn. Harrows," *Memoirs of the Philadelphia Society for Promoting Agriculture*, IV (1818), pp. 184–187.

[299]David Low, "The Harrow," *The Cultivator* (August, 1835), p. 87.

[300]James M. Garnett, "Improved Harrow," *The American Farmer*, I:14 (July 2, 1819), p. 112; "The Harrow," *Monthly Journal of Agriculture*, I:2 (June, 1846), pp. 591–593; *The Genesee Farmer*, X:4 (April, 1849), p. 84; Martin Doyle, *A Cyclopedia of Practical Husbandry and Rural Affairs in General* (London, 1851), pp. 272–273;

Civil War replaced it with modern spring and disc harrows.[301] Because it was not patented and could be cheaply home made, the A harrow was still being recommended by some at the end of the nineteenth century.[302] On a small piece of land, today, a mule-drawn wooden harrow, though more than a century out of vogue, is better—objectively better—than a complex steel harrow dragged along by a heavy expensive tractor: it does not pack the earth so hard that plowing becomes difficult, it does the job slowly but efficiently, and can be locally made, procured by barter, and home repaired.

 NONREGIONAL PATTERNS

Material folk culture must not be considered in regional terms alone, for some material does not affect the regions within which it naturally exists. The immigrants who have arrived since the second quarter of the nineteenth century have not usually altered the regions laid out by the immigrants who came before the Revolution; rather, they have produced fascinating pockets and then often gone on to become more solidly a part of the Ameri-

David A. Wells, *The Year-Book of Agriculture* (Philadelphia, 1856), pp. 95–96.

[301]"Improvements in Harrows," *The Cultivator and Country Gentleman,* LV:1954 (July 10, 1890), pp. 550–551; "Harrows and Harrowing," *American Agriculturist,* XXXIX:5 (May, 1880), p. 188.

[302]George A. Martin, *Farm Appliances. A Practical Manual* (New York, 1892), pp. 51–52.

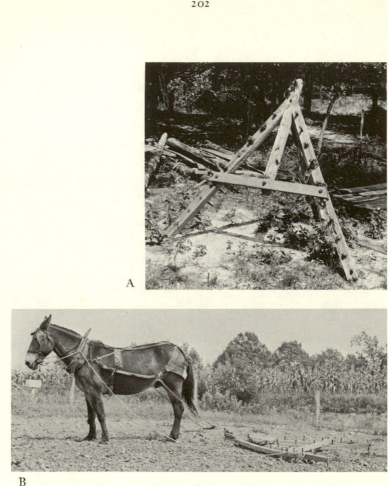

A

B

FIGURE 57

THE TRIANGULAR HARROW

A. "Rake"; west of Orchid, Louisa County, Virginia (August, 1966). B.
"Rake"; south of Cuckoo, Louisa County, Virginia (August, 1966). C.
Model of an "A drag" made by Roy Harris, Hindsville, Madison
County, Arkansas, private collection of Ralph Rinzler, Office of Per-
forming Arts, Smithsonian Institution, Washington, D.C. The harrow

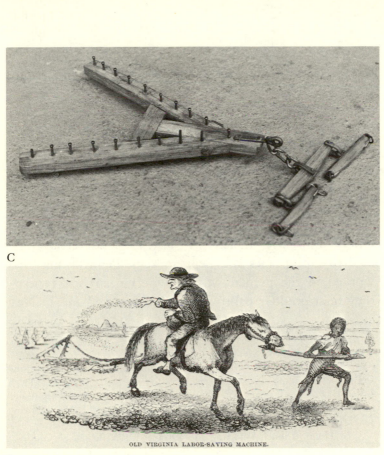

C

D

OLD VIRGINIA LABOR-SAVING MACHINE.

proper measures about seven and one-half inches long; the teeth are brads; the other metal parts are hand forged. D. From "A Winter in the South," *Harper's New Monthly Magazine*, XV:LXXXVIII (September, 1857), p. 436. The article which this engraving accompanies is a description of the family and travels of Squire Broadacre, an educated and content Virginia farmer. Once when traveling by boat to Richmond, "the Squire made acquaintance with a gentleman who occupied an adjoining seat, and they got into a discussion on the subject of agricultural improvement, the stranger advocating, and the Squire condemning, the introduction of certain labor-saving machines. . . ."

can way of life than many whose ancestors arrived in the seventeenth century. The people who came from farming villages in the foothills of the Carpathian Mountains in northeastern Hungary to settle in a Pennsylvania coal mining town around 1910 have become almost completely acculturated; a few, though, continue to make *paskas* during the Easter season, which are loaves of bread decorated with crosses and braids formed out of pliable dough.[303] In Wisconsin,[304] Missouri,[305] and central Texas,[306] nineteenth-century Germans built of brick-nogged half-timber in the Old World style. Italians in New England terraced the land to raise grapes and peppers;[307] in Pennsylvania they worked in the garden with Mediterranean hoe types;[308] they built outdoor bakeovens in Louisiana;[309] and in New

[303]John Kaminsky, "Carpatho-Slav Culture and Culture Change in St. Clair, Pennsylvania," unpublished master's thesis, Pennsylvania State College (August, 1951), pp. 25–26, 67, 72, 81.

[304]Richard W. E. Perrin, "'Fachwerkbau' Houses in Wisconsin," *Journal of the Society of Architectural Historians*, XVIII:1 (March, 1959), pp. 29–33; Richard W. E. Perrin, "German Timber Farmhouses in Wisconsin," *Wisconsin Magazine of History*, XLIV:3 (Spring, 1961), pp. 199–202.

[305]Henry Lionel Williams and Ottalie K. Williams, *A Guide to Old American Houses, 1700–1900* (New York, 1962), p. 95.

[306]Terry G. Jordan, "German Houses in Texas," *Landscape*, 14:1 (Autumn, 1964), pp. 24–26; Marvin Eickenroht, "The Kaffee-Kirche at Fredericksburg, Texas, 1846," *Journal of the Society of Architectural Historians*, XXV:1 (March, 1966), pp. 60–63.

[307]Clifton Johnson, *Highways and Byways of New England* (New York, 1921), pp. 256–257.

[308]Clement Valetta, "Italian Immigrant Life in Northampton County, Pennsylvania, 1890–1915, Part II," *Pennsylvania Folklife*, 15:1 (Autumn, 1965), p. 42.

[309]Fred Kniffen, "The Outdoor Oven in Louisiana," *Louisiana History*, I:1 (1960), p. 34.

Orleans for St. Joseph's Day people of Italian heritage still erect altars on which special types of bread, Italian and Louisianan delicacies, icons, and bowls of lucky beans are displayed.[310] Dutch settlers in Michigan wore the same kinds of clothes that they did in Holland: inside, the women wore white caps which they covered with dark bonnets out of doors, and the men roved out in baggy pants.[311] Outdoor bakeovens were built by Latvians in Mississippi[312] and by Belgians in Wisconsin.[313] Scots from Nova Scotia settled in western Maryland and hooked rugs very different from those of their neighbors.[314] Finns in New England wove baskets of birch bark;[315] in the Great Lakes area[316] and in western Pennsylvania[317] they built

[310]Lyle Saxon, Edward Dreyer, and Robert Tallant, *Gumbo Ya-Ya* (Boston, 1945), chapter 5. The tradition was still going strong in 1964.

[311]Alieda J. Pieters, *A Dutch Settlement in Michigan* (Grand Rapids, 1923), p. 101.

[312]Rudolf Heberle and Dudley S. Hall, *Displaced Persons in Louisiana and Mississippi* (Baton Rouge, 1950), pp. 60–61.

[313]Fred L. Holmes, *Old World Wisconsin* (Eau Claire, 1944), p. 164, photo after p. 134.

[314]John Ramsay, "A Note on the Geography of Hooked Rugs," *Antiques*, XVIII:6 (December, 1930), pp. 510–512.

[315]Allen H. Eaton, *Handicrafts of New England* (New York, 1949), pp. 55–56.

[316]Richard W. E. Perrin, "Log Sauna and the Finnish Farmstead: Transplanted Architectural Idioms in Northern Wisconsin," *Wisconsin Magazine of History*, XLIV:4 (Summer, 1961), pp. 284–286; Cotton Mather and Matti Kaups, "The Finnish Sauna: A Cultural Index to Settlement," *Annals of the Association of American Geographers*, 53:4 (December, 1963), pp. 494–504; John I. Kolehmainen and George W. Hill, *Haven in the Woods* (Madison, Wis., 1956), pp. 37, 86.

[317]MacEdward Leach and Henry Glassie, *A Guide for Collectors of Oral Traditions and Folk Cultural Material in Pennsylvania* (Harris-

saunas for bathing. Others from the Fennoscandian peninsula who settled in the Great Lakes area made flat bread and distinctive cheeses,[318] carved log barrel chairs,[319] and employed horizontal log construction[320] quite different from the Central European-derived American type.

Unlike the Amish, who carefully display their nonconformity to the world, most contemporary Americans of recent immigrant background conform outwardly and carry private traditions which will not segregate them from the larger society. The strongest ethnic tradition, accordingly, is a language other than English, spoken only in the home or at the club, and the only material tradition which persists with strength is cookery.[321] Although changed in America as a result of the availability of new ingredients and existing side by side in the diet with

burg, 1968), p. 55. The information comes originally from the W. P. A. Job No. 126, "Racial Backgrounds in Lawrence County," (May 18, 1939), part II, chapter IV, p. 3, an unpublished manuscript deposited in the State Archives of Pennsylvania.

[318]Erna Oleson Xan, *Wisconsin My Home* (Madison, 1952), pp. 52–56, 105.

[319]Erwin O. Christensen, *Early American Wood Carving* (Cleveland and New York, 1952), p. 95.

[320]Richard W. E. Perrin, "John Bergen's Log House," *Wisconsin Magazine of History*, XLIV:1 (Autumn, 1960), pp. 12–14; Richard W. E. Perrin, "Log Houses in Wisconsin," *Antiques*, LXXXIX:6 (June, 1966), pp. 867–871.

[321]Cf. Robert I. Kutak, *The Story of a Bohemian-American Village* (Louisville, 1933), pp. 67–68; Peter Paul Jonitis, "The Acculturation of the Lithuanians of Chester, Pennsylvania," unpublished doctoral thesis, University of Pennsylvania (1951), pp. 300–302, 464–465; Herbert J. Gans, *The Urban Villagers: Group and Class in the Life of Italian-Americans* (New York, 1966), p. 33.

American foods,[322] the Old World cuisine is often consciously maintained as a component of ceremony and a quiet symbol of the ethnic group. Mrs. Marie Kocyan, who came as a young woman in 1912 to the Polish community in Wilkes-Barre, Pennsylvania, describes the customs observed by her family at Christmas:

> For Christmas we start off at the first star—shines in the sky—and we all gather in the dining room and have these wafers like Christ at His last supper. It's unleavened bread, and each one of us take his unleavened bread and wishes—the older people first and the husband, and all the children with their husbands and then the little children; they go down the line. And that's a fine moment where we wish each other everything the best for the coming year. And there's also an empty chair for a traveler that might have no place to go—it's ready for anyone who comes, which represents Christ. These are very fine moments of Christmas. Then we start with the soup and then go down to the cold fish and poppy seed cake or whatever we happen to have. Then regular Christmas is an afterthought, and the turkey. . . . One of the typicals that we celebrate is imported mushroom soup [on] Christmas Eve. And the mushrooms are very expen-

[322]Cf. Pauline V. Young, *The Pilgrims of Russian-Town* (Chicago, 1932), pp. 24-26, 222; Francis Anthony Ianni, "The Acculturation of the Italo-Americans in Norristown, Pennsylvania: 1900 to 1950," unpublished doctoral dissertation, Pennsylvania State College. (August, 1952), pp. 154-156, 206, 216.

sive, so we have it just once a year. And we like them when they are sent direct to us from Poland 'cause they taste entirely different than other countries'. . . . [The fish] is a pike that's skinned and the meat is chopped up and it's stuffed back again into the pike. It's steamed in a very low oven—I always go into the cooking, I'm sorry—go into a very low oven and then the meat that is chopped up you give equal parts of onions chopped up real fine. And then you put yolks of eggs and whole eggs to hold it together and a little bit of crumbs, and with that you stuff the skin, sew it, and then twist it into your roaster and steam it on very, very low heat for hours. . . . Then, you serve it with whipped cream and horse radish. O, and, of course, you have to have a dill. You have to have some carrots. You have to have all the green stuff that will give a nice taste to the fish. . . . The most popular cake is the cake that has poppy seed in it. . . . The poppy seed is ground, then it's creamed, yolks of eggs and raisins are put in, and you cover this dough like you make for any other cake and then roll it up and bake it.[323]

Off a back road in the hills of central New York, near an abandoned shed and the charred ruins of a house,

[323]Mrs. Marie Kocyan; tape-recorded interview, May 24, 1967. Mrs. Kocyan was born in Warsaw in 1895. She and her husband, an intellectual doctor who is also of Polish heritage, are devoted to the history and welfare of the Polish people, most of them originally dependent upon the coal mines for their living, in the Wilkes-Barre area.

sits a corncrib (Fig. 58). Its basic form—rectangular
floor plan, gable-end door, one side which flares outward
—is the same as that of many corncribs found in Pennsyl-
vania and the North.[324] But, on one side was a lean-to
which stretched to the gound and the whole was thatched
with grass about eight inches deep, laid over a single layer
of cornstalks, laid over round narrow purlins, nailed to
hewn beech rafters. Thatching, which is found through
most of Europe,[325] was employed by the early settlers in
the Tidewater[326] and New England,[327] but was quickly
replaced by the alternate British roofing tradition of
wooden shingles. Thatching lasted longer in the Mid-
Atlantic region and a very few examples could be found
there at the beginning of our century.[328] There are still

[324]Examples in which only one side flares outward may be found
in the North; much more common are keystone corncribs or granaries
on which both sides flare outward, see Lewis F. Allen, *Rural Architec-
ture* (New York, 1852), pp. 343–344 (Allen considers the type "old
fashioned"); Amos Long, Jr., "Pennsylvania Corncribs," *Pennsylvania
Folklife*, 14:1 (October, 1964), pp. 16–23.

[325]C. F. Innocent, *The Development of English Building Con-
struction* (Cambridge, 1916), pp. 188–222.

[326]Forman, *The Architecture of the Old South*, pp. 15, 155. A
mid-nineteenth century thatched English barn in the Tidewater can be
found in Edwin Hemphill, "Why Barns?—Then and Now," *Virginia
Cavalcade*, VII:3 (Winter, 1957), p. 18.

[327]Hugh Morrison, *Early American Architecture From the First
Colonial Settlements to the National Period* (New York, 1952), p. 35.

[328]Clifton Johnson, *Highways and Byways from the St. Law-
rence to Virginia* (New York, 1913), p. 254; Alfred L. Shoemaker,
"Straw Roofs in the Pennsylvania Dutch Country," *The Pennsylvania
Dutchman*, II:1 (May 1, 1950), p. 3; Stevenson Whitcomb Fletcher,
Pennsylvania Agriculture and Country Life, 1640–1840 (Harrisburg,
1950), pp. 82–83; Alliene Saeger De Chant, *Down Oley Way* (Kutz-
town, 1953), p. 34.

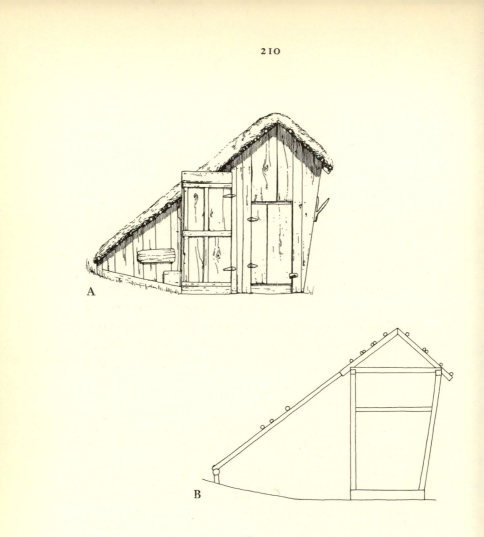

FIGURE 58

THATCHED CORNCRIB

A. Front view. The shed had fallen in before the building was dis-
covered, but the parts were there to be seen, and this is a not-too-
conjectural restoration. B. Cross-section. C. Plan. D. Plan of the roof of
the crib showing the positions of the purlins and the rafters. E. Detail
of the thatching. The building is located northeast of Whig Corners,
Otsego County, New York (March, 1965).

C

D

E

thatched barns in Quebec,[329] and a few roughly thatched open sheds—pigsties, mostly—exist in the Piedmont of Virginia and the Ohio Valley,[330] but a neatly thatched building in normally progressive central New York is a surprise. It might be explained as a survival of a seventeenth-century New England tradition; however, the man who rented the land to the corncrib builder remembers that it was constructed about thirty years ago "by a Yugoslav or a Pollack, some old duffer from the old country. It doesn't conform to anything around here, but you could point out that some of the Old World did arrive over here."[331]

The student of folklife does not study primitive—nonliterate—societies;[332] yet, he cannot ignore them. Prim-

[329]Robert-Lionel Séguin, *Les Granges du Québec du XVIIe au XIXe siècle* (Ottawa, 1963), pp. 42–48.

[330]Johnson, *Highways and Byways of the South*, pp. 196, 229, 235. Half a century later I have found quasithatched pigsties in the same areas—north of Rixeyville, Culpeper County, Virginia (July, 1962), west of Yellow Springs, Greene County, Ohio (August, 1963), for examples—and only in those general areas. In September 1967 I noted a number of pigsties roofed with pine boughs in the Carolina Tidewater and one south of Glennville, Tattnall County, Georgia, covered with Spanish moss.

[331]Ray Rogers; interview at his home between Whig Corners and Middlefield Center, Otsego County, New York, August 8, 1966.

[332]Cf. John Greenway, "Folksong as an Anthropological Province: The Anthropological Approach," in Mody C. Boatright, Wilson M. Hudson, and Allen Maxwell, eds., *A Good Tale and a Bonnie Tune* (Dallas, 1964), pp. 210–211; Robert Wildhaber, "A Bibliographic Introduction to American Folklife," *New York Folklore Quarterly*, XXI:4 (December, 1965), p. 276.

itive culture can influence folk culture (as the quickest glance at American traditional foods will attest), but more important is the fact that as a result of acculturation primitive societies can reach a status quo of partial assimilation which brings them within the realm of folklife and makes the traditional, nonpopular aspects of their culture (many of which were formerly primitive) folk. Most of the Indians of the eastern United States are gone—gone West, gone into the society of the popular culture, or just gone —but some in New York, in Florida, have achieved some cultural stability and formed islands within their regions.

In east-central Mississippi dwell about 3200 Choctaw,[333] the descendents of those who refused to be removed to Oklahoma with most of the Choctaw after the Treaty of Dancing Rabbit Creek in 1830,[334] and refused again in 1903, when many more left after the government rediscovered them and renewed pressure.[335] Their culture is a mixture of aboriginal, nineteenth century southern, contemporary American, and (in, for example, current beadwork) Pan-Indian elements; the proportions in the combination vary among the seven Mississippi Choctaw communities. Almost all the men are farmers: many have

[333]*The Mississippi Choctaw Indians* (Philadelphia, n.d.), p. 4. I visited among the Choctaw in August, November, and December of 1963.

[334]Grant Forman, *The Five Civilized Tribes* (Norman, Okla., 1934), pp. 71–76.

[335]*The Ninth Annual Report of the Commission to the Five Civilized Tribes to the Secretary of the Interior for the Fiscal Year Ended June 30, 1902* (Washington, 1902), p. 24; *Sixth Annual Report* (1899), pp. 17–18; *Eleventh* (1904), pp. 18–19.

small independent farms with some acreage in cotton, a few raise livestock, others are sharecroppers on the farms of their white neighbors, and some work in the pine forests. Their architecture, like their agriculture, is typical of the Anglo-American Deep South (Fig. 59). The men dress like other Mississippi farmers; the older women, however, make, embroider, and wear traditional dresses of a long and full mid-nineteenth century cut. Some songs and dances are still accompanied by striking sticks and several old men continue to make the small hand drums which are played before and during the traditional stickball game.[336] Although over a century old, George Catlin's description of the sticks used in the game remains completely applicable:

> The sticks with which this tribe play, are bent into an oblong hoop at the end, with a sort of slight web of small thongs tied across, to prevent the ball from passing through. The players hold one of these in each hand, and by leaping into the air, they catch the ball between the two nettings and throw it, without being allowed to strike it, or catch it in their hands.[337]

In addition to making their own sticks, the modern players often go barefoot as their ancestors did, although they wear bright, satiny softball uniforms. The modern dyed,

[336]For Mississippi Choctaw musical instruments: Frances Densmore, "Choctaw Music," *Anthropological Papers, 28*, B. A. E. Bulletin, 136 (Washington, 1943), pp. 117–118, 120, 128–130.

[337]George Catlin, *Illustrations of the Manners, Customs, and Conditions of the North American Indians*, II (London, 1851), p. 124.

FIGURE 59

CHOCTAW LOG CABIN

This cabin, inhabited by a Choctaw Indian, is located south of Philadel-
phia, Neshoba County, Mississippi (November, 1963). It displays many
of the features common to folk houses of the Deep South: it has a
front porch and rear kitchen shed; its roof extends to cover the ex-
ternal gable end chimney of brick; it is supported by piers rather than
a full foundation, and it is built of small pine logs, split in half, the
round side facing outwards, with boards nailed vertically to the insides
of the logs in lieu of chinking.

split cane baskets (Fig. 60) follow the precontact patterns of the Indians of the Southeast.[338] During the nineteenth century these were made by the women for trade to their white neighbors;[339] now they are marketed over great distances through an arts and crafts organization.

The traditional houses and industries in most villages and many small towns, in New England especially, are consistent with those of the countryside, making such aggregates of people and services integral to the regions within which they exist. But cities, generally, are culturally related less to the rural areas which surround them than to other, often distant, cities and are, therefore, foreign outposts within folk regions. Material folk culture, with the constant exception of cookery, thrives less well in an urban environment than oral traditions do; still, there are distinctive metropolitan material folk traditions—the results of migration between urban centers and the very nature of city living.

City children, among whom the folklorist has long collected, possess a body of material culture. Of the

[338]See Otis Tufton Mason, *Indian Basketry*, II (New York, 1904), pp. 290–291; Frank G. Speck, "Decorative Art and Basketry of the Cherokee," *Bulletin of the Public Museum of the City of Milwaukee*, II:2 (July 27, 1920), pp. 60, 65–66; John R. Swanton, *Source Material for the Social and Ceremonial Life of the Choctaw Indians* (Washington, 1931), pp. 40–41; John R. Swanton, *The Indians of the Southeastern United States* (Washington, 1946), pp. 604–608.

[339]Thelma V. Bounds, *Children of Nanih Waiya* (San Antonio, 1964), pp. 4, 52, 61.

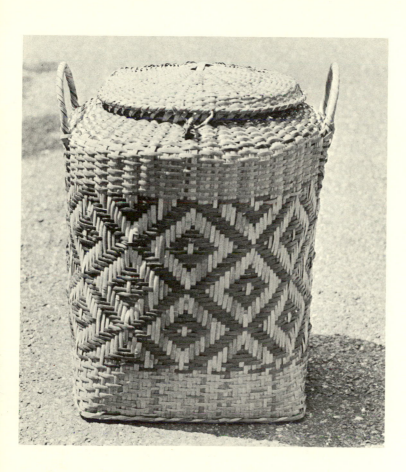

FIGURE 60

CHOCTAW BASKET

Dyed, split cane basket made for sale at the Choctaw Fair, which takes place in August at about the same time as the old green corn festival; west of Philadelphia, Neshoba County, Mississippi (August, 1963).

flotsam of the streets and back alleys, Philadelphia boys construct a variety of traditional weapons: bows and arrows, "top shooters," bolas, slingshots with subtypes for bobby pins or rocks (Fig. 61), spears, whips, slings, and—when they are a little older—zip guns. A coat hanger after a little bending becomes a "key" with which simple locks can be jimmied. With found paint, the boys mark the guidelines for traditional street games.

The usual American folk house has its door in the side—not in the gable—and is oriented with that door toward a road, lane, or waterway. The adaptation of one of these rural types to an urban situation often yields a house built with its gable to the street (as I houses were in Charleston, South Carolina[340]), or with the front door through its gable end. In southern Louisiana and from there along the Gulf Coast, a common folk house type is the shotgun—a one-story, one-room wide house with its front door in the gable end. The shotgun may have developed out of the dwellings of the Indians or the Haitian slaves;[341] it almost surely developed without European antecedents in the coastal bayou country. Although born in the country, the shotgun house was well suited to urban life; it is found, as a result, quite commonly in New Orleans and in the poorer (mostly Negro) sections of towns in the Deep South, at least partially because it appeared practical to those who designed the company housing for

[340]See Morrison, *Early American Architecture*, pp. 415–416.
[341]Fred Kniffen, "The Physiognomy of Rural Louisiana," *Louisiana History*, IV:4 (Fall, 1963), pp. 293–294.

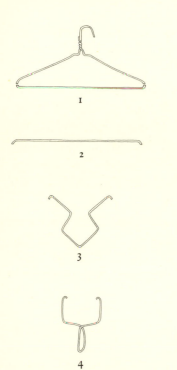

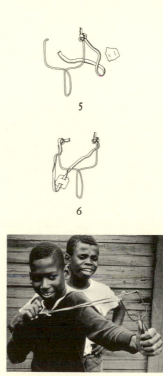

FIGURE 61

SLINGSHOT

Piggy Becket and Lenny Divers, West Philadelphia, Pennsylvania, begin making a slingshot by finding a coat hanger. The bottom of the hanger is cut off (1,2), bent (3), and "crossed" (4). A large rubber band is tied to one arm (5); a "patch" cut from an inner tube is slipped on, and the rubber band is tied to the end of the other arm. The tops of the two arms are clinched down over the knots in the rubber band (6) and within fifteen minutes a slingshot for "light stones," bits of brick and cement block, is ready for use. In the photograph, Piggy, with Lenny looking on, demonstrates the springy, efficient weapon's handling (September, 1966).

mill workers. The New Orleans examples illustrate the kinds of variation engendered by the transfer of a rural house type to the city. The front porch, almost always present on country shotguns, is often missing and steps lead from the front door directly to the sidewalk (Fig. 62B). Addition after handmade addition is often tacked onto its rear (Fig. 62A); the last in line may be two stories high, giving the house the name of "camel-" or "humpback." Shotgun houses may be built to fill an oddly shaped lot and have, therefore, eccentric floor plans with front and rear or side walls which are not parallel. A few have been built a full two stories high and two may be built side by side with a common roof and central wall or an open, narrow bricked passage between them (Fig. 62B).

The reverse of material which does not fit into regional patterns because of its erratic or local distribution is that which is nonregional by virtue of its being found commonly in all regions. The various regions, for instance, share the same quilt patterns—the log cabin quilt is basically the same and carries the same name throughout the eastern United States (Fig. 63).[342] This uniformity oc-

[342]See Marie D. Webster, *Quilts* (Garden City, 1928), facing p. 118; Ruth E. Finley, *Old Patchwork Quilts* (Philadelphia and London, 1929), plates 2–3; Carrie A. Hall and Rose G. Kretsinger, *The Romance*

A

B

FIGURE 62

SHOTGUN HOUSES

A. Shotgun house with rear additions, Simon Bolivar and Jackson, New Orleans, Orleans Parish, Louisiana (November, 1962). B. Pair of shotgun houses with a common roof and open passage between them, Sixth Street, New Orleans, Orleans Parish, Louisiana (November, 1963). The hip roof so common on shotguns (B and the house to the right in A) seems to connect the type with the Caribbean. The close association of the shotgun house with the Negro, not only in the Deep South but also up the Mississippi and Ohio Valleys (it is common in the black neighborhoods of Louisville, Kentucky, for example), might also suggest something about its origin. For other examples, see the background of Fig. 35A.

FIGURE 63

THE LOG CABIN QUILT

A. East of South Edmeston, Otsego County, New York (November, 1964). B. At Allen, southeast of Carlisle, Cumberland County, Pennsylvania (March, 1968). C. Near New Baltimore, north of Warrenton, Fauquier County, Virginia (August, 1965).

curred when a powerful influence—usually a popular one
—acted to bring the local traditions into conformity or
when the same tradition was brought by most of the early
settlers. Until about 1840, the same tools and technology
were used in all of the regions for splitting shingles: the
wood was split with a froe struck by a club and twisted;
the resultant rough board was clamped in the jaws of a
shaving horse and smoothed down with a drawshave (Fig.
64).[343] Exactly these tools and methods were employed in
Britain, France, and Central Europe.[344]

of the Patchwork Quilt in America (New York, 1935), plates II,
XLVII, LXII; Marie Knorr Graeff, *Pennsylvania German Quilts* (Ply-
mouth Meeting, 1946), p. 18; Elizabeth Wells Robertson, *American
Quilts* (New York, 1948), pp. 86–89; Lilian Baker Carlisle, *Pieced Work
and Applique Quilts at Shelburne Museum* (Shelburne, 1957), pp. 26–29;
Marguerite Ickis, *The Standard Book of Quilt Making and Collecting*
(New York, 1959), pp. 86–87; Lydia Roberts Dunham, Florence Haslett,
and Cile M. Bach, *Denver Art Museum Quilt Collection* (Denver,
1963), pp. 96–97; Averil Colby, *Patchwork Quilts* (Copenhagen, 1965),
pp. 78–79.

[343]"Making Split and Shaved Shingles," *American Agriculturist*
XXXVIII:6 (June, 1879), p. 223; Mercer, *Ancient Carpenters' Tools*,
pp 11–16; Stephen C. Wolcott, "The Frow—A Useful Tool," *The
Chronicle of the Early American Industries Association*, I:6
(July, 1934), pp. 1, 3; Frank H. Wildung, *Woodworking Tools at
Shelburne Museum* (Shelburne, 1957), pp. 1, 54–55; Harriette Simpson
Arnow, *Seedtime on the Cumberland* (New York, 1960), pp. 263–265;
Bradford Angier, "Shake Roof," *The Beaver*, Outfit 293 (Spring, 1963),
pp. 52–53; Eric Sloane, *A Museum of Early American Tools* (New
York, 1964), pp. 30–35, 38–39.

[344]H. L. Edlin, *Woodland Crafts in Britain* (New York, 1949),
pp. 13–15, 94, 98; F. Lambert, *Tools and Devices for Coppice Crafts*
(London, 1957), pp. 20–25, 32–33; H. Bichsel, "Das Schindeln," *Schwei-
zer Volkskunde*, 30:1 (1940), pp. 1–3; Štefan Apáthy, "Šindliarstvo v
okolí Bardejova," *Slovenský Národopis*, II:1–2 (1954), pp. 65–93.

FIGURE 64

SHINGLE MAKING TOOLS

A. Froe club, Rankin County, Mississippi, from Laurence C. Jones, *Piney Woods and Its Story* (New York, 1922), facing p. 28. B. Froe, from east of Waynesboro, Augusta County, Virginia (August, 1966). C. Drawshave, from near Livingston Manor, Sullivan County, New York (July, 1967). D. Shaving horse, southwest of Yellow Springs, Greene County, Ohio (August, 1963).

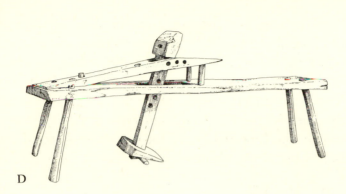

D

Those traits which were found throughout the eastern United States during the pre-Civil War period when the regions were being formed display uneven patterns of persistence which serve to reinforce the currently observable material folk culture regions. The fieldworker interviewing in upstate New York today would find that the oldest men vaguely remember that when they were young, the old men still split shingles with froe and club. The old men of southeastern Pennsylvania used the froe occasionally in their youth and can supply a complete if inactive description of the technology involved. In the South, the fieldworker need not ferret out an old man for a description, as middle-aged and younger men split and shaved shingles with regularity up until recently—with a little luck our fieldworker will come across one of those who still does. Snake, worm, or Virginia rail fences (Fig.

65) were constructed commonly before about 1850 in all of the eastern regions.[345] In the North, now, stone walls still cross the landscape and a rare vestige of a snake fence may be found. In the Mid-Atlantic region, snake fences were almost completely replaced by post and rail fences in the nineteenth century. Traditional fencing of any kind is unusual in the Lowland South today, but in some of the upland areas of the South—the Ozarks, the Blue Ridge

[345]For some material on American traditional fencing: George E. Waring, Jr. and W. S. Courtney, *The Farmers' and Mechanics' Manual* (New York, 1868), pp. 125–134; George A. Martin, *Fences, Gates, and Bridges: A Practical Manual* (Chicago, New York and Springfield, 1903), pp. 7–12; H. F. Raup, "The Fence in the Cultural Landscape," *Western Folklore*, VI (1947), pp. 1–7; Logan Esarey, *The Indiana Home* (Crawfordsville, 1947), pp. 82–83; Robert Steele Withers, "The Stake and Rider Fence," *Missouri Historical Review*, XLIV:3 (April, 1950), pp. 225–231; Mamie Meredith, "The Nomenclature of American Pioneer Fences," *Southern Folklore Quarterly*, XV:2 (June, 1951), pp. 109–151; McNall, *Agricultural History of the Genesee Valley*, pp. 87–88, 144–145, 197–198; Douglas Leechman, "Good Fences Make Good Neighbours," *Canadian Geographical Journal*, XLVII:6 (December, 1953), pp. 218–235; Eugene Cotton Mather and John Fraser Hart, "Fences and Farms," *The Geographical Review*, XLIV:2 (April, 1954), pp. 201–223; Martin Wright, "Log Culture in Hill Louisiana," unpublished doctoral dissertation, Louisiana State University (August, 1956), pp. 124–136; Harry Symons, *Fences* (Toronto, 1958); Wilbur Zelinsky, "Walls and Fences," *Landscape*, 8:3 (1959), pp. 14–20; Amos Long, Jr., "Fences in Rural Pennsylvania," *Pennsylvania Folklife*, 12:2 (Summer, 1961), pp. 30–35; Vera V. Via, "The Old Rail Fence," *Virginia Cavalcade*, XII:1 (Summer, 1962), pp. 33–40; Bogue, *Prairie to Corn Belt*, pp. 73–74, 79–80, 245, 268; T. S. Buie, "Rail Fences," *American Forests*, 70:10 (October, 1964), pp. 44–46; Austin E. Fife, "Jack Fences of the Intermountain West" in D. K. Wilgus, ed., *Folklore International* (Hatboro, Pa., 1967), pp. 51–54; Darrell Henning, "Common Farm Fences of Long Island," *Friends of the Nassau County Historical Museum Bulletin*, II:1 (Spring, 1967), pp. 6–13.

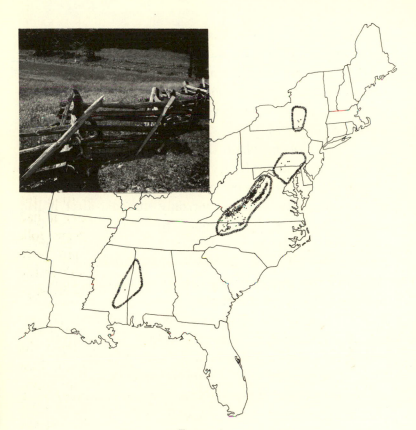

FIGURE 65

THE SNAKE FENCE

The four areas on the map were chosen to represent their regions (Fig. 9) because fieldwork within them has been thorough enough to reveal that snake fences were common within each of them during the nine-teenth century and thorough enough to indicate that the dots on the map, each standing for one fence observed between 1962 and 1968, give a fair comparative impression of the amount of extant snake fence. The photograph is of a snake fence with leaning rail supports, located south of Augusta, Hampshire County, West Virginia (June, 1964).

and Alleghenies in Virginia, especially—snake fences remain common (Fig. 65). In the Upland South snake fence subtypes may be found: some have no support at the corners so that the fence can be taken down and moved, but most have rails set in at an angle or vertical stakes at the corners to add rigidity.

The areas in which the generally possessed material persisted with strength beyond the Civil War and then World War I do not represent areas of static retention, for in them the early material not only survived after it had expired elsewhere, it continued to develop. New folk forms like the blues and the transverse-crib barn were being developed from old folk models in the South at the same time that pop song and architectural types were supplanting folk ones in the North.

The slat-back chair is a characteristic material feature of Western European folk culture,[346] and from the earliest days slat-back chairs were made all along the East Coast. The finer slat-back chairs are among the distinguishing regional traits: those of New England and New York are different from those made in New Jersey, eastern Pennsylvania, and central Maryland; the differences can be traced to the parts of England from which the early settlers came.[347] However, the squatty, simple slat-back chairs

[346]Sigurd Erixon, "West European Connections and Culture Relations," *Folk-Liv*, 1938:2, p. 157.

[347]Luke Vincent Lockwood, *Colonial Furniture in America*, II (New York, 1913), pp. 13–20; John Cummings, "Slat-Back Chairs," *Antiques*, LXXII:1 (July, 1957), pp. 60–63; Marion Day Iverson, *The American Chair, 1630–1890* (New York, 1957), chapter 9.

of the seventeenth, eighteenth, and early nineteenth centuries, which lacked turnings except for finials, were essentially the same throughout the eastern United States (Fig. 66A, B). Early in the nineteenth century mass-produced fancy chairs, which were based on the elegant English Sheraton chairs of the close of the eighteenth century[348] and which are called Hitchcock chairs after their most prominent manufacturer,[349] began filling the slat-back's role in the parlors, the kitchens and on the porches of the North. Plank chairs—late, stylish Windsor chairs which cross bred with the fancy chairs on occasion—incompletely replaced the slat-back chair in southeastern Pennsylvania at about the same time. Hitchcock shipped his chairs south, but they were never accepted there; in the South the slat-back continued as the most common type. And it continued to develop.

In the South, in about the second quarter of the nineteenth century, the slat-back chair began to be constructed with its rear posts shaved down and curved backward instead of standing up straight. The resultant type is often aptly termed a "rabbit-" or "mule-ear" (Fig. 66D–F).

[348]Emilie Rich Underhill, "Our Fancy Chairs Adopt Sheraton Details," in Zilla Rider Lea, ed., *The Ornamented Chair. Its Development in America (1700–1890)* (Rutland, 1960), pp. 35–39. Read the "Fancy Furniture" chapter in Charles F. Montgomery's superb *American Furniture: The Federal Period* (New York, 1966), and see particularly examples 468, 469, 470, 473, and 490.

[349]Esther Stevens Brazer, "Random Notes on Hitchcock and His Competitors," in Alice Winchester, ed., *The Antiques Book* (New York, 1950), pp. 135–142; J. R. Dolan, *The Yankee Peddlers of Early America* (New York, 1964), pp. 126–129.

A

C

B

FIGURE 66

SLAT-BACK CHAIRS

A. Slat-back chair, from Middletown, Massachusetts, private collection of Marilyn Kimball of Oxford, Ohio. B. Slat-back chair, south of Orchid, Louisa County, Virginia (August, 1966). C. Square-post slat-back chair, southeast of Gum Spring, Louisa County, Virginia (August, 1966). D. Mule-ear slat-back chair, north of Alpharetta, Fulton County, Georgia (November, 1966). This is the form the mule-ear chair takes most commonly throughout the South. E. Mule-ear, slat-back chair, from near Louisa, Louisa County, Virginia (August, 1966). The mule-

D

F

E

ear chairs found from the Coast, across the Blue Ridge, into the Valley
in Virginia take this form. Often the rear posts are exotically formed,
the post being much smaller in diameter above the line of the seat than
it is below; the rear posts are occasionally banded or deeply scored; in
a few rare instances they have strange finials perched on the top. Two
chairs of exactly this subtype were among the few ties to southern folk
culture in evidence at Resurrection City of the Poor People's Campaign
in Washington, D.C. (May–June, 1968). F. Mule-ear slat-back chair, in
Paxville, Clarendon County, South Carolina (September, 1967). Such
chairs are commercially distributed throughout the Lowland South;
their commercial nature affects neither positively nor negatively their
folk nature.

This improvement in comfort, which inspired its Southern Mountain name, "settin' chair," seems to have been a response to influence coming from the fancy chairs, the backs of which were similarly bent. Possibly, the fancy chair's influence was seconded by the square-post slat-back with tapered rear posts, a folk type found widely in Europe since the Middle Ages, rarely in New England,[350] commonly in Quebec and eastern Ontario,[351] and occasionally in eastern Virginia (Fig. 66C). Because the antiquarians who have been entrusted with American furniture scholarship have been bound by a curious combination of aesthetic and economic factors which render a piece desirable and collectable, little has been published on the mule-ear chair.[352] It seems to have begun to

[350]Irving Phillips Lyon, "Square-Post Slat-Back Chairs: A Seventeenth Century Type Found in New England," *Antiques*, XX:4 (October, 1931), pp. 210–216.

[351]Jeanne Minhinnick, *Early Furniture in Upper Canada Village* (Toronto, 1964), pp. 26–27, facing p. 1.

[352]"Country Furniture: A Symposium," *Antiques*, XCIII:3 (March, 1968), pp. 342–371, reveals that the notion of country furniture parallels that of "folk-art": it is a post facto judgment which fails to take folk cultural concepts into account and which attempts to draw the subjective perimeters of the material worth attention and preservation. The nine authorities on antiques who comprise the symposium, unlike the contributors to "What Is American Folk Art? A Symposium" (footnote 39), do reach consensus: country furniture is about what Charles O. Cornelius corralled into the "Provincial Types" chapter of his *Early American Furniture* (New York, 1926) or what Nancy Doris Palmer discusses in *The Perpetuation of Colonial Charm* (Frederick, 1928), p. 91 (!); it is nonacademic furniture, not necessarily rurally made, which echoes the academic styles of the eighteenth and early nineteenth centuries and/or has individualistic zing. Taken together, academic and country furniture, in good art historical fashion, leave out of scholarly sight most furniture.

develop as a simple slat-back with fancy chair pretensions in all of the regions, as related chairs can be found nearly everywhere in the East, but it became common only in the Midwest[353] and South. From the early nineteenth century to the present, the southern mule-ear chair has undergone continual modification so that, while the same chairs can be found throughout the South, the South's subregions also present distinctive subtypes. In eastern Virginia the chair typically has two slats—the top one about twice as wide as the one below it—and a pronounced curve to the rear posts (Fig. 66E). In the Carolina-Georgia Tidewater and through much of the Deep South, the rear posts are curved but little; in some instances they are not bent but only shaved down, and many late chairs have exactly the mule-ear proportions, though the posts are neither shaved nor bent. These chairs usually have three slats, the top one of which may be arched or notched (Fig. 66F). The mountain mule-ear has moderately bent rear posts and, typically, three slats of about equal size and shape. The mule-ear settin' chair is still made in little country shops throughout the South, especially, but by no means exclusively, in the Southern Appalachians[354] and the Ozarks.[355]

[353]Examples are pictured in Ralph and Terry Kovel, *American Country Furniture, 1780–1875* (New York, 1965), pp. 92–98.

[354]See Allen H. Eaton, *Handicrafts of the Southern Highlands* (New York, 1937), pp. 150–161; Ralph Erskine, "Adventures Among the Mountain Craftsmen," in Roderick Peattie, ed., *The Great Smokies and the Blue Ridge* (New York, 1943), pp. 200–203; John Parris, *My Mountains, My People* (Asheville, 1957), pp. 41–43.

[355]John Robert Vincent, "A Study of Two Ozark Woodworking Industries," unpublished master's thesis, University of Missouri (June, 1962), chapter II.

Today's southern chairmaker turns the posts green so that they will shrink over the rounds and hold the chair together without glue. The rear posts are flattened with a drawshave, soaked or steamed, bent and placed into drying racks to attain their distinctive contour. The seat, depending upon where the chair is put together, is made of a plank, bent slats, hide, corn shucks, twine, or white oak splints, the inner bark of the hickory tree, thick paper strips purchased at a cotton mill, leather thongs, rope, or strips of inner tube woven in a twill pattern.

 CONCLUSIONS

In cities and among groups which settled in the East before Jamestown and after Appomattox, material folk culture can be found which does not affect the broad spatial patterns, but an examination of the material traditions of the eastern United States leads to the recognition of three major divisions: North, Mid-Atlantic, South (Figs. 7–9). There are traits which bind the South together—external gable-end chimneys and cloth bonnets worn by women while gardening would be examples—but the South separates into two basic regions: Upland and Lowland. The folk culture of the Upland South is a combination of English Chesapeake Tidewater, and German, Scotch-Irish and English Pennsylvania elements. Distinct Upland subregions can be established through an analysis of the proportion of Pennsylvania to Tidewater elements

among the characteristic traits; ranging the subregions
from that with the highest proportion of traits with a
Pennsylvania provenance to that with the lowest, these
are: the Valley of Virginia, the Alleghenies and Blue
Ridge, the Piedmont, the Ozarks, and the Tennessee Val-
ley-Bluegrass. The Lowland South consists basically of the
English Tidewater from southern North Carolina south
around the coast to Louisiana and its Upland-influenced
inland extension, the Deep South. Peripheral are French
Louisiana and the Chesapeake Tidewater.

Southern Pennsylvania with neighboring New Jer-
sey, Delaware, and Maryland is the smallest though per-
haps most influential of the material folk culture regions.
While its traits are Continental as well as British in origin,
it is a consistent American region. The least complicated
region is the North, for it represents the logical westward
projection of English New England. The North consists
of a series of indistinct subregions: southern and eastern
New England; northwestern New England, New York,
and northern Pennsylvania; and the Great Lakes area. The
eastern Midwest north of the South and south of the
North is a conglomerate of detached Upland South,
North and Mid-Atlantic pockets—a pattern which con-
trasts with the blend of different folk cultures which pro-
duced consistent new regions in the South.

Studies of individual material items reveal temporal
patterns, but the separate chronological lists of folk objects
do not correlate neatly as those of popular objects do.
Change within the material folk culture of the eastern

United States has been incessant, but it has been slow and has not led in a single direction: internal change has led simultaneously toward more and less standardization, more and less provincialism: the overall effect has been one of stability. However, popular influences coming from without have imposed a temporal pattern over material traditions. In general, the amount of material folk culture—the proportion of any group's material culture which can be qualified "folk"—has been decreasing since the eighteenth century. This decline has been accelerated during certain periods: the mid-eighteenth century, stretching from the 1730's in English areas to the 1760's in German Pennsylvania; the mid-nineteenth century, ranging from the 1830's in New England to the 1860's in the South; and the time of World War I. After the middle two quarters of the eighteenth century, when scientific agriculture and classically inspired architecture reached beyond the aristocracy, all of the regions included some folk-popular mixtures among their distinguishing traits. But, it was not until after the traditional cultures in the East had had over a century to settle into the still-dominant regions that war-supported mid-nineteenth century industrialization and urbanization resulted in the victory of popular over folk culture in the North and triggered the changes which ensured a similar situation through most of the remainder of the East by the second decade of the twentieth century. The onslaught of popular culture has left the regions with unequal shares of surviving, thriving material folk culture; from the region richest in material traditions today to that which is the poorest, they are: Upland South, Lowland

South, Mid-Atlantic, North. In those four regions the sets of conservative, deviant ideas—folk cultures—were and are fundamentally different in the ways they work and are worked upon, in the ways they reveal themselves and are allowed to show.

Material folk culture is not yet a thing of the past alone—there are informants by the thousands, artifacts by the millions waiting to be studied—but there is little place for material folk culture in our world. It cannot last. Many material traditions were developed as solutions to practical problems which no longer exist, and modern technologies provide easier solutions than folk ones do for the problems that remain. The material traditions for which a modern need can be found are few. Some material traditions are carried on despite practical reasons for their discontinuance because they remain satisfying to their practitioners. A tourist market has been found to replace a portion of the withering market for folk crafts.[356] Many ethnic groups have selected some annual customs and associated traditional foods as safe things to which they can cling in order to preserve some group identity.[357] But daily, there are fewer who can provide the fieldworker

[356]See Charles Counts, *Encouraging American Handcrafts: What Role in Economic Development?* (Washington, 1966). The directors of programs of economic assistance involving folk crafts, generally and tragically, misunderstand the folk nature and cultural significance of the traditions they are striving to manipulate; read Counts' book carefully, or see Jonathan Williams, "The Southern Appalachians," *Craft Horizons,* XXVI:3 (June, 1966), especially pp. 63–64.

[357]For example: Eleanor E. Torell, "Family Changes in Three Generations of Swedes," *American Swedish Historical Museum Year Book* (1946), pp. 74–75.

with detailed information about their material folk culture. When all the active bearers of material traditions are dead, the objects they have left behind will continue to be instructive and a century from now fieldworkers will be bringing in fresh data. But daily, there is less to study and the answers become more difficult to obtain.

The young study of American material folk culture needs students. It needs cultural geographers, folklorists, archaeologists, anthropologists, sociologists, psychologists, linguists,[358] antiquarians, and historians—local historians, social historians, agricultural historians, architectural historians, and art historians. It needs those willing to plow through early publications, those willing to prepare, circulate, and tabulate questionnaires, those willing to undertake premature surveys of the whole field—but most it needs those willing to do intensive, systematic fieldwork. The full answers to material folk culture's questions can come only after many detailed field studies of individual craftsmen, many regional studies of specific items, many local studies of types, construction, and uses have been published. The number of totally satisfactory works published to date on American material folk culture is very,

[358]Studies of oral and material traditions overlap at dialect. Students of dialect have made much use of the terminology of material objects; see: Hans Kurath, *A Word Geography of the Eastern United States* (Ann Arbor, 1949). For examples of studies of material culture which make good use of terminology, see: Abbott Lowell Cummings, *Rural Household Inventories* (Boston, 1964); G. B. Adams, "The Work and Words of Haymaking," *Ulster Folklife*, 12 (1966), pp. 66–91; 13 (1967), pp. 29–53.

very small. Without such works a complete understanding of folk culture—its definition, processes, causes, and results —is impossible, and the absence of that understanding hampers the work not only of scholars but of educators, museum personnel,[359] and social workers as well.

From its first page, this essay has consisted of conclusions and it would be even more presumptuous to offer the larger patterns which could be labeled its conclusions —the patterns which are distinctive of and unite the eastern United States. Part of the philosophical duty of the student of folk culture is to point out temporal continuities and regional differences in an attempt to balance the picture of chronological change and spatial homogeneity presented by the historian. Still, with the realization that a scholar from outside might be able to perceive them more clearly, some of the characteristics of the East might be suggested. There is, for example, the predictable emphasis

[359]Every American museum which displays some folk cultural material sorely needs the kind of research upon which the European folklife museums are based. Reports like these should inspire the American curator: A. J. Bernet Kempers, *Vijftig Jaar Nederlands Openluchtmuseum* (Arnhem, 1962); Holger Rasmussen, ed., *Dansk Folkemuseum & Frilandsmuseet: History and Activities* (Copenhagen, 1966).

on wood:[360] log and frame construction, clapboard or vertical board siding, paneled walls, shingle roofing, wood splint basketry, dugout boats and troughs, rail fencing, wooden truss and log abutment bridges, and beehives, animal traps, latches, and kitchen utensils of wood. Further, in comparison with most of the European areas from which the settlers came, there seems to be a less logical connection between form, construction, use, and environment, and a greater variety of types with less variation within type.

The New World situation also seems to involve a kind of folk culture different from that found elsewhere. Factors operative on the development of this American style "folk" include the initial contact of numerous different cultures in an environment to which none was perfectly suited; constant migration; an early change of popular society's base from country to city, farm to factory; a change in the primary cause of isolation from topography to economics; the conflict of acceptability versus practicality within differing environments and social groups; the strain within the many multicultural individuals who carry restrictive and contradictory folk and popular elements in

[360]Cf. John A. Kouwenhoven, *The Arts in Modern American Civilization* (New York, 1967), pp. 45–53; Brooke Hindle, *Technology in Early America* (Chapel Hill, 1966), p. 26. Although Kouwenhoven in a weak moment identifies his fascinating concept of "the vernacular"—the characteristically American, utilitarian aesthetic—with folk art (p. 13), both of these men recognize most clearly the importance of wood in the material *popular* culture of the United States—wooden works in mass-produced clocks, the flimsy balloon frame, for examples.

nearly equal amounts; and the consciousness of tradition which is a by-product of the pervasive mass media.

The folk cultures of the eastern United States have not been studied. American folklorists have limited their collecting and research to small areas of oral retention, have only just begun to notice material culture,[361] and have made no real motions in the direction of the complete study of folk culture. American anthropologists have sought the exotic and, while they have studied cultures around the borders of the United States, they have not yet faced the complexities of the American situation. Scholars from the chronologically oriented disciplines, such as American studies, have paid attention to only the artifacts and individuals bobbing in the mainstream of Western civilization. If American folk cultures were receiving sufficient study, there would be little reason to worry about their limits, but a definable void exists, and until the folk cultures of the eastern United States are studied, our picture of man will remain incomplete.

[361]See Stith Thompson, "Advances in Folklore Studies," in A. L. Kroeber, ed., *Anthropology Today* (Chicago, 1955), pp. 587–596; Wayland D. Hand, "American Folklore After Seventy Years: Survey and Prospect," *Journal of American Folklore*, 73:287 (January–March, 1960), p. 4.

 BIBLIOGRAPHY

[Abbott, Jacob]. *New England and Her Institutions.* Boston: John Allen, 1835.

Abels, Robert. *Bowie Knives.* Columbus: Ohio Historical Society, 1962.

Adams, G. B. "The Work and Words of Haymaking." *Ulster Folklife,* 12(1966) pp. 66–91; 13(1967) pp. 29–53.

Addy, Sidney Oldall. *The Evolution of the English House.* Social England Series, London: Swan Sonnenschein, 1898.

Adney, Edwin Tappan, and Howard I. Chapelle. *The Bark Canoes and Skin Boats of North America.* U.S. National Museum Bulletin 230, Washington: Smithsonian Institution, 1964.

Agee, James, and Walker Evans. *Let Us Now Praise Famous Men.* New York: Ballantine, 1966, reprint of 1941 ed.

Agricultural Economics Research Institute. *The Rural Industries of England and Wales.* 4 vols., London: Oxford University Press, 1926–1927.

Allen, James Lane. "The Blue-Grass Region of Kentucky." *Harper's New Monthly Magazine*, LXXII:429 (February, 1886) pp. 365–382; reprinted in James Lane Allen, *The Blue-Grass Region of Kentucky and other Kentucky Articles*. New York: Harper and Brothers, 1892.

Allen, Lewis F. *Rural Architecture*. New York: C. M. Saxton Agricultural Book Publisher, 1852.

Anderson, W. A. *Social Change in a Central New York Community*. Bulletin 907, Ithaca: Cornell University Agricultural Experiment Station, 1954.

Andrews, Edward Deming, and Faith Andrews. *Shaker Furniture: The Craftsmanship of an American Communal Sect*. New York: Dover, 1950, first pub. 1937.

Angier, Bradford. "Shake Roof." *The Beaver*, Outfit 293 (Spring, 1963) pp. 52–53.

Anson, Peter F. *Fishermen and Fishing Ways*. London, Bombay and Sydney: George G. Harrap, 1932.

Anson, Peter F. *Scots Fisherfolk*. Banff: Banffshire Journal for the Saltire Society, 1950.

Apáthy, Štefan. "Šindliarstvo v okolí Bardejova." *Slovenský Národopis*, II:1–2 (1954) pp. 65–93.

Appleton, William Sumner. "A Description of Robert McClaflin's House." *Old-Time New England*, XVI:4 (April, 1926) pp. 157–167.

Arensberg, Conrad M., and Solon T. Kimball. *Culture and Community*. New York, Chicago and Burlingame: Harcourt, Brace & World, 1965.

Arnott, Margaret L. "Easter Eggs and Easter Bread of Southeastern Pennsylvania." *Expedition*, 3:3(1961) pp. 24–33.

Arnow, Harriette Simpson. *Seedtime on the Cumberland*. New York: Macmillan, 1960.

Arr, E. H. [Ellen H. Rollins]. *New England Bygones*. Philadelphia: J. B. Lippincott, 1880.

Ashley, Alta. "Trap Day on Monhegan." *Down East*, XIII:5 (January, 1967) pp. 16-19.

Ashley, Clifford W. *The Yankee Whaler*. Boston and New York: Houghton Mifflin, 1926.

Atkinson, J. C. *Forty Years in a Moorland Parish*. London: Macmillan, 1891.

Atwater, Mary Meigs. *The Shuttle-Craft Book of American Hand-Weaving*. New York: Macmillan, 1939.

Bachman, Calvin George. *The Old Order Amish of Lancaster County*. Pennsylvania German Society vol. 60, Lancaster: Pennsylvania German Society, 1961, first pub. as vol. 49, 1941.

Bailey, L. H., ed. *Cyclopedia of American Agriculture*. 4 vols., New York and London: Macmillan, 1907-1908.

Bailey, Rosalie Fellows. *Pre-Revolutionary Dutch Houses and Families*. New York: William Morrow, 1936.

Baines, Anthony. *Musical Instruments Through the Ages*. Baltimore: Penguin, 1961.

Baldwin, Leland D. *The Keelboat Age on Western Waters*. Pittsburgh: Pittsburgh University Press, 1941.

Barbeau, Marius. " 'All Hands Aboard Scrimshawing.' " *The American Neptune*, XII:2 (April, 1952) pp. 99-122.

Barbeau, Marius. "Island of Orleans." *Canadian Geographical Journal*, V:3 (September, 1932) pp. 154-171.

Barbeau, Marius. "Isle aux Coudres." *Canadian Geographical Journal*, XII:4 (April, 1936) pp. 200-211.

Barbeau, Marius. "The Origin of the Hooked Rug." *Antiques*, LII:2 (August, 1947) pp. 110-113.

Barber, Edwin Atlee. *Tulip Ware of the Pennsylvania-German Potters*. Philadelphia: The Pennsylvania Museum and School of Industrial Art, 1903.

Barber, Joel. *Wild Fowl Decoys*. New York: Dover, 1954, first pub. 1934.

Barley, M. W. *The English Farmhouse and Cottage*. London: Routledge and Kegan Paul, 1961.

Barnett, H. G. *Innovation: The Basis of Cultural Change*. New York, Toronto, London: McGraw-Hill, 1953.

Bartlett, Stuart. "Garrison Houses Along the New England Frontier." *The Monograph Series*, XIX:3, pp. 33–48; *Pencil Points*, XIV:6 (June, 1933) pp. 253–268.

Batsford, Harry and Charles Fry. *The English Cottage*. London: Batsford, 1950.

Baumgarten, Karl. "Probleme mecklenburgischer Niedersachsenhausforschung." *Deutsches Jahrbuch Für Volkskunde* (1955) pp. 169–182.

Baver, Russell S. "Corn Culture in Pennsylvania." *Pennsylvania Folklife*, 12:1 (Spring, 1961) pp. 32–37.

Bayard, Émile. *Les Meubles Rustiques Regionaux de la France*. Paris: Libraire Garniere Fréres, 1925.

Beam, Lura. *A Maine Hamlet*. New York: Wilfred Funk, 1957.

Beauchamp, W. M. "Rhymes from Old Powder-Horns." *Journal of American Folk-Lore*, II (1889) pp. 117–122; V (1892) pp. 284–290.

Bednárik, Rudolf. "K Študiu Cholvarkov na Kysuciach." *Sborník Slovenského Národného Múzea Etnografia*, LVII (1963) pp. 28–39.

Beecham, H. A. and John Higgs. *The Story of Farm Tools*. Young Farmers' Club Booklet No. 24, London: Evans Brothers, 1961, 2nd ed.

Bennett, H. S. *Life on the English Manor*. London: Cambridge University Press, 1962, first pub. 1937.

Benvenuti, B. *Farming in Cultural Change*. Bibliotheca Sociologica Ruralis No. 1, Assen: Van Gorcum, 1962.

Berg, Gösta. *Sledges and Wheeled Vehicles: Ethnological Studies from the View-Point of Sweden*. Nòrdiska Museets Handlingar, 4, Stockholm: C. E. Fritzes, 1935.

Berkebile, Don H. "Conestoga Wagons in Braddock's Campaign,

1755." *Contributions from the Museum of History and Technology*. U.S. National Museum Bulletin, 218, Washington: Smithsonian Institution, 1959, pp. 141–153.

Betar, Yasmine. *Finest Recipes from the Middle East*. Washington: author, 1964, first pub. 1957.

Bichsel, H. "Das Schindeln." *Schweizer Volkskunde*. 30:1 (1940) pp. 1–3.

Bidwell, Percy Wells and John I. Falconer. *History of Agriculture in the Northern United States, 1620–1860*. Carnegie Institution, Publication No. 358, New York: Peter Smith, 1941.

Bissell, Charles S. *Antique Furniture in Suffield Connecticut, 1670–1835*. n.p.: Connecticut Historical Society and Suffield Historical Society, 1956.

Black, Mary and Jean Lipman. *American Folk Painting*. New York: Clarkson N. Potter, 1966.

Blair, C. Dean. *The Potters and Potteries of Summit County, 1828–1915*. Akron: Summit County Historical Society, 1965.

Blair, Don. *Harmonist Construction; Principally as Found in the Two-Story Houses Built in Harmonie, Indiana, 1814–1824*. Indiana Historical Society Publications, 23:2, Indianapolis: Indiana Historical Society, 1964.

Blake, John L. *The Modern Farmer; or, Home in the Country: Designed for Instruction and Amusement on Rainy Days and Winter Evenings*. Auburn: Derby and Miller; Buffalo: Derby, Orton and Mulligan; Cincinnati: Henry W. Derby, 1854.

Bluestein, Gene. "America's Folk Instrument: Notes on the Five-String Banjo." *Western Folklore*, XXIII:4 (October, 1964) pp. 241–248.

Blunt, Elizabeth L. *When Folks Was Folks*. New York: Cochrane Publishing Co., 1910.

Boas, Franz. *Primitive Art*. New York: Dover, 1955, reprint of 1927 ed.

Boatright, Mody C., Wilson M. Hudson and Allen Maxwell, eds. *A Good Tale and a Bonnie Tune.* Texas Folklore Society Publication, XXXII, Dallas: Southern Methodist University Press, 1964.

Bobart, H. H. *Basketwork Through the Ages.* London, New York, Toronto: Oxford University Press, modern reprint of 1936 ed.

Bogue, Allan G. *From Prairie to Corn Belt: Farming on the Illinois and Iowa Prairies in the Nineteenth Century.* Chicago and London: University of Chicago Press, 1963.

Boëthius, Gerda. *Studier i den nordiska timmerbyggnadskonsten från vikingatiden till 1800-talet. En undersökning utgående fran Anders Zorns samlingar i Mora.* Stockholm: Fritzes Hovbokhandel i distribution, 1927.

Bond, Lewis R. "Homemade Straw Hats in Solebury." *A Collection of Papers Read Before the Bucks County Historical Society,* IV (1917) pp. 406–409.

Bonner, James C. "Plantation Architecture of the Lower South on the Eve of the Civil War." *Journal of Southern History,* XI (1945) pp. 370–388.

Book of famous Old New Orleans Recipes Used in the South for more than 200 years, A. New Orleans: Peerless Printing, n.d., c. 1960.

Boone, Frank. "The Adirondack Guide Boat." *North Country Life,* 12:1 (Winter, 1958) pp. 26–28.

Born, W. "Types of the Spinning Wheel." *Ciba Review,* 28 (December, 1939) pp. 998–1002.

Borneman, Henry S. *Pennsylvania German Illuminated Manuscripts: A Classification of Fraktur-Schriften and An Inquiry into Their History and Art.* Norristown: Pennsylvania German Society, 1937.

Botkin, B. A. *Lay My Burden Down: A Folk History of Slavery.* Chicago: University of Chicago Press, 1961, reprint of 1945 ed.

Bounds, Thelma V. *Children of Nanih Waiya*. San Antonio: Naylor, 1964.

Bowen, Eli. *The Pictorial Sketch-Book of Pennsylvania. Or Its Scenery, Internal Improvements, Resources, and Agriculture, Popularly Described*. Philadelphia: Willis P. Hazard, 1852.

Bowen, Richard Le Baron, Jr. "The Origins of Fore-and-Aft Rigs, Part I." *The American Neptune*, XIX:3 (July, 1959) pp. 155–199.

Bowers, Lessie. *Plantation Recipes*. New York: Robert Speller, 1959.

Bowles, Ella Shannon. *Handmade Rugs*. Boston: Little, Brown, 1927.

Brandt, Gustav. *Bauernkunst in Schleswig-Holstein: Hausrat und Wohnraum in alter Zeit*. Berlin and Leipzig: Kunstwissenschaft, n.d., c. 1935.

Bressler, Leo A. "Agriculture Among the Germans in Pennsylvania During the Eighteenth Century." *Pennsylvania History*, XXII:2 (April, 1955) pp. 102–133.

Brewington, M. V. *Chesapeake Bay Log Canoes*. 2 parts, Museum Publication No. 3, Newport News: Mariner's Museum, 1937.

Brewington, M. V. *Chesapeake Bay Log Canoes and Bugeyes*, Cambridge, Md.: Cornell Maritime Press, 1963.

Bridenbaugh, Carl. *The Colonial Craftsman*. New York: New York University Press; London: Oxford University Press, 1950.

Briggs, Martin S. *The English Farmhouse*. London: Batsford, 1953.

Brown, Frank Choteau. " 'The Old House' at Cutchogue, Long Island, New York." *Old-Time New England*, XXXI:1 (July, 1940) pp. 10–21.

Brown, Nelson Courtlandt. *Logging*. New York: John Wiley; London: Chapman and Hall, 1949.

Brumbaugh, G. Edwin. *Colonial Architecture of the Pennsylvania*

Germans. Pennsylvania German Society Proceedings XLI, Part II, Lancaster: Pennsylvania German Society, 1933.

Bryan, Charles F. "American Folk Instruments: The Appalachian Dulcimer." *Tennessee Folklore Society Bulletin*, XVIII:1 (March, 1952) pp. 1–5.

Bryant, Ralph Clement. *Logging*. New York: John Wiley; London: Chapman and Hall, 1913.

Bucchieri, Theresa F. *Feasting with Nonna Serafina (A Guide to the Italian Kitchen)*. South Brunswick, N.J.: A. S. Barnes, 1966.

Buchanan, Ronald H. "A Decade of Folklife Study." *Ulster Folklife*, 11 (1965) pp. 63–75.

Buchanan, Ronald H. "Geography and Folk Life." *Folk Life*, I (1963) pp. 5–15.

Bucher, Robert C. "The Continental Log House." *Pennsylvania Folklife*, 12:4 (Summer, 1962) pp. 14–19.

Bucher, Robert C. "The Cultural Backgrounds of Our Pennsylvania Homesteads." *Bulletin of the Historical Society of Montgomery County, Pennsylvania*, XV:3 (Fall, 1966) pp. 22–26.

Buckley, Bruce R. and M. W. Thomas, Jr. "Traditional Crafts in America," in Steve Kenin, Ralph Rinzler and Mary Vernon, eds., *Newport Folk Festival July 1966*. New York: Newport Folk Foundation, 1966, pp. 42–43, 65–66, 68, 70.

Buie, T. S. "Rail Fences." *American Forests*, 70:10 (October, 1964) pp. 44–46.

Burbank, Leonard F. "Lyndeboro Pottery." *Antiques*, XIII:2 (February, 1928) pp. 124–126.

Burroughs, Paul H. *Southern Antiques*. Richmond, Va.: Garrett and Massie, 1931.

Cahill, Holger. *American Folk Art: The Art of the Common Man in America, 1750–1900*. New York: Museum of Modern Art, W. W. Norton, 1932.

Callahan, North. *Smoky Mountain Country.* New York: Duell, Sloan and Pearce; Boston: Little, Brown, 1952.

Campbell, Åke. "Irish Fields and Houses: A Study of Rural Culture." *Béaloideas,* V:1 (1935) pp. 57–74.

Campbell, Åke. "Notes on the Irish House." *Folkliv,* 1937:2–3, pp. 205–234; 1938:2, pp. 173–196.

Campbell, John C. *The Southern Highlander and His Homeland.* New York: Russell Sage, 1921.

Campbell, William P. *101 American Primitive Water Colors and Pastels from the Collection of Edgar William and Bernice Chrysler Garbisch.* Washington: National Gallery of Art, 1966.

Carawan, Guy and Candie and Robert Yellin. *Ain't You Got a Right to the Tree of Life? The People of Johns Island, South Carolina—Their Faces, Their Words and Their Songs.* New York: Simon and Schuster, 1966.

Carlisle, Lilian Baker. *Pieced Work and Applique Quilts at Shelburne Museum.* Museum Pamphlet Series, Number 2, Shelburne: Shelburne Museum, 1957.

Carter, Bobby G. "Folk Methods of Preserving and Processing Food," in Thomas G. Burton and Ambrose N. Manning, *A Collection of Folklore by Undergraduate Students of East Tennessee State University.* Monograph No. 3, Johnson City, Tenn.: Institute of Regional Studies, East Tennessee State University, 1966, pp. 27–31.

Casagrande, Joseph P., ed. *In the Company of Man.* New York, Evanston and London: Harper and Row, 1964, first pub. 1960.

Case, Lora. *Hudson of Long Ago: Progress of Hudson During the Past Century, Personal Reminiscences of an Aged Pioneer.* Hudson, Ohio: Hudson Library and Historical Society, 1963, first pub. 1897.

Catlin, George, *Illustrations of the Manners, Customs, and Condi-*

tion of the North American Indians. 2 vols., London: Henry G. Bohn, 1851.

Caudill, Harry M. *Night Comes to the Cumberlands: A Biography of a Depressed Area.* Boston and Toronto: Little, Brown, 1963.

Chansler, Walter S. "Water-Craft of the Lower Wabash." *Fur News and Outdoor World,* XXXIV:3 (September, 1921) pp. 10–11, 15.

Chapelle, Howard I. *American Sailing Craft.* New York: Kennedy Brothers, 1936.

Chapelle, Howard I. *American Small Sailing Craft: Their Design, Development, and Construction.* New York: W. W. Norton, 1951.

Chapelle, Howard I. "The Migrations of an American Boat Type." *Contributions from the Museum of History and Technology,* U.S. National Museum Bulletin 228, Paper 25, Washington: Smithsonian Institution, 1961, pp. 133–154.

Chapelle, Howard I. *The National Watercraft Collection.* U.S. National Museum Bulletin 219, Washington: Smithsonian Institution, 1960.

Childe, V. Gordon. *Prehistoric Migrations in Europe.* Oslo: H. Aschehoug, 1950.

Chiles, Mary Ruth and Mrs. William P. Trotter, eds. *Mountain Makin's in the Smokies: A Cookbook.* Gatlinburg. Tenn.: Great Smoky Mountains Natural History Association, 1957.

Christensen, Erwin O. *American Crafts and Folk Arts.* America Today Series No. 4, Washington, D.C.: Robert B. Luce, 1964.

Christensen, Erwin O. *Early American Wood Carving.* Cleveland and New York: World Publishing, 1952.

Christensen, Erwin O. *The Index of American Design.* New York: Macmillan; Washington: National Gallery of Art, 1959.

Clark, Andrew Hill. *Three Centuries and the Island: A Historical Geography of Settlements and Agriculture in Prince Edward Island, Canada.* Toronto: University of Toronto Press, 1959.

Clark, Blanche Henry. *The Tennessee Yeoman, 1840–1860.* Nashville: Vanderbilt University Press, 1942.

Clark, Cameron. "Houses of Bennington, Vermont, and Vicinity." *White Pine Series,* VIII:5 (October, 1922) pp. 2–16.

Clark, Thomas D. *The Kentucky.* New York and Toronto: Farrar and Rinehart, 1942.

Clement, Arthur W. *Our Pioneer Potters.* New York: author, 1947.

Cline, Walter M. *The Muzzle-Loading Rifle . . . Then and Now.* Huntington, W. Va.: Standard, 1942.

Coffin, Robert P. Tristram. *Mainstays of Maine.* New York: Macmillan, 1944.

Coffin, Robert P. Tristram. *Yankee Coast.* New York: Macmillan, 1947.

Colby, Averil. *Patchwork Quilts.* Copenhagen: Charles Scribner's Sons, 1965.

Combs, Josiah Henry. *The Kentucky Highlanders from A Native Mountaineer's Viewpoint.* Lexington, Ky.: J. L. Richardson, 1913.

Congdon, Herbert Wheaton. *Old Vermont Houses.* New York: Alfred A. Knopf, 1946.

Connally, Ernest Allen. "The Cape Cod House: an Introductory Study." *Journal of the Society of Architectural Historians,* XIX:2 (May, 1960) pp. 47–56.

Connett, Eugene V. *Duck Decoys.* New York: D. Van Nostrand, 1953.

Connor, Seymour V. "Log Cabins in Texas." *The Southwestern Historical Quarterly,* LIII:2 (October, 1949) pp. 105–116.

Cook, Olive and Edwin Smith. *English Cottages and Farmhouses.* New York: Thomas Y. Crowell, 1955.

Copeland, Jennie F. *Every Day But Sunday*. Brattleboro, Vt.: Stephen Daye, 1936.

Copland, Samuel. *Agriculture Ancient and Modern: A Historical Account of its Principles and Practice, Exemplified in Their Rise, Progress, and Development.* 2 vols., London: Virtue, 1866.

Copp, James H., ed. *Our Changing Rural Society: Perspectives and Trends.* Ames, Iowa: Iowa State University Press, 1964.

Cornelius, Charles Over. *Early American Furniture.* New York and London: Century, 1926.

Cotten, Fred R. "Log Cabins of the Parker County Region." *West Texas Historical Association Year Book,* XXIX (October, 1953) pp. 96–104.

Couch, W. T., ed. *Culture in the South.* Chapel Hill: University of North Carolina Press, 1935.

Couch, W. T., ed. *These Are Our Lives As Told by the People and Written by Members of the Federal Writers' Project of the Works Progress Administration in North Carolina, Tennessee, and Georgia.* Chapel Hill: University of North Carolina Press, 1939.

Coulson, Thomas. "The Conestoga Wagon." *Journal of the Franklin Institute,* 246:3 (September, 1948) pp. 215–222.

"Country Furniture: A Symposium." *Antiques,* XCIII:3 (March, 1968) pp. 342–371.

Counts, Charles. *Encouraging American Handcrafts: What Role in Economic Development?* Washington: U.S. Department of Commerce, 1966.

Courtney, W. S. and George E. Waring. *The Farmers' and Mechanics' Manual.* New York: E. B. Treat, 1868.

Cross, Eric. *The Tailor and Ansty.* New York: Devin-Adair, 1964, first pub. 1942.

Crowell, Ivan C. "The Little Old Mills of New Brunswick." *Collections of the New Brunswick Historical Society,* 19 (1966) pp. 79–87.

Culbertson, John Newton. "A Pennsylvania Boyhood." *American Heritage*, XVIII:1 (December, 1966) pp. 80–88.

Cummings, Abbott Lowell. *Rural Household Inventories*. Boston: The Society for the Preservation of New England Antiquities, 1964.

Cummings, John. "Slat-Back Chairs." *Antiques*, LXXII:1 (July, 1957) pp. 60–63.

Curwen, E. Cecil. *Plough and Pasture*. London: Cobbett Press, 1946.

Dain, Martin J. *Faulkner's County: Yoknapatawpha*. New York: Random House, 1964.

Danaher, Kevin. *In Ireland Long Ago*. Cork: Mercier, 1964.

Dauzvardis, Josephine J. *Popular Lithuanian Recipes*. Chicago: Lith. Cath. Press Society, 1955.

Davidson, William H. *Pine Log and Greek Revival. Houses and People of Three Counties in Georgia and Alabama*. Chattahoochee Valley Historical Society Publication No. 6, Alexander City, Ala.: Outlook, 1965.

Davie, W. Galsworthy and E. Guy Dawber. *Old Cottages and Farmhouses in Kent and Sussex*. London: Batsford, 1900.

Davie, W. Galsworthy and W. Curtis Green. *Old Cottages and Farmhouses in Surrey*. London: Batsford, 1908.

Day, Clarence Albert. *A History of Maine Agriculture, 1604–1860*. University of Maine Studies, Second Series No. 68, Orono, Me.: University of Maine, 1954.

Deane, Samuel. *The New England Farmer; or Georgical Dictionary Containing A Compendious Account of the Ways and Methods in which the Important Art of Husbandry, in All Its Various Branches, Is, or May Be, Practiced, to the Greatest Advantage in this Country*. Worcester, Mass.: Isaiah Thomas, 1797.

De Chant, Alliene Saeger. *Down Oley Way*. Kutztown: author, 1953.

Deetz, James and Edwin S. Dethlefsen. "Death's Head, Cherub, Urn and Willow." *Natural History*, LXXVI:3 (March, 1967) pp. 28–37.

De Jonge, C. H. and W. Vogelsang. *Höllandische Möbel und Raumkunst von 1650–1780*. Stuttgart: Julius Hoffman, 1922.

De Laet, S. J. *The Low Countries*. London: Thames and Hudson, 1958.

Densmore, Frances, "Choctaw Music." *Anthropological Papers No. 28*. Bureau of American Ethnology Bulletin 136, Washington: Smithsonian Institution, 1943.

Derrick, Freda. *Country Craftsmen*. London: Chapman and Hall, 1947.

Dick, Everett. *The Dixie Frontier*. New York: Capricorn Books, 1964, reprint of 1948 ed.

Dickerman, Charles W. *How to Make the Farm Pay; Or, The Farmer's Book of Practical Information on Agriculture, Stock Raising, Fruit Culture, Special Crops, Domestic Economy and Family Medicine*. Philadelphia, Cincinnati, Chicago, St. Louis, and Springfield: Ziegler and McCurdy, 1871.

Dilliard, Maud Esther. *Old Dutch Houses of Brooklyn*. New York: Richard R. Smith, 1945.

Dillin, Capt. John G. W. *The Kentucky Rifle*. Washington: National Rifle Association, 1924; York, Pa.: George Shumway, Trimmer Printing, 1959.

Dolan, J. R. *The Yankee Peddlers of Early America*. New York: Bramhall House, 1964.

Dole, Philip. "The Calef Farm: Region and Style in Oregon." *Journal of the Society of Architectural Historians*, XXIII:4 (December, 1964) pp. 200–209.

Donaldson, Alfred L. *A History of the Adirondacks*. 2 vols., New York: Century, 1921.

Dooley, Mrs. James H. *Dem Good Ole Times*. New York: Doubleday, Page, 1906.

Dornbusch, Charles H. and John K. Heyl. *Pennsylvania German Barns*. Pennsylvania German Folklore Society, XXI, Allentown: Schlechter's, 1958.

Dorrance, Ward Allison. *The Survival of French in the Old District of Sainte Genevieve*. [Columbia]: University of Missouri, 1935.

Dorson, Richard M., ed. *Folklore Research around the World: A North American Point of View*. Indiana University Folklore Series No. 16, Bloomington: Indiana University Press, 1961. Also in *Journal of American Folklore*, LXXIV:294 (October–December, 1961).

Downing, Antoinette Forrester. *Early Homes of Rhode Island*. Richmond, Va.: Garrett and Massie, 1937.

Downing, Antoinette F. and Vincent J. Scully. *The Architectural Heritage of Newport, Rhode Island, 1640–1915*. New York: Clarkson N. Potter, 1967, 2nd ed.

Doyle, Martin. *A Cyclopaedia of Practical Husbandry and Rural Affairs in General*. London: Henry G. Bohn, 1851.

Drake, Daniel and Emmet Field Horine, ed. *Pioneer Life in Kentucky, 1785–1800*. New York: Henry Schuman, 1948.

Drake, Samuel Adams. *Nooks and Corners of the New England Coast*. New York: Harper and Brothers, 1875.

Drepperd, Carl W. and Lurelle VanArsdale Guild. *New Geography of American Antiques*. New York: Award; London: Tandem, 1967.

Driscoll, Eleanor. "Quilts in Moore County." *North Carolina Folklore*, IV:1 (July, 1956) pp. 11–14.

Du Bois, W. E. Burghardt. "The Negro Landholder in Georgia." *Bulletin of the Department of Labor*, 35 (July, 1901) pp. 647–777.

Dunbar, Gary S. "Hop Growing in Franklin County." *North Country Life*, 8:4 (Fall, 1954) pp. 21–23.

Dunbar, Seymour. *A History of Travel in America*. New York: Tudor, 1939.

Dundes, Alan. "The American Concept of Folklore." *Journal of the Folklore Institute*, III:3 (December, 1966) pp. 226–249.

Dundes, Alan, ed. *The Study of Folklore*. Englewood Cliffs, N.J.: Prentice-Hall, 1965.

Dundore, M. Walter. "The Saga of the Pennsylvania Germans in Wisconsin." *The Pennsylvania German Folklore Society*, XIX (1954) pp. 33–164.

Dunham, Lydia Roberts, Florence Haslett and Cile M. Bach. *Denver Art Museum Quilt Collection*. Denver Art Museum Winter Quarterly, 1963.

Dunton, William Rush, Jr. *Old Quilts*. Catonsville, Md.: author, 1946.

Duprey, Kenneth. *Old Houses on Nantucket*. New York: Architectural Book Publishing Co., 1959.

Durand, Loyal, Jr. "Dairy Barns of Southeastern Wisconsin: Relation to Dairy Industry and to Regions of 'Yankee' and 'German' Settlement." *Annals of the Association of American Geographers*, XXXII:1 (March, 1942) pp. 112–113.

Durand, Loyal, Jr. " 'Mountain Moonshining' in East Tennessee." *The Geographical Review*, XLVI:2 (April, 1956) pp. 168–181.

Durant, Kenneth, ed. *Guide-Boat Days and Ways*. Blue Mountain Lake, N.Y.: Adirondack Museum, 1963.

Dwight, Timothy. *Travels in New-England and New-York*. 4 vols., London: William Baynes and Son and Ogle, Duncan, 1823

Earle, Walter K. *Scrimshaw: Folk Art of the Whalers*. Cold Spring Harbor, N.Y.: Whaling Museum Society, Inc., 1957.

Early, Eleanor. *New England Cookbook*. New York: Random House, 1954.

Earnest, Adele. *The Art of the Decoy: American Bird Carvings*. New York: Clarkson N. Potter, 1965.

Eaton, Allen H. *Handicrafts of New England*. New York: Harper & Brothers, 1949.

Eaton, Allen H. *Handicrafts of the Southern Highlands*. New York: Russell Sage, 1937.

Eaton, Allen and Lucinda Crile. *Rural Handicrafts in the United States*. U.S.D.A. Miscellaneous Publication No. 610, Washington: U.S.D.A. and Russell Sage, 1946.

Eben, Carl Theo., trans., *Gottlieb Mittelberger's Journey to Pennsylvania and Return to Germany in the Year 1754*. Philadelphia: John Jos. McVey, 1898. Oscar Handlin and John Clive prepared an edition published at Cambridge by Harvard University Press in 1960.

Eberlein, Harold Donaldson. *The Manors and Historic Houses of the Hudson Valley*. Philadelphia and London: J. B. Lippincott, 1924.

Eberlein, Harold Donaldson. "The Seventeenth Century Connecticut House." *The White Pine Series of Architectural Monographs*, V:1 (February, 1919) pp. 1–14.

Eberlein, Harold Donaldson and Cortlandt V. D. Hubbard. *Historic Houses and Buildings of Delaware*. Dover: Public Archives Commission, 1962.

Eckstorm, Fannie Hardy. *The Handicrafts of the Modern Indians of Maine*. Bulletin III, Bar Harbor: Abbe Museum, Lafayette National Park, 1932.

Edlin, H. L. *Woodland Crafts in Britain*. New York: Batsford, 1949.

Edmonson, Munro S., Donald E. Thompson, Gustavo Correa, and William Madsen. *Nativism and Syncretism*. Publication 19, New Orleans: Middle American Research Institute, Tulane University, 1960.

Eickenroht, Marvin. "The Kaffee-Kirche at Fredericksburg, Texas, 1846." *Journal of the Society of Architectural Historians*, XXV:1 (March, 1966) pp. 60–63.

Ekblaw, K. J. T. *Farm Structures*. New York: Macmillan, 1920.

Ellison, Ralph. *Shadow & Act*. New York: New American Library, 1966.

Embury, Aymar II. "Pennsylvania Farmhouses: Examples of Rural Dwellings of a Hundred Years Ago." *The Architectural Record*, XXX:V (November, 1911) pp. 475–485.

Embury, Aymar II. "Roofs: The Varieties Commonly Used in the Architecture of the American Colonies and the Early Republic." *The Monograph Series*, XVIII:1 (April, 1932) pp. 250–264.

Erixon, Sigurd. "European Ethnology in our Time." *Ethnologia Europaea*, I:1 (1967) pp. 3–11.

Erixon, Sigurd. "Folklife Research in Our Time." *Gwerin*, 3 (1962) pp. 271–291.

Erixon, Sigurd. "The North-European Technique of Corner Timbering." *Folkliv*, 1937:1, pp. 13–60.

Erixon, Sigurd. "Regional European Ethnology." *Folkliv*, 1937:2/3, pp. 89–108; 1938:3, pp. 263–294.

Erixon, Sigurd. "West European Connections and Culture Relations." *Folk-Liv*, 1938:2, pp. 137–172.

Erskine, Ralph C. *The Mountains and the Mountain Shop*. Tryon, N.C.: Ralph C. Erskine Co., 1913.

Esarey, Logan. *The Indiana Home*. Crawfordsville, Indiana: R. E. Banta, 1947.

Evans, E. Estyn. "Cultural Relics of the Ulster Scots in the Old West of North America." *Ulster Folklife*, 11 (1965) pp. 33–38.

Evans, E. Estyn. "Donegal Survivals." *Antiquity*, XIII:50 (June, 1939) pp. 207–222.

Evans, E. Estyn. "Folklife Studies in Northern Ireland." *Journal of the Folklore Institute*, II:3 (December, 1965) pp. 355–363.

Evans, E. Estyn. *Irish Folk Ways*. New York: Devin–Adair, 1957.

Evans, E. Estyn. *Irish Heritage: The Landscape, The People and Their Work*. Dundalk: W. Tempest, 1963, first pub. 1942.

Evans, E. Estyn. "The Ulster Farmhouse." *Ulster Folklife*, I (1955) pp. 27–31.

Evans, George Ewart. *Ask the Fellows Who Cut the Hay*. London: Faber and Faber, 1962, first edition 1956.

Evans, George Ewart. *The Pattern Under the Plough: Aspects of the Folk-Life of East Anglia*. London: Faber and Faber, 1966.

Farm Buildings: A Compilation of Plans for General Farm Barns, Cattle Barns, Dairy Barns, Horse Barns, Sheep Folds, Swine Pens, Poultry Houses, Silos, Feeding Racks, Sheds, Farm Gates, Portable Fences, Etc., Chicago: Sanders, 1907.

Farm-Housing Survey, The, U.S.D.A. Miscellaneous Publication No. 323, Washington: Government, 1939.

Farnill, Barrie. *Robin Hood's Bay: The Story of a Yorkshire Community*. Clapham, via Lancaster: Dalesman, 1966.

Farquhar, Roger Brooke. *Historic Montgomery County, Maryland, Old Homes and History*. Silver Spring, Md.: author, 1952.

Farrand, Max, ed. *A Journey to Ohio in 1810 As Recorded in the Journal of Margaret Van Horn Dwight*. New Haven: Yale University Press, 1913.

Fenton, Alexander. "An Approach to Folk Life Studies." *Keystone Folklore Quarterly*, XII:1 (Spring, 1967) pp. 5–21.

Fenton, Alexander. "Material Culture as an Aid to Local History Studies in Scotland." *Journal of the Folklore Institute*, II:3 (December, 1965) pp. 326–339.

Fenton, Alexander. "Ropes and Rope-Making in Scotland." *Gwerin*, III:3 (1961) pp. 142–156; III:4 (1961) pp. 200–214.

Fenton, William N. "From Longhouse to Ranch-type House: The Second Housing Revolution of the Seneca Nation," in Elisabeth Tooker, ed., *Iroquois Culture, History, and Prehistory: Proceedings of the 1965 Conference on Iroquois Research*.

Albany: University of New York, State Education Department, N.Y. State Museum and Science Service, 1967, pp. 7–24.

Fernholm, Håkan. "Ljusterfiske." *Folk-Liv*, VI (1942) pp. 50–72.

Fessenden, Thomas G. *The Complete Farmer and Rural Economist*. Boston: Otis, Broaders; Philadelphia: Thomas, Cowperthwaite, 1840.

Fife, Austin E. "Folklore of Material Culture on the Rocky Mountain Frontier." *Arizona Quarterly*, 13:2 (Summer, 1957) pp. 101–110.

Fife, Austin E. "Jack Fences of the Intermountain West." in D. K. Wilgus, ed., *Folklore International: Essays in Traditional Literature, Belief and Custom in Honor of Wayland Debs Hand*. Hatboro, Pa.: Folklore Associates, 1967, pp. 51–54.

Fife, Austin E. "Western Rural Mail Boxes." paper read at the annual meeting of the American Folklore Society, Denver, Colorado, November 20, 1965.

Finberg, Joscelyne. *Exploring Villages*. London: Routledge and Kegan Paul, 1958.

Finley, Robert and E. M. Scott. "A Great Lakes-To-Gulf Profile of Dispersed Dwelling Types." *The Geographical Review*, XXX:3 (July, 1940) pp. 412–419.

Finley, Ruth E. *Old Patchwork Quilts and The Women Who Made Them*. Philadelphia and London: J. B. Lippincott, 1929.

Fishwick, Marshall W. "Where Do 'American Studies' Begin?" *Stetson University Bulletin*, LIX:1 (January, 1959) pp. 1–13.

Fitch, James Marston. *American Building, The Forces That Shape It*. Boston: Houghton Mifflin, 1948.

Fitzgerald, Ken. *Weathervanes and Whirligigs*. New York: Clarkson N. Potter, 1967.

Fletcher, Stevenson Whitcomb. *Pennsylvania Agriculture and Country Life, 1640–1840*. Harrisburg: Pennsylvania Historical and Museum Commission, 1950.

Fletcher, Stevenson Whitcomb. *Pennsylvania Agriculture and Country Life, 1840–1940.* Harrisburg: Pennsylvania Historical and Museum Commission, 1955.

Flexner, James Thomas. "The Cult of the Primitives." *American Heritage,* VI:2 (February, 1955) pp. 38–47.

Flint, Charles L. *The Agriculture of Massachusetts As Shown in Returns of the Agricultural Societies, 1854.* Boston: William White, 1855.

Flower, Milton E. *Wilhelm Schimmel and Aaron Mountz: Wood Carvers.* Williamsburg: Abby Aldrich Rockefeller Folk Art Collection, 1965.

Flower, Robin. *The Western Island; or, The Great Blasket.* New York: Oxford University Press, 1945.

Folkers, Johann Ulrich. "Die Schichtenfolge im alten Bestand niedersächsischer Bauernhäuser Mecklenburgs." in *Festschrift Richard Wossildo,* Neumünster: Karl Machholtz, 1939.

Fontana, Bernard L. and J. Cameron Greenleaf. "Johnny Ward's Ranch: A Study in Historic Archaeology." *The Kiva,* 28:1–2 (October–December, 1962) pp. 1–115.

Forbes, Harriette Merrifield. *Gravestones of Early New England and the Men Who Made Them.* Boston: Houghton Mifflin, 1927.

Ford, Thomas R., ed. *The Southern Appalachian Region: A Survey.* Lexington: University of Kentucky Press, 1962.

Forman, Grant. *The Five Civilized Tribes.* Norman: University of Oklahoma Press, 1934.

Forman, Henry Chandlee. *The Architecture of the Old South: The Medieval Style, 1585–1850.* Cambridge: Harvard University Press, 1948.

Forman, Henry Chandlee. *Early Manor and Plantation Houses of Maryland.* Easton, Md.: author, 1934.

Forman, Henry Chandlee. *Early Nantucket and Its Whale Houses.* New York: Hastings House, 1966.

Forman, Henry Chandlee. *Tidewater Maryland Architecture and Gardens.* New York: Bonanza, 1956.

Forman, Henry Chandlee. *Virginia Architecture in the Seventeenth Century.* Williamsburg: Virginia 350th Anniversary Celebration Corporation, 1957.

Forrester, Harry. *The Timber-Framed Houses of Essex.* Chelmsford: Tindal Press, 1965, first pub., 1959.

Foster, George M. "What Is Folk Culture?" *American Anthropologist,* 55:2, 1 (April–June, 1953) pp. 159–173.

Foster, I. Ll. and L. Alcock, eds. *Culture and Environment: Essays in Honour of Sir Cyril Fox.* London: Routledge and Kegan Paul, 1963.

Foster, W. A. and Deane G. Carter. *Farm Buildings.* New York: John Wiley, 1922.

Foster, William D. *Cottages, Manoirs and Other Minor Buildings of Normandy and Brittany.* New York: Architectural Book Publishing Co., 1926.

Fowler, John. *Journal of a Tour in the State of New York in the Year 1830.* London: Whittaker, Treacher, and Arnot, 1831.

Fox, Cyril. "Sleds, Carts and Waggons." *Antiquity,* V:18 (June, 1931) pp. 185–199.

Fox, Sir Cyril. "Some South Pembrokeshire Cottages." *Antiquity* XVI:64 (December, 1942) pp. 307–319.

Fox, Sir Cyril and Lord Raglan. *Monmouthshire Houses: A Study of Building Techniques and Smaller House-Plans in the Fifteenth to Seventeenth Centuries.* 3 vols., Cardiff: National Museum of Wales, 1951–1954.

Fox, John Jr. *Blue-grass and Rhododendron: Out-doors in Old Kentucky.* New York: Charles Scribner's Sons, 1901.

Fox, William Price. "The Lost Art of Moonshine." *The Saturday Evening Post,* 239:7 (March 25, 1966) pp. 34–35.

Frankenberg, Ronald. *Communities in Britain: Social Life in Town and Country.* Baltimore: Penguin Books, 1966.

Franklin, M. S. "The Houses and Villages of North Smithfield,

Rhode Island." The Monograph Series, XXI:4, *Pencil Points* (August, 1935) pp. 431–446.

Frary, I. T. *Early Homes of Ohio*. Richmond, Va.: Garrett and Massie, 1936.

Frary, I. T. *Ohio in Homespun and Calico*. Richmond, Va.: Garrett and Massie, 1942.

Frederick, J. George. *The Pennsylvania Dutch and Their Cookery*. New York: The Business Bourse, 1935.

Fretz, Warren. "Old Methods of Taking Fish." *A Collection of Papers Read Before the Bucks County Historical Society*, V (1926) pp. 361–375.

Fussell, G. E. *The English Rural Labourer: His Home, Furniture, Clothing and Food from Tudor to Victorian Times*. London: The Batchworth Press, 1949.

Fussell, G. E. *The Farmer's Tools: A.D. 1500–1900*. London: Andrew Melrose, 1952.

Gailey, Alan. "The Peasant Houses of the South-west Highlands of Scotland: Distribution, Parallels and Evolution." *Gwerin*, III:5 (June, 1962) pp. 227–242.

Gans, Herbert J. *The Urban Villagers—Group and Class in the Life of Italian-Americans*. New York: The Free Press; London: Collier-Macmillan, 1966, first pub. 1962.

Gardner, George W. "Some Early 'Single Room Houses' of Lincoln, Rhode Island." The Monograph Series, XXI:1, *Pencil Points* (February, 1935) pp. 93–108.

Garnett, James M. "Improved Harrow." *American Farmer*, I:14 (July 2, 1819) p. 112.

Garrett, Mitchell B. *Horse and Buggy Days on Hatchet Creek*. University, Ala.: University of Alabama Press, 1964, first pub. 1957.

Garvan, Anthony N. B. *Architecture and Town Planning in Colonial Connecticut*. New Haven: Yale University Press, 1951.

Gates, Paul Wallace. "Large-Scale Farming in Illinois, 1850–1870."
Agricultural History, VI:1 (January, 1932) pp. 14–25.

Gebhard, Torsten. *Die Volkstümliche Möbelmalerei in Altbayern.*
Munich: Georg D. W. Callwey, 1937.

*George Dudley Seymour's Funiture Collection in the Connecticut
Historical Society.* Catalogue No. 2, n.p.: Connecticut His-
torical Society, 1958.

Gibbons, Phebe Earle. *"Pennsylvania Dutch" and Other Essays.*
Philadelphia: J. B. Lippincott, 1882.

Gilbert, Russell Wieder. *A Picture of the Pennsylvania Germans.*
Pennsylvania History Studies No. 1, Gettysburg: Pennsyl-
vania Historical Association, 1962, third ed.

Gillardon, C. "Das Safierhaus." *Schweizerisches Archiv für Volks-
kunde*, 48:4 (1952) pp. 201–232.

Gillon, Edmund Vincent, Jr. *Early New England Gravestone
Rubbings.* New York: Dover, 1966.

Gimbutas, Marija. *The Balts.* London: Thames and Hudson, 1963.

Gimbutas, Marija. *The Prehistory of Eastern Europe.* I, Cam-
bridge: Peabody Museum, 1956.

Glassie, Henry. "The Appalachian Log Cabin." *Mountain Life and
Work*, XXXIX:4 (Winter, 1963) pp. 5–14.

Glassie, Henry, "A Central Chimney Continental Log House."
Pennsylvania Folklife, XVIII:2 (Winter, 1968–1969), pp.
32–39.

Glassie, Henry. "The Old Barns of Appalachia." *Mountain Life
and Work*, XL:2 (Summer, 1965) pp. 21–30.

Glassie, Henry. "The Pennsylvania Barn in the South." *Pennsyl-
vania Folklife*, 15:2 (Winter, 1965–1966) pp. 8–19; 15:4 (Sum-
mer, 1966) pp. 12–25.

Glassie, Henry. "The Smaller Outbuildings of the Southern
Mountains." *Mountain Life and Work*, XL:1 (Spring, 1964)
pp. 21–25.

Glassie, Henry. "The Types of Southern Mountain Cabin," in

Jan H. Brunvand, *The Study of American Folklore*. New York: W. W. Norton, 1968, pp. 338–370.

Glassie, Henry. "The Wedderspoon Farm." *New York Folklore Quarterly*, XXII:3 (September, 1966) pp. 165–187.

Glassie, Henry. "William Houck, Maker of Pounded Ash Adirondack Pack-Baskets." *Keystone Folklore Quarterly*, XII:1 (Spring, 1967) pp. 23–54.

Glenn, Leonard [Clifford]. "The Plucked Dulcimer of the Southern Appalachians." *Folkways Monthly*, I:2 (January, 1963) pp. 63–68.

Goodenough, Ward Hunt. *Cooperation in Change*. New York: Russell Sage, 1963.

Goodman, W. L. *The History of Woodworking Tools*. London: G. Bell, 1964.

Goodrich, Frances Louisa. *Mountain Homespun*. New Haven: Yale University Press, 1931.

Goldstein, Kenneth S. *A Guide for Field Workers in Folklore*. Hatboro, Pa.: Folklore Associates, 1964.

Goldstein, Kenneth S. "William Robbie: Folk Artist of the Buchan District, Aberdeenshire," in Horace P. Beck, ed., *Folklore in Action: Essays for Discussion in Honor of MacEdward Leach*. Bibliographical and Special Series, 14, Philadelphia: American Folklore Society, 1962, pp. 101–111.

Götzger, Heinrich and Helmut Prechter. *Das Bauernhaus in Bayern*. Munich: Callwey, 1960.

Gould, John. *The House That Jacob Built*. New York: William Morrow, 1947.

Gould, Mary Earle. *Early American Wooden Ware and Other Kitchen Utensils*. Springfield, Mass.: Pond-Ekberg, 1942; Rutland, Vt.: Charles E. Tuttle, 1962.

Gould, R. E. *Yankee Boyhood: My Adventures on a Maine Farm Seventy Years Ago*. New York: W. W. Norton, 1950.

Gowans, Alan. *Architecture in New Jersey*. New Jersey Historical Series, 6, Princeton: D. Van Nostrand, 1964.

Gowans, Alan. *Images of American Living: Four Centuries of Architecture and Furniture as Cultural Expression.* New York and Philadelphia: J. B. Lippincott, 1964.

Gowans, Alan. "New England Architecture in Nova Scotia." *The Art Quarterly,* XXV:1 (Spring, 1962) pp. 6–33.

Grady, Joseph F. *The Adirondacks Fulton Chain-Big Moose Region: The Story of a Wilderness.* Little Falls: Journal and Courier Co., 1933.

Graeff, Marie Knorr. *Pennsylvania German Quilts.* Home Craft Course Vol. 14, Plymouth Meeting, Pa.: Mrs. C. Naaman Keyser, 1946.

Graham, Hettie Wright. "The Fireside Industries of Kentucky." *The Craftsman,* I:4 (January, 1902) pp. 45–48.

Grancsay, Stephen V. *American Engraved Powder Horns: A Study Based on the J. H. Grenville Gilbert Collection.* New York: Metropolitan Museum of Art, 1946; Philadelphia: Ray Riling Arms Books, 1965.

Grant, I. F. *Highland Folk Ways.* London: Routledge and Kegan Paul, 1961.

Gray, Lewis Cecil. *History of Agriculture in the Southern United States to 1860.* 2 vols., Publication No. 430, Washington, D.C.: Carnegie Institution, 1933.

Greeley, Horace. *What I Know of Farming.* New York: G. W. Carleton, 1871.

Gregor, Walter. *An Echo of the Olden Time from the North of Scotland.* Edinburgh and Glasgow: John Menzies; Peterhead: David Scott, 1874.

Gregory, H. F. "The Pirogue-Builder: A Vanishing Craftsman." *Louisiana Studies,* III:3 (Fall, 1964) pp. 316–318.

Gregory, Hiram F., Jr. "The Black River Commercial Fisheries: A Study in Cultural Geography." *Louisiana Studies,* V:1 (Spring, 1966) pp. 3–36.

Grossinger, Jennie. *The Art of Jewish Cooking.* New York: Random House, 1958.

Grossman, Charles S. "Great Smoky Pioneers." *The Regional Review*, VII:1,2 (July-August, 1941) pp. 2–6.

Gschwend, M. "Schlafhäuser." *Schweizer Volkskunde,* 39:4 (1949) pp. 56–59.

Gschwend, Max. *Schwyzer Bauernhäuser.* Schweizer Heimatbücher, Bern: Paul Haupt, 1957.

Guldbeck, Per. "By-Gone Fishing Techniques." *The Chronicle of the Early American Industries Association,* XIII:4 (December, 1960) pp. 44–45.

Guthrie, Charles S. "Corn: The Mainstay of the Cumberland Valley." *Kentucky Folklore Record,* XII:3 (July–September, 1966) pp. 87–91.

Hahm, Konrad. *Deutsche Bauernmöbel.* Jena: Eugen Diedrichs, 1939.

Hale, Richard W., Jr. "The French Side of the 'Log Cabin Myth'." *Proceedings of the Massachusetts Historical Society,* LXXII (October 1957–December 1960) pp. 118–125.

Hall, Carrie A. and Rose G. Kretsinger. *The Romance of the Patchwork Quilt in America.* New York: Bonanza, modern reprint of 1935 ed.

Hall, Edward T. *The Silent Language.* New York: Fawcett World Library, 1964, first pub. 1959.

Hall, Eliza Calvert. *A Book of Hand-Woven Coverlets.* Boston: Little, Brown, 1931; Rutland, Vt.: Charles E. Tuttle, 1966.

Hall, James. *Sketches of History, Life and Manners, in the West.* 2 vols., Philadelphia: Harrison Hall, 1835.

Hall, Joseph S. *Smoky Mountain Folks and Their Lore.* Asheville: Great Smoky Mountains Natural History Association, 1964.

Hall, Mr. and Mrs. S. C. *Ireland: Its Scenery, Character, &c.* 3 vols., London: Hall, Virtue, n.d., new edition of 1841–1843.

Halsey, Abigail Fithian. *In Old Southampton.* New York: Columbia University Press, 1952, first pub. 1940.

Halsey, Francis W., ed. *A Tour of Four Great Rivers: The Hudson, Mohawk, Susquehanna and Delaware in 1769, Being the Journal of Richard Smith of Burlington, New Jersey.* Port Washington, L.I., N.Y.: Ira J. Friedman, 1964, reprint of 1906 ed.

[Halsted, Byron David]. *Barn Plans and Outbuildings.* New York: Orange Judd, 1881, 1891, 1906, 1909.

Hamlin, Talbot. *Greek Revival Architecture in America: Being an Account of Important Trends in American Architecture and American Life Prior to the War Between the States.* New York: Dover, 1964, reprint of 1944.

Hammond, S. H. *Hills, Lakes and Forest Streams: or, a Tramp in the Chateaugay Woods.* New York: J. C. Derby, 1854.

Hand, Wayland D. "American Folklore After Seventy Years: Survey and Prospect." *Journal of American Folklore,* 73:287 (January–March, 1960) pp. 1–11.

Hanson, Charles E., Jr. *The Plains Rifle.* New York: Bramhall House, 1960.

Harder, Kelsie. "A Vocabulary of Wagon Parts." *Tennessee Folklore Society Bulletin,* XXVIII:1 (March, 1962) pp. 12–30.

Harding, Stanley. *The Amateur Trapper and Trap-Makers' Guide.* Chicago and New York: M. A. Donohue, 1903.

Hark, Ann and Preston A. Barba. *Pennsylvania German Cookery, A Regional Cookbook.* Allentown: Schlechter's, 1956.

Harney, Geo. E. *Barns, Outbuildings and Fences.* New York: Geo. E. Woodward, 1870.

"Harrow, The." *Monthly Journal of Agriculture,* I:12 (June, 1846) pp. 591–593.

"Harrows and Harrowing." *American Agriculturist,* XXXIX:5 (May, 1880) p. 188.

Hart, Albert Bushnell, ed. *Commonwealth History of Massachusetts.* I, New York: State History Company, 1927.

Hart, Innes. "Rude Forefathers." *The Architectural Review,* LXXXVI:516 (November, 1939) pp. 185–188.

Hart, John Fraser, and Eugene Cotton Mather. "The American Fence." *Landscape*, 6:3 (Spring, 1957) pp. 4–9.

Hart, John Fraser, and Eugene Cotton Mather. "The Character of Tobacco Barns and Their Role in the Tobacco Economy of the United States." *Annals of the Association of American Geographers*, 51:3 (September, 1961) pp. 274–293.

Hart, John Fraser and Eugene Cotton Mather. "Signs of the Tawny Weed." *Landscape*, 12:2 (Winter, 1962–1963) pp. 28–31.

Hartley, Dorothy. *Food in England*. London: MacDonald, 1954.

Hartley, Dorothy. *Made in England*. London: Methuen, 1951.

Harvey, Nigel. *The Story of Farm Buildings*. Young Farmers' Club Booklet No. 27, London: Evans Brothers, 1953.

Hayden, Arthur. *Chats on Cottage and Farmhouse Funiture*. London: Ernest Benn, 1950, first pub. 1912.

Hayward, W. J. "Early Western Pennsylvania Agriculture." *Western Pennsylvania Historical Magazine*, 6:3 (July, 1923) pp. 177–189.

Headley, J. T. *The Adirondack; or Life in the Woods*. New York: Baker and Scribner, 1849.

Heberle, Rudolf, and Dudley S. Hall. *Displaced Persons in Louisiana and Mississippi*. Baton Rouge: Louisiana State University Press, 1950.

Hedrick, Ulysses Prentiss. *A History of Agriculture in the State of New York*. New York: Hill and Wang for New York State Historical Association, 1966, reprint of 1933 ed.

Heizmann, Louis J. "Are Barn Signs Hex Marks?" *The Historical Review of Berks County*, XII:1 (October, 1946) pp. 11–14.

Hemphill, Edwin. "Why Barns?—Then and Now." *Virginia Cavalcade*, VII:3 (Winter, 1957) pp. 17–27.

Henning, Darrell. "Common Farm Fences of Long Island." *Friends of the Nassau County Historical Museum Bulletin*, II:1 (Spring, 1967) pp. 6–13.

Henning, Darrell D. "Maple Sugaring: History of a Folk Technology." *Keystone Folklore Quarterly*, XI:4 (Winter, 1966) pp. 239–274.

Herbert, Henry William. *Frank Forester's Fish and Fishing of the United States and British Provinces of North America.* New York: Stringer and Townsend, 1851.

Hershey, Mary Jane. "A Study of the Dress of the (Old) Mennonites of the Franconia Conference." *Pennsylvania Folklife*, 9:3 (Summer, 1958) pp. 24–47.

Herskovits, Melville J. *The Myth of the Negro Past.* Boston: Beacon Press, 1964, first pub. 1941.

Hewett, Cecil A. "The Barns at Cressing Temple, Essex, and Their Significance in the History of English Carpentry." *Journal of the Society of Architectural Historians*, XXVI:1 (March, 1967) pp. 48–70.

Higgs, J. W. Y. *Folk Life Collection and Classification.* Handbook for Museum Curators, Part C, Section 6, London: Museums Association, 1963.

High, Fred. *It Happened in the Ozarks.* Berryville, Ark.: Braswell Printing, apparently 1954.

Hindle, Brooke. *Technology in Early America.* Chapel Hill: University of North Carolina Press for the Institute of Early American Life and Culture at Williamsburg, Virginia, 1966.

Historic American Buildings Survey Catalog of the Measured Drawings and Photographs of the Survey in the Library of Congress March 1, 1941. Washington: Government, 1941.

Historic American Buildings Survey Catalog of the Measured Drawings and Photographs of the Survey in the Library of Congress, Comprising Additions Since March 1, 1941. Washington: Government, 1959.

Hodges, Sidney Cecil. "Handicrafts in Sevier County, Tennessee." unpublished master's thesis, University of Tennessee, August, 1951.

Holbrook, Stewart H. *The American Lumberjack.* New York:

Collier Books, 1962, first published in 1938 as *Holy Old Mackinaw*.

Holme, Charles. *Old Houses in Holland*. New York: The Studio, 1913.

Holme, Charles, ed. *The Village Homes of England*. London, Paris, New York: The Studio, 1912.

Holmes, Fred L. *Old World Wisconsin: Around Europe in the Badger State*. Eau Claire: E. M. Hale, 1944.

Hommel, R. P. [Pennsylvania German Zither]. *Antiques*, XXII:6 (December, 1932) p. 238.

Honey, W. B. *English Pottery and Porcelain*. London: A. and C. Black, 1933.

Hooper, Edward James. *The Practical Farmer, Gardener and Housewife; or, Dictionary of Agriculture, Horticulture and Domestic Economy*. Cincinnati: Geo. Conclin, 1842.

Hopfen, H. J., and E. Biesalski. *Small Farm Implements*. FAO Development Paper No. 32, Rome: Food and Agriculture Organization of the United Nations, 1953.

Hopkins, Alfred. *Modern Farm Buildings*. New York: McBride, Nast, 1913.

Hopkins, C. A. Porter. "Maryland Decoys and Their Makers." *The Maryland Conservationist*, XLII:6 (November-December, 1965) pp. 2–5.

Hopkins, Thomas Smith, and Walter Scott Cox. *Colonial Furniture of West New Jersey*. Haddonfield, N.J.: Historical Society of Haddonfield, 1936.

"Hops—Otsego County, N.Y." *The Northern Farmer*, II:10 (October, 1855) p. 457.

Horn, Walter, and F. W. B. Charles. "The Cruck-built Barn of Middle Littleton in Worcestershire, England." *Journal of the Society of Architectural Historians*, XXV:4 (December, 1966) pp. 221–239.

Hornell, James. *Water Transport, Origins and Early Evolution*. Cambridge: Cambridge University Press, 1946.

Horsbrugh, Patrick. "Barns in Central Illinois." *Landscape*, 8:3 (Spring, 1959) pp. 12–13.

Hostetler, John A. *Amish Society*. Baltimore: Johns Hopkins Press, 1963.

How to Build, Furnish and Decorate. New York: Co-operative Building Plan Association, 1883.

Howard, Guy. *Walkin' Preacher of the Ozarks*. New York and London: Harper and Brothers, 1944.

Howard, Mrs. B. C. *Fifty Years in a Maryland Kitchen*. New York: M. Barrows, 1944.

Howe, Henry. *Historical Collections of the Great West*, 2 vols. in 1, New York: George F. Tuttle; Cincinnati: author, 1857.

Howells, John Mead. *Lost Examples of Colonial Architecture*. New York: Dover, 1963, first pub. 1931.

Howells, John Mead. *The Architectural Heritage of the Piscataqua: Houses and Gardens of the Portsmouth District of Maine and New Hampshire*. New York: Architectural Book Publishing Co., 1965.

Hudleston, N. A. *Lore and Laughter of South Cambridgeshire*. Cambridge: St. Tibbs Press, n.d., c. 1952.

Huguenin, Mary Vereen, and Anne Montague Stoney, eds. *Charleston Receipts*. Charleston: Junior League of Charleston, 1966, first pub. 1950.

Hultkrantz, Åke, ed. *International Dictionary of Regional European Ethnology and Folklore: General Ethnological Concepts*. I, Copenhagen: UNESCO, CIAP, Rosenkilde and Bagger, 1960.

Hultkrantz, Åke. "Some Remarks on Contemporary European Ethnological Thought." *Ethnologia Europaea*, I:1 (1967) pp. 38–44.

Hummel, Charles F. "English Tools in America: The Evidence of the Dominys." *Winterthur Portfolio*, II (1965) pp. 27–46.

Hunter, Dard Jr. "John and Caleb Vincent." *The Chronicle of the*

Early American Industries Association, IX:3 (September, 1956) pp. 26–28.

Hunter, Rowland C. *Old Houses in England.* New York: John Wiley; London: Chapman and Hall, 1930.

Huntingford, G. W. B. "Ancient Agriculture." *Antiquity,* VI:23 (1932) pp. 327–337.

Hutchison, Ruth. *The New Pennsylvania Dutch Cookbook.* New York: Paperback Library, 1966.

Huyett, Laura. "Straw Hat Making Among the Old Order Amish." *Pennsylvania Folklife,* 12:3 (Fall, 1961) pp. 40–41.

Ianni, Francis Anthony. "The Acculturation of the Italo-Americans in Norristown, Pennsylvania: 1900 to 1950." unpublished Ph.D. dissertation, Sociology, Pennsylvania State College, August, 1952.

Ickis, Marguerite. *The Standard Book of Quilt Making and Collecting.* New York: Dover, 1959, reprint of 1949 ed.

"Implements for Cutting Up Corn." *American Agriculturist,* XXVII:10 (October, 1868) p. 365.

"Improvements in Harrows." *The Cultivator and Country Gentleman,* LV:1954 (July 10, 1890) pp. 550–551.

"Improvement of the Geddes Harrow." *The Country Gentleman,* I:6 (February 10, 1853) p. 82.

Ingemann, W. M. *The Minor Architecture of Worcestershire.* London: John Trianti, 1938.

Innocent, C. F. *The Development of English Building Construction.* The Cambridge Technical Series, Cambridge: Cambridge University Press, 1916.

Isham, Norman M. and Albert F. Brown. *Early Connecticut Houses: An Historical and Architectural Study.* New York: Dover, 1965, reprint of 1900 ed.

Iverson, Marion Day. *The American Chair, 1630–1890.* New York: Hastings House, 1957.

Jack, Phil R. "Gravestone Symbols of Western Pennsylvania." in Kenneth S. Goldstein and Robert H. Byington, eds., *Two Penny Ballads and Four Dollar Whiskey.* Hatboro, Pa.: Folklore Associates for the Pennsylvania Folklore Society, 1966, pp. 165–173.

Jackson, Bruce. "Folk Ingenuity Behind Bars." *New York Folklore Quarterly*, XXII:4 (December, 1966) pp. 243–250.

Jaekel, Frederic B. "Squirrel-Tailed Bakeoven in Bucks County." *A Collection of Papers Read Before the Bucks County Historical Society*, IV (1917) pp. 579–586.

Jekyll, Gertrude. *Old English Household Life.* London: Batsford, 1925.

Jekyll, Gertrude. *Old West Surrey: Some Notes and Memories.* New York and Bombay: Longmans, Green, 1904.

Jenkin, A. K. Hamilton. *Cornish Homes and Customs.* London and Toronto: J. M. Dent, 1934.

Jenkins, J. Geraint. *Agricultural Transport in Wales.* Cardiff: National Museum of Wales, 1962.

Jenkins, J. Geraint. *The English Farm Wagon: Origins and Structure.* Museum of English Rural Life, Reading: Oakwood Press for the University of Reading, 1961.

Jenkins, J. Geraint. "Folk Life Studies and the Museum." *Museums Journal*, 61:3 (December, 1961) pp. 3–7.

Jenkins, J. Geraint. *Traditional Country Craftsmen.* London: Routledge and Kegan Paul, 1965.

Johnson, Clifton. *Among English Hedgerows.* New York: Macmillan, 1900, 1907, 1925.

Johnson, Clifton. *Highways and Byways from the St. Lawrence to Virginia.* New York: Macmillan, 1913.

Johnson, Clifton. *Highways and Byways of New England.* New York: Macmillan, 1921.

Johnson, Clifton. *Highways and Byways of the Mississippi Valley.* New York: Macmillan, 1906.

Johnson, Clifton. *Highways and Byways of the South*. New York: Macmillan, 1904.

Johnson, Clifton. *New England and Its Neighbors*. New York: Macmillan, 1902.

Johnson, Cuthbert W. *The Farmer's Encyclopaedia, and Dictionary of Rural Affairs*. Philadelphia: Carey and Hart, 1844.

Johnson, Guion Griffis. *A Social History of the Sea Islands*. Chapel Hill: University of North Carolina Press, 1930.

Johnston, Francis Benjamin and Thomas Tileston Waterman. *The Early Architecture of North Carolina*. Chapel Hill: University of North Carolina Press, 1947.

Jones, Agnes Halsey and Louis C. Jones. *New-Found Folk Art of the Young Republic*. Cooperstown: New York State Historical Association, 1960.

Jones, Gwyn E. "The Nature and Consequences of Technical Change in Farming." *Folk Life*, 3 (1965) pp. 79–87.

Jones, Laurence C. *Piney Woods and Its Story*. New York, London, Chicago, Edinburgh: Fleming H. Revell, 1922.

Jones, Louis C., ed. *Growing Up in the Cooper Country: Boyhood Recollections of the New York Frontier*. Syracuse: Syracuse University Press, 1965.

Jones, Louis C. "Style in American Folk Art." in Henry Glassie and Ralph Rinzler, eds., *Newport Folk Festival 1967*. New York: Newport Folk Foundation, 1967, pp. 9, 35.

Jones, Michael Owen. "A Traditional Chairmaker At Work." *Mountain Life and Work*, XLIII:1 (Spring, 1967) pp. 10–13.

Jones, Michael Owen. "The Study of Traditional Furniture: Review and Preview." *Keystone Folklore Quarterly*, XII:4 (Winter, 1967) pp. 233–245.

Jones, N. E. *The Squirrel Hunters of Ohio or Glimpses of Pioneer Life*. Cincinnati: Robert Clarke, 1898.

Jones, Sydney R. *English Village Homes and Country Buildings*. London: Batsford, 1947, first pub. 1936.

Jonitis, Peter Paul. "The Acculturation of the Lithuanians of Ches-

ter, Pennsylvania." unpublished Ph.D. thesis, Sociology, University of Pennsylvania, 1951.

Jordan, Terry G. "German Houses in Texas." *Landscape*, 14:1 (Autumn, 1964) pp. 24–26.

Jordan, Weymouth T. *Hugh Davis and His Alabama Plantation.* University, Ala.: University of Alabama Press, 1948.

Judson, Ardis. "The Last of the Pounded Ash Basket Makers." *Yankee*, 29:8 (August, 1965) pp. 70–71, 114.

Julien, Carl and Chlothilde R. Martin. *Sea Islands to Sand Hills.* Columbia: University of South Carolina Press, 1954.

Kallbrunner, Hermann. "Farms and Villages: The European Pattern." *Landscape*, 6:3 (Spring, 1957) pp. 13–17.

Kaminsky, John. "Carpatho-Slav Culture and Culture Change in St. Clair, Pennsylvania," unpublished M.A. thesis, Sociology, Pennsylvania State College, August, 1951.

Kauffman, Henry J. *Early American Ironware: Cast and Wrought.* Rutland, Vt.: Charles E. Tuttle, 1966.

Kauffman, Henry J. "Pennsylvania Barns." *The Farm Quarterly*, 9:3 (Autumn, 1954) pp. 58–61, 80, 83.

Kauffman, Henry J. *Pennsylvania Dutch American Folk Art.* New York: Dover, 1964, first pub. 1946.

Kauffman, Henry J. *The Pennsylvania-Kentucky Rifle.* Harrisburg: Stackpole, 1960.

Kaups, Matti and Cotton Mather. "Eben: Thirty Years Later in a Finnish Community in the Upper Peninsula of Michigan." *Economic Geography*, 44:1 (January, 1968) pp. 57–70.

Keil, Charles. *Urban Blues.* Chicago and London: University of Chicago Press, 1966.

Kelly, J. Frederick. "A Seventeenth-Century Connecticut Log House." *Old-Time New England*, XXXI:2 (October, 1940) pp. 28–41.

Kelly, J. Frederick. *The Early Domestic Architecture of Connecticut.* New York: Dover, 1963, reprint of 1924 ed.

Kelly, J. Frederick. "The Norton House, Guilford, Conn." *Old-Time New England,* XIV:3 (January, 1924) pp. 122–130.

Kelsey, Carl. *The Negro Farmer.* Chicago: Jennings and Pye, 1903.

Kelsey, Rayner Wickersham, ed. *Cazenove Journal 1794: A Record of the Journey of Theophile Cazenove through New Jersey and Pennsylvania (Translated from the French).* Haverford, Pa.: Pennsylvania History Press, 1922.

Kempers, A. J. Bernet. *Vijftig Jaar Nederlands Openluchtmuseum.* Arnhem: Rijksmuseum voor Volkskunde, "Het Nederlands Openluchtmuseum," 1962.

Kendall, Arthur Isaac. "Rifle Making in the Great Smokies." *The Regional Review,* VI:1,2 (January-February, 1941) pp. 20–31.

Kendall, Edward C. "John Deere's Steel Plow." *Contributions from the Museum of History and Technology,* U.S. National Museum Bulletin 218, Paper 2, Washington: Smithsonian Institution, 1959, pp. 15–25.

Kephart, Horace. *Our Southern Highlanders.* New York: Outing Publishing Co., 1913; New York: Macmillan, 1926.

Kerkhoff, Jennie Ann. *Old Homes of Page County, Virginia.* Luray, Va.: Lauck & Co., 1962.

Kettell, Russell Hawes. *The Pine Furniture of Early New England.* New York: Dover, modern reprint of 1929 ed.

Keune, Russell V. and James Replogle. "Two Maine Farm Houses." *Journal of the Society of Architectural Historians,* XX:1 (March, 1961) pp. 38–39.

Kimball, Yeffe and Jean Anderson. *The Art of American Indian Cooking.* Garden City, N.J.: Doubleday, 1965.

Kindig, Joe, Jr. *Thoughts on the Kentucky Rifle in its Golden Age.* York: Trimmer, 1960.

King, Arden R. "A Note on Emergent Folk Cultures and World Culture Change." *Social Forces,* 31:3 (March, 1953) pp. 234–237.

Kislinger, Max. *Alte Bäuerliche Kunst*. Linz: Oberösterreichischer Landesverlag, 1963.

Klees, Frederic. *The Pennsylvania Dutch*. New York: Macmillan, 1950.

Klopfer, Paul. *Das deutsche Bauern- und Bürgerhaus*. Leipzig: Alfred Kröner, 1915.

Kniffen, Fred. "The American Covered Bridge." *The Geographical Review*, XLI:1 (January, 1951) pp. 114–123.

Kniffen, Fred. "Folk Housing: Key to Diffusion." *Annals of the Association of American Geographers*, 55:4 (December, 1965), pp. 549–577.

Kniffen, Fred B. "Louisiana House Types." in Philip L. Wagner and Marvin W. Mikesell, eds., *Readings in Cultural Geography*. Chicago: University of Chicago Press, 1962, pp. 157–169, reprinted from *Annals of the Association of American Geographers*, XXVI (1936) pp. 179–193.

Kniffen, Fred. "The Outdoor Oven in Louisiana." *Louisiana History*, I:1 (1960) pp. 25–35.

Kniffen, Fred. "The Physiognomy of Rural Louisiana." *Louisiana History*, IV:4 (Fall, 1963) pp. 291–299.

Kniffen, Fred. "A Spanish (?) Spinner in Louisiana." *Southern Folklore Quarterly*, XIII:4 (December, 1949) pp. 192–199.

Kniffen, Fred. "To Know the Land and Its People." *Landscape*, 9:3 (Spring, 1960) pp. 20–23.

Kniffen, Fred. "The Western Cattle Complex." *Western Folklore*, XII:3 (July, 1953) pp. 179–185.

Kniffen, Fred, and Henry Glassie. "Building in Wood in the Eastern United States: A Time-Place Perspective." *The Geographical Review*, LVI:1 (January, 1966) pp. 40–66.

Knipmeyer, William B. "Settlement Succession in Eastern French Louisiana." unpublished Ph.D. dissertation, Geography and Anthropology, Louisiana State University (August, 1956).

Kolehmainen, John I., and George W. Hill. *Haven in the Woods:*

The Story of the Finns in Wisconsin. Madison: State Historical Society of Wisconsin, 1965.

Kollmorgen, Walter M. *Culture of a Contemporary Rural Community: The Old Order Amish of Lancaster County, Pennsylvania*. Rural Life Studies: 4, Washington: U.S.D.A. Bureau of Agricultural Economics, 1942.

Koock, Mary Faulk. *The Texas Cookbook*. Boston and Toronto: Little, Brown, 1965.

Koroleff, Alexander Michael, and Ralph C. Bryant. *The Transportation of Logs on Sleds*. Yale University School of Forestry Bulletin, 13, New Haven: Yale University Press, 1925.

Kouwenhoven, John A. *The Arts in Modern American Civilization*. New York: W. W. Norton, 1967, first published as *Made in America* in 1948.

Kovel, Ralph and Terry. *American Country Furniture, 1780-1875*. New York: Crown, 1965.

Kubler, George. *The Shape of Time: Remarks on the History of Things*. New Haven and London: Yale University Press, 1962.

Kück, Eduard. *Das alte Bauernleben der Lüneburger Heide*. Leipzig: Theod. Thomas, 1906.

Kurath, Hans. *A Word Geography of the Eastern United States*. Studies in American English, 1, Ann Arbor: University of Michigan Press, 1949.

Kutak, Robert I. *The Story of a Bohemian-American Village: A Study of Social Persistence and Change*. Louisville, Ky.: Standard Printing Co., 1933.

Kytle, Elizabeth. *Willie Mae*. New York: New American Library, 1964, reprint of 1958 ed.

Laedrach, Walter. *Der Bernische Speicher*. Berner Heimatbücher, Bern: Paul Haupt, 1954.

Lambert, F. *Tools and Devices for Coppice Crafts*. Young Farmer's Club Booklet No. 31, London: Evans Brothers, 1957.

Lancaster, Clay. *Ante Bellum Houses of the Bluegrass.* Lexington: University of Kentucky Press, 1961.

Lancaster, Robert A., Jr. *Historic Virginia Homes and Churches.* Philadelphia and London: J. B. Lippincott, 1915.

Land, Mary. *Louisiana Cookery.* Baton Rouge: Louisiana State University Press, 1954.

Landis, Henry Kinzer. *Early Kitchens of the Pennsylvania Germans.* Pennsylvania German Society Proceedings, XLVII, Part 2, Norristown: Pennsylvania German Society, 1939.

Landis, Henry Kinzer and George Diller Landis. "Lancaster Rifle Accessories." *The Pennsylvania German Folklore Society,* IX (1944) pp. 106–184.

Landis, Henry Kinzer and George Diller Landis. "Lancaster Rifles." *The Pennsylvania German Folklore Society,* VII (1942) pp. 107–157.

Lea, Zilla Rider, ed. *The Ornamented Chair: Its Development in America (1700–1890).* Rutland, Vt.: Charles E. Tuttle for the Esther Stevens Brazer Guild, 1960.

Leach, MacEdward, and Henry Glassie. *A Guide for Collectors of Oral Traditions and Folk Cultural Material in Pennsylvania.* Harrisburg: Pennsylvania Historical and Museum Commission, 1968.

Learned, M. D. "The German Barn in America." *University of Pennsylvania University Lectures Delivered by Members of the Faculty in the Free Public Lecture Course, 1913–1914.* Philadelphia: University of Pennsylvania Press, 1915.

Leechman, Douglas. "Good Fences Make Good Neighbours." *Canadian Geographical Journal,* XLVII:6 (December, 1953) pp. 218–235.

Lemon, James T. "The Agricultural Practices of National Groups in Eighteenth-Century Southeastern Pennsylvania." *The Geographical Review,* LVI:4 (October, 1966) pp. 467–496.

Leser, Paul. *Entstehung und Verbreitung des Pfluges.* Anthropos-Bibliothek III, 3, Münster: Aschendorffsche, 1931.

Lewis, Oscar. *Life in a Mexican Village: Tepoztlán Restudied.* Urbana: University of Illinois Press, 1963, reprint of 1951 ed.

Lichten, Frances. *Folk Art of Rural Pennsylvania.* New York: Charles Scribner's Sons, modern reprint of 1946 ed.

Lindsay, J. Seymour. *Iron and Brass Implements of the English and American House.* Bass River, Mass.: Carl Jacobs, 1964, first pub. 1927.

Lipman, Jean. *American Folk Decoration.* New York: Oxford University Press, 1951.

Lismer, Marjorie. *Seneca Splint Basketry.* Indian Handcrafts, 4, Chilocco, Okla.: U.S. Office of Indian Affairs, 1941.

Little, George A. *Malachi Horan Remembers.* Dublin: M. H. Gill, 1944.

Little, Nina Fletcher. *The Abby Aldrich Rockefeller Folk Art Collection.* Boston and Toronto: Colonial Williamsburg, Little, Brown, 1957; Williamsburg: Colonial Williamsburg, 1966.

Lloyd, Nathaniel. *A History of the English House.* London: The Architectural Press; New York: William Helburn, 1931.

Lloyd, Nelson. "Among the Dunkers." *Scribner's Magazine,* XXX:5 (November, 1901) pp. 513–528.

Lockwood, Luke Vincent. *Colonial Furniture in America.* 2 vols. in 1, New York: Castle Books, 1957, first pub. 1901, other eds. 1913, 1926.

London, Anne and Bertha Kahn Bishov. *The Complete American-Jewish Cookbook.* Cleveland and New York: World Publishing, 1952.

London, J. C. *An Encyclopaedia of Cottage, Farm, and Villa Architecture and Furniture.* London: Frederick Ware; New York: Scribner, Welford, 1869.

Long, Amos, Jr. "Bakeovens in the Pennsylvania Folk-Culture." *Pennsylvania Folklife,* 14:2 (December, 1964) pp. 16–29.

Long, Amos, Jr. "Dryhouses in the Pennsylvania Folk-Culture." *Pennsylvania Folklife*, 13:2 (Winter, 1962–1963) pp. 16–23.

Long, Amos, Jr. "Fences in Rural Pennsylvania." *Pennsylvania Folklife*, 12:2 (Summer, 1961) pp. 30–35.

Long, Amos, Jr. "Outdoor Bakeovens in Berks." *Historical Review of Berks County*, XXVIII:1 (Winter, 1962–1963) pp. 11–14, 31–32.

Long, Amos, Jr. "Outdoor Privies in the Dutch Country." *Pennsylvania Folklife*, 13:3 (July, 1963) pp. 33–38.

Long, Amos, Jr. "Pennsylvania Cave and Ground Cellars." *Pennsylvania Folklife*, 11:2 (Fall, 1960) pp. 36–41.

Long, Amos, Jr. "Pennsylvania Corncribs." *Pennsylvania Folklife*, 14:1 (October, 1964) pp. 16–23.

Long, Amos, Jr. "Pennsylvania Summer-Houses and Summer-Kitchens." *Pennsylvania Folklife*, 15:1 (Autumn, 1965) pp. 10–19.

Long, Amos, Jr. "Smokehouses in the Lebanon Valley." *Pennsylvania Folklife*, 13:1 (Fall, 1962) pp. 25–32.

Long, Amos, Jr. "Springs and Springhouses." *Pennsylvania Folklife*, 11:1 (Spring, 1960) pp. 40–43.

Long, Amos, Jr. "The Ice-House in Pennsylvania." *Pennsylvania Folklife*, 14:4 (Summer, 1965) pp. 46–55.

Long, Amos, Jr. "The Woodshed." *Pennsylvania Folklife*, XVI:2 (Winter, 1966–1967) pp. 38–45.

Long, Theodore K. *Tales of the Cocolamus.* New Bloomfield, Pa.: Carson Long Institute, 1936.

Lord, Priscilla Sawyer and Daniel J. Foley. *The Folk Art and Crafts of New England.* Philadelphia and New York: Chilton Books, 1965.

Love, Paul. "Patterned Brickwork in Southern New Jersey." *Proceedings of the New Jersey Historical Society*, LXXIII:3 (July, 1955) pp. 182–208.

Low, David. "The Harrow." *The Cultivator* (August, 1835) pp. 87–88.

Lowie, Robert H. *The Crow Indians.* New York: Holt, Rinehart and Winston, 1956, first pub. 1935.

Lucas, A. T. "Furze: A Survey and History of its Uses in Ireland." *Béaloideas,* XXVI (1958 [1960]) pp. 1–203.

Lucas, E. V. *Highways and Byways in Sussex.* London: Macmillan, 1907.

Ludwig, Allan I. *Graven Images: New England Stonecarving and Its Symbols, 1650–1815.* Middletown, Conn.: Wesleyan University Press, 1966.

Ludwig, G. M. "The Influence of the Pennsylvania Dutch in the Middle West." *The Pennsylvania German Folklore Society,* X (1945) pp. 1–101.

Luther, Clair Franklin. *The Hadley Chest.* Hartford: Case, Lockwood and Brainard, 1935.

Lyford, Carrie A. *Iroquois Crafts.* Lawrence, Kan.: Bureau of Indian Affairs, 1945.

Lyford, Carrie A. *Ojibwa Crafts (Chippewa).* Indian Handcrafts, 5, Lawrence, Kan.: Bureau of Indian Affairs, 1943.

Lynch, Edmund E. "Fishing on Otsego Lake." unpublished M.A. thesis, Cooperstown Graduate Program, State University of New York College at Oneonta, May 1965.

Lynch, Ernest Carlyle, Jr. *Furniture Antiques Found in Virginia: A Book of Measured Drawings.* New York: Bonanza, reprint of 1954 ed.

Lyon, Irving Phillips. "Square-Post Slat-Back Chairs: A Seventeenth Century Type found in New England." *Antiques,* XX:4 (October, 1931) pp. 210–216.

Macdonald, Dorothy K. *Fibres, Spindles and Spinning-Wheels.* n.p.: Royal Ontario Museum of Archaeology, 1950.

MacDonald, George. *Peasant Life: Sketches of the Villagers and Field-Laborers in Glenaldie.* London: Strahan, 1871.

Mackey, William J., Jr. *American Bird Decoys.* New York: E. P. Dutton, 1965.

Macrae, Marion. *The Ancestral Roof, Domestic Architecture of Upper Canada.* Toronto: Clarke, Irwin, 1963.

Major, Howard. *The Domestic Architecture of the Early American Republic: The Greek Revival.* Philadelphia and London: J. B. Lippincott, 1926.

"Making Split and Shaved Shingles." *American Agriculturist,* XXXVIII:6 (June, 1879) p. 223.

Mankowitz, Wolf and Reginald G. Haggar. *The Concise Encyclopedia of English Pottery and Porcelain.* New York: Hawthorn Books, n.d., c. 1957.

Marshall, L. T. "Hop Culture." *Report of the Commissioner of Patents for the Year 1861: Agriculture,* Washington: Government, 1862, pp. 289–293.

Marshall, Sybil. *Fenland Chronicle.* London: Cambridge University Press, 1967.

Martin, George A. *Farm Appliances. A Practical Manual.* New York: Orange Judd, 1892.

Martin, George A. *Fences, Gates and Bridges: A Practical Manual.* Chicago, New York, Springfield, Mass.: Orange Judd, 1903.

Mason, Otis Tufton. *Indian Basketry: Studies in a Textile Art Without Machinery.* 2 vols., New York: Doubleday, Page, 1904.

Mason, Robert Lindsay. *The Lure of the Great Smokies.* Boston and New York: Houghton Mifflin, 1927.

Mather, Eugene Cotton and John Fraser Hart. "Fences and Farms." *The Geographical Review,* XLIV:2 (April, 1954) pp. 201–223.

Mather, Cotton, and Matti Kaups. "The Finnish Sauna: A Cultural Index to Settlement." *Annals of the Association of American Geographers,* 53:4 (December, 1963) pp. 494–504.

Mayes, L. J. *The History of Chairmaking in High Wycombe.* London: Routledge and Kegan Paul, 1960.

McNall, Neil Adams. *An Agricultural History of the Genesee Valley, 1790–1860*. American Historical Association, Philadelphia: University of Pennsylvania Press, 1952.

McCourt, Desmond. "Weavers' Houses Around South-West Lough Neagh." *Ulster Folklife*, 8 (1962) pp. 43–56.

Meade, R. K. "Mode of Cultivating Indian Corn. Harrows." *Memoirs of the Philadelphia Society for Promoting Agriculture*, IV (1818) pp. 184–187.

Mejborg, R. *Nordiske Bøndergaarde I Det XVIde, XVIIde og XVIII de Aarhundrede: I: Slesvig*. Copenhagen: Lehman and Stages, 1892.

Mercer, Henry C. *Ancient Carpenters' Tools*. Doylestown: Bucks County Historical Society, 1960, first pub. 1929, also in *Old-Time New England*, XV:4; XVI: 1,2,3,4; XVII:2,4; XVIII:3; XIX:1.

Mercer, Henry C. "Ancient Methods of Threshing in Bucks County." *A Collection of Papers Read Before the Bucks County Historical Society*, V (1926) pp. 315–323.

Mercer, Henry C. *The Bible in Iron; or, the Pictured Stoves and Stove Plates of the Pennsylvania Germans*. Doylestown: Bucks County Historical Society, 1914, 1941, 1961; first published as *The Decorated Stove Plates of the Pennsylvania Germans*, Bucks County Historical Society Contributions to American History, 6, Doylestown: McGinty's, 1899.

Mercer, Henry C. "The Origin of Log Houses in the United States." *A Collection of Papers Read Before the Bucks County Historical Society*, V (1926) pp. 568–583. There is a modern reprint, and it also appeared in *Old-Time New England*, XVIII:1 (July, 1927); XVIII:2 (October, 1927).

Mercer, Henry C. "The Survival of the Mediaeval Art of Illuminative Writing Among Pennsylvania Germans." *Proceedings of the American Philosophical Society*, XXXVI (1897) pp. 424–433.

Mercer, Henry C. "The Zithers of the Pennsylvania Germans." *A*

*Collection of Papers Read Before the Bucks County Histori-
cal Society*, V (1926) pp. 482–497.

Meredith, Mamie. "The Nomenclature of American Pioneer
Fences." *Southern Folklore Quarterly*, XV:2 (June, 1951)
pp. 109–151.

Meyer, Johan. *Fortids Kunst i Norges Bygder*. Oslo: H.
Aschehoug, 1930.

Meyer-Heisig, Erich. *Deutsche Bauerntöpferei*. Munich: Prestel,
1955.

Michelsen, Peter. *Danish Wheel Ploughs: An Illustrated Cata-
logue*. Publications from the International Secretariat for
Research on the History of Agricultural Implements No. 2,
Copenhagen: National Museum, 1959.

Millar, Donald. "An Eighteenth Century German House in Penn-
sylvania." *The Architectural Record*, 63:2 (February, 1928)
pp. 161–168.

Miller, Roland B. "The Adirondack Guide Boat." *North Country
Life*, 4:4 (Fall, 1950) pp. 22–23.

Miller, Roland B. "The Adirondack Pack-basket." *The New York
State Conservationist*, 3:1 (August-September, 1948) pp.
8–9.

Miner, Horace. *Culture and Agriculture: An Anthropological
Study of a Corn Belt County*. Occasional Contributions
from the Museum of Anthropology of the University of
Michigan No. 14, Ann Arbor: University of Michigan
Press, 1949.

Miner, Horace. *St. Denis: A French-Canadian Parish*. Chicago:
University of Chicago Press, 1939.

Miner, T. B. "Progress of the Age." *The Northern Farmer*, II:3
(March, 1855) pp. 115–117.

Minhinnick, Jeanne. *Early Furniture in Upper Canada Village,
1800–1837*. Toronto: Ryerson, 1964.

Mississippi Choctaw Indians, The. Philadelphia, Miss.: Choctaw
Indian Agency, n.d., c. 1961.

Mitchell, N. C. "The Lower Bann Fisheries." *Ulster Folklife*, 11 (1965) pp. 1–32.

Moholy-Nagy, Sibyl. *Native Genius in Anonymous Architecture*. New York: Horizon, 1957.

Montgomery, Charles F. *American Furniture: The Federal Period in the Henry Francis duPont Winterthur Museum*. New York: Viking, 1966.

Mook, Maurice A., and John A. Hostetler. "The Amish and Their Land." *Landscape*, 6:3 (Spring, 1957) pp. 21–29, reprinted in " 'S Pennsylvaanisch Deitsch Eck," *Morning Call*, Allentown, July 8, 15, 22, 29, 1961.

Morand, Dexter. *The Minor Architecture of Suffolk*. London: John Trianti, 1929.

Morley, Margaret W. *The Carolina Mountains*. Boston and New York: Houghton Mifflin, 1913.

Morris, E. P. *The Fore-and-Aft Rig in America: A Sketch*. New Haven: Yale University Press, 1927.

Morrison, Hugh. *Early American Architecture from the First Colonial Settlements to the National Period*. New York: Oxford University Press, 1952.

Murphy, Michael J. *At Slieve Gullion's Foot*. Dundalk: Tempest, 1945.

Murtagh, William J. *Moravian Architecture and Town Planning: Bethlehem, Pennsylvania, and Other Eighteenth-Century American Settlements*. Chapel Hill: University of North Carolina Press, 1967.

Needham, Walter, and Barrows Mussey. *A Book of Country Things*. Brattleboro, Vt.: Stephen Greene, 1965; reprinted as *Grandfather's Book of Country Things*, New York: Paperback Library, 1966.

Nemec, Helmut. *Alpenländsiche Bauernkunst*. Wien: Kremayr and Scheriau, 1966.

Nevill, Ralph. *Old Cottage and Domestic Architecture in South-West Surrey, and Notes on the Early History of the Division*. Guildford: Billing and Sons, 1889.

Newcomb, Rexford. *Architecture of the Old North-West Territory*. Chicago: University of Chicago Press, 1950.

Newcomb, Rexford. *Old Kentucky Architecture*. New York: William Helburn, 1940.

Newhouse, S. *The Trapper's Guide*. New York: Oakley, Mason, 1869; Kenwood, N.Y.: Oneida Community, 1895.

Newswanger, Kiehl, and Christian. *Amishland*. New York: Hastings House, 1954.

Nichols, Frederick Doveton, and Francis Benjamin Johnston. *The Early Architecture of Georgia*. Chapel Hill: University of North Carolina Press, 1957.

Niederer, Frances J. *The Town of Fincastle, Virginia*. Charlottesville: University Press of Virginia, 1966.

Nixon, H. C. *Lower Piedmont Country*. New York: Duell, Sloan and Pearce, 1946.

Norris, Wilfred. "The Gravestones in the Old Burying Ground at Watertown, Mass. Their Decorative Carving, Lettering and Symbolism." *Old-Time New England*, XVI:2 (October, 1925) pp. 65–74.

Northern Traveller, and Northern Tour; with the Routes to The Springs, Niagara, and Quebec, and the Coal Mines of Pennsylvania; also, the Tour of New-England, The. New York: J. & J. Harper, 1830.

Norton, F. H. "The Crafts Pottery in Nashua, New Hampshire." *Antiques*, XIX:4 (April, 1931) pp. 304–305.

Norton, F. H. "The Exeter Pottery Works." *Antiques*, XXII:1 (July, 1932) pp. 22–25.

Norton, F. H., and V. J. Duplin, Jr. "The Osborne Pottery at Gonic, New Hampshire." *Antiques*, XIX:2 (February, 1931) pp. 123–124.

Nutting, Wallace. *Furniture of the Pilgrim Century (of American Origin) 1620–1720*. 2 vols., New York: Dover, 1965, reprint of 1924 ed.

Nutting, Wallace. *Furniture Treasury*. 3 vols., New York: Macmillan, 1948–1949, first pub. 1928, 1933.

Nutting, Wallace. *A Windsor Handbook*. Saugus, Mass.: Wallace Nutting, 1917.

Ocracoke Cook Book. Ocracoke, N.C.: Woman's Society of Christian Service of the United Methodist Church, n.d., c. 1965.

ó Danachair, Caoimhín. "The Combined Byre-and-Dwelling in Ireland." *Folk Life*, II (1964) pp. 58–75.

ó Danachair, Caoimhín. "Hearth and Chimney in the Irish House." *Béaloideas*, XVI:I-II (1946) pp. 91–104.

ó Danachair, Caoimhín. "Materials and Methods in Irish Traditional Building." *Journal of the Royal Society of Antiquaries of Ireland*, LXXXVII:1 (1957) pp. 61–74.

ó Danachair, Caoimhín. "The Spade in Ireland." *Béaloideas*, XXXI (1963[1965]) pp. 98–114.

ó Danachair, Caoimhín. "Three House Types." *Ulster Folklife*, 2 (1956) pp. 22–26.

Odum, Howard W. "Folk Sociology as a Subject Field for the Historical Study of Total Human Society and the Empirical Study of Group Behavior." *Social Forces*, 31:3 (March, 1953) pp. 193–223.

Ohm, Annaliese. *Volkskunst am Unteren Rechten Niederrhein*. Dusseldorf: Rheinland-Verlag GmbH, 1960.

Oliver, Basil. *The Cottages of England: A Review of Their Types and Features from the 16th to the 18th Centuries*. New York: Charles Scribner's Sons; London: Batsford, 1929.

Oliver, Basil. *Old Houses and Village Buildings in East Anglia, Norfolk, Suffolk, and Essex*. London: Batsford; New York: William Helburn, 1912.

Olmsted, Frederick Law. *A Journey in the Back Country.* New York: Mason Brothers, 1860.

[Olmsted, Frederick Law]. *Walks and Talks of an American Farmer in England.* 2 parts, New York: George P. Putnam, 1852.

Omwake, John. *The Conestoga Six-Horse Bell Teams of Eastern Pennsylvania.* Cincinnati: Ebbert and Richardson, 1930.

O'Neill, J. W. *The American Farmer's New and Universal Handbook.* Philadelphia: Charles Desilver, 1859.

Ormsbee, Thomas H. *The Windsor Chair.* New York: Deerfield Books, 1962.

ó Suilleabháin, Seán. *A Handbook of Irish Folklore.* Hatboro, Pa.: Folklore Associates, 1963, reprint of 1942 ed.

Owsley, Frank Lawrence. *Plain Folk of the Old South.* Chicago: Quadrangle Books, 1965, reprint of 1949 ed.

Palardy, Jean. *Les Meubles Anciens du Canada Français.* Paris: Arts et Metiers Graphiques, 1963.

Palmer, Nancy Doris. *The Perpetuation of Colonial Charm.* Frederick, Md.: Marken and Bielfeld, 1928.

Panum, Hortense. *The Stringed Instruments of the Middle Ages: Their Evolution and Development.* London: W. Reeves, n.d., c. 1939.

Parris, John. *My Mountains, My People.* Asheville: Citizen-Times Publishing Co., 1957.

Passmore, J. B. *The English Plough.* Reading University Studies, London: Humphrey Milford, Oxford University Press, 1930.

Pearsall, Marion. *Little Smoky Ridge.* University, Ala.: University of Alabama Press, 1959.

Pearson, Haydn S. *The Countryman's Cookbook.* New York and London: McGraw-Hill, 1946.

Peat, Wilbur D. *Indiana Houses of the Nineteenth Century.* Indianapolis: Indiana Historical Society, 1962.

Peate, Iorwerth C. "Some Welsh Houses." *Antiquity*, X:40 (December, 1936) pp. 448–459.

Peate, Iorwerth C. "The Study of Folk Life: and Its Part in the Defence of Civilization." *Gwerin*, II:3 (June, 1959) pp. 97–109.

Peate, Iorwerth C. *The Welsh House: A Study in Folk Culture.* Liverpool: Hugh Evans, 1946.

Peattie, Roderick, ed. *The Great Smokies and the Blue Ridge: The Story of the Southern Appalachians.* New York: Vanguard, 1943.

Peesch, Reinhard. *Holzgerät in seinen Urformen.* Deutsche Volkskunde, 42, Berlin: Akademie-Verlag, 1966.

Pendleton, Charles S. "Illicit Whiskey-Making." *Tennessee Folklore Society Bulletin*, XII:1 (March, 1946) pp. 1–16.

Pennsylvania Dutch Cook Book of Fine Old Recipes. Reading, Pa.: Culinary Arts Press, 1936, 1961.

Perrin, Richard W. E. " 'Fachwerkbau' Houses in Wisconsin." *Journal of the Society of Architectural Historians*, XVIII:1 (March, 1959) pp. 29–33.

Perrin, Richard W. E. "German Timber Farmhouses in Wisconsin: Terminal Examples of a Thousand-Year Building Tradition." *Wisconsin Magazine of History*, XLIV:3 (Spring, 1961) pp. 199–202.

Perrin, Richard W. E. *Historic Wisconsin Buildings: A Survey of Pioneer Architecture, 1835–1870.* Milwaukee Public Museum Publications in History No. 4, Milwaukee: Milwaukee Public Museum, 1962.

Perrin, Richard W. E. "John Bergen's Log House." *Wisconsin Magazine of History*, XLIV:1 (Autumn, 1960) pp. 12–14.

Perrin, Richard W. E. "Log Houses in Wisconsin." *Antiques*, LXXXIX:6 (June, 1966) pp. 867–871.

Perrin, Richard W. E. "Log Sauna and the Finnish Farmstead: Transplanted Architectural Idioms in Northern Wisconsin."

Wisconsin Magazine of History, XLIV:4 (Summer, 1961) pp. 284–286.

Perrin, Richard W. E. "Wisconsin 'Stovewood' Walls, Ingenious Forms of Early Log Construction." *Wisconsin Magazine of History,* 46:3 (Spring, 1963) pp. 215–219.

Peterkin, Julia, and Doris Ulmann. *Roll, Jordan, Roll.* Indianapolis and New York: Bobbs-Merrill, 1933.

Peterson, Charles E. "Early Ste. Genevieve and Its Architecture." *The Missouri Historical Review,* XXXV:2 (January, 1941) pp. 207–232.

Peterson, Charles E. "The Houses of French St. Louis." in John Francis McDermott, ed., *The French in the Mississippi Valley.* Urbana: University of Illinois Press, 1965, pp. 17–40.

Peterson, Frederick. "The Fishermen of Gloucester." *Americana,* XXXI:3 (July, 1937) pp. 461–491.

Peterson, Harold L. *American Knives: The First History and Collectors' Guide.* New York: Charles Scribner's Sons, 1958.

Peto, Florence. *American Quilts and Coverlets.* New York: Chanticleer Press, 1949.

Phillips, Yvonne. "The Bousillage House." *Louisiana Studies,* III:1 (Spring, 1964) pp. 155–158.

Phillips, Yvonne. "The Syrup Mill." *Louisiana Studies,* IV:4 (Winter, 1965) pp. 354–356.

Pierce, Wesley George. *Goin' Fishin': The Story of the Deep-Sea Fishermen of New England.* Salem, Mass.: Marine Research Society, 1934.

Pieters, Alieda J. *A Dutch Settlement in Michigan.* Grand Rapids: The Reformed Press, 1923.

Pike, Robert E. *Tall Trees, Tough Men.* New York: W. W. Norton, 1967.

Plumb, Charles S. *Indian Corn Culture.* Chicago: Breeder's Gazette Print, 1895.

Podolák, Ján. "Zimná Doprava Sena z Horských Lúk na Západnej

Strane Vel'kje Fatry." *Slovenský Národopis,* X:4 (1962) pp. 565–574.

Poor, Alfred Easton. *Colonial Architecture of Cape Cod, Nantucket and Martha's Vineyard.* New York: William Helburn, 1932.

Porte Crayon. "North Carolina Illustrated." *Harper's New Monthly Magazine,* XIV:LXXXII (March, 1857) pp. 433–450; XIV:LXXXIV (May, 1857) pp. 741–755; XV:LXXXVI (July, 1857) pp. 154–164; XV:LXXXVII (August, 1857) pp. 289–300.

Post, Lauren C. *Cajun Sketches from the Prairies of Southwest Louisiana.* Baton Rouge: Louisiana State University Press, 1962.

Powell, Sumner Chilton. *Puritan Village: The Formation of a New England Town.* Garden City, N.Y.: Doubleday, 1963.

Powers, Stephen. *Afoot and Alone; A Walk from Sea to Sea by the Southern Route.* Hartford: Columbian Book Co., 1872.

Prolix, Peregrine. *A Pleasant Peregrination Through the Prettiest Parts of Pennsylvania.* Philadelphia: Grigg and Elliot, 1836.

Pugh, Lamont. "Hog-Killing Day." *Virginia Cavalcade,* VII:3 (Winter, 1957) pp. 41–46.

Putnam, John. "The Plucked Dulcimer." *Mountain Life and Work,* XXXIV:4 (1958) pp. 7–13.

Quilts and Coverlets in the Newark Museum. Newark: Newark Museum, 1948.

Radford, William A. *Radford's Practical Barn Plans.* New York: Radford Architectural Co., 1909.

Raine, James Watt. *The Land of Saddle-bags.* New York: Council of Women for Home Missions and Missionary Education Movement of the United States and Canada, 1924.

Raine, James Watt. *Saddlebag Folk: The Way of Life in the Kentucky Mountains.* Evanston, Ill.: Row, Peterson, 1942.

Raistrick, Arthur. *Pennine Walls.* Cross Hills: Dalesman, 1961, first pub. 1946.

Ramsay, John. "A Note on the Geography of Hooked Rugs." *Antiques,* XVIII:6 (December, 1930) pp. 510–512.

Ramsay, John. *American Potters and Pottery.* Clinton, Mass.: Hale, Cusman and Flint, 1939.

Ramsey, Frederic, Jr. *Been Here and Gone.* London: Cassell, 1960.

Randell, Arthur R., Enid Porter, ed. *Sixty Years a Fenman.* London: Routledge and Kegan Paul, 1966.

Randolph, Peter. *From Slave Cabin to Pulpit.* Boston: James H. Earle, 1893.

Randolph, Vance. *The Ozarks: An American Survival of Primitive Society.* New York: Vanguard, 1931.

Range, Willard. *A Century of Georgia Agriculture, 1850–1950.* Athens: University of Georgia Press, 1954.

Raper, Arthur F. *Preface to Peasantry: A Tale of Two Black Belt Counties.* Chapel Hill: University of North Carolina Press, 1936.

Raper, Arthur. *Tenants of the Almighty.* New York: Macmillan, 1943.

Rasmussen, Holger, ed. *Dansk Folkemuseum and Frilandsmuseet: History and Activities. Axel Steensberg in Honour of his 60th Birthday 1st June 1966.* [Copenhagen]: Nationalmuseet, 1966.

Raup, H. F. "The Fence in the Cultural Landscape." *Western Folklore,* VI (1947) pp. 1–7.

Rawlings, Marjorie Kinnan. *Cross Creek Cookery.* New York: Charles Scribner's Sons, 1942.

Rawson, Marion Nicholl. *Little Old Mills.* New York: E. P. Dutton, 1935.

Rawson, Marion Nicholl. *Of the Earth Earthy.* New York: E. P. Dutton, 1937.

Raymond, Eleanor. *Early Domestic Architecture of Pennsylvania.* New York: William Helburn, 1931.

Redfield, Robert. "The Folk Society." *The American Journal of Sociology*, LII:4 (January, 1947) pp. 293–311.

Redfield, Robert. *The Little Community and Peasant Society and Culture*. Chicago: University of Chicago Press, 1960, reprint of 1953, 1956 eds.

Redfield, Robert. *The Primitive World and Its Transformations*. Ithaca: Cornell University Press, 1962, first pub. 1953.

Rees, Alwyn D. *Life in a Welsh Countryside*. Cardiff: University of Wales, 1950.

Reeves, James. *The Idiom of the People*. New York: W. W. Norton, 1965.

Reinecke, George F., ed. "Early Louisiana French Life and Folklore from the Anonymous Breaux Manuscript as edited by Professor Jay K. Dichty." *Louisiana Folklore Miscellany*, II:3 (May, 1966) pp. 1–58.

Reinecke, George F. "The New Orleans Twelfth Night Cake." *Louisiana Folklore Miscellany*, II:2 (April, 1965) pp. 45–54.

Reinert, Guy F. *Coverlets of the Pennsylvania Germans*. Pennsylvania German Folklore Society, XIII, Allentown: Schlechter's, 1949.

Reinert, Guy F. *Pennsylvania German Splint and Straw Baskets*. Home Craft Course Vol. XXII, Plymouth Meeting, Pa.: Mrs. C. Naaman Keyser, 1946.

Report of the Commission to the Five Civilized Tribes to the Secretary of the Interior. Washington: Government, 1899, 1902, 1904.

Reynolds, Helen Wilkinson. *Dutch Houses in the Hudson Valley Before 1776*. New York: Dover, 1965, reprint of 1929 ed.

Rice, A. H. and John Baer Stoudt. *The Shenandoah Pottery*. Strasburg, Va.: Shenandoah Publishing House, 1929.

Richardson, E. P. *A Short History of Painting in America*. New York: Thomas Y. Crowell, 1963.

Riedl, Norbert F. "Folklore and the Study of Material Aspects of

Folk Culture." *Journal of American Folklore,* 79:314 (October–December, 1966) pp. 557–563.

Riedl, Norbert F. "Folklore vs. 'Volkskunde'." *Tennessee Folklore Society Bulletin,* XXI:2 (June, 1965) pp. 47–53.

Ringgold, James. "On the Best Mode of Harvesting Indian Corn." *The American Farmer,* IV:16 (July 5, 1822) pp. 125–126.

Ritchie, Jean. *The Dulcimer Book.* New York: Oak Publications, 1963.

Riviere, Georges Henri. "Folk Architecture Past, Present and Future." *Landscape,* 4:1 (Summer, 1954) pp. 5–12.

Robacker, Earl F. *Pennsylvania Dutch Stuff.* Philadelphia: University of Pennsylvania Press, 1944.

Robacker, Earl F. *Pennsylvania German Cooky Cutters and Cookies.* Home Craft Course Vol. 18, Plymouth Meeting, Pa.: Mrs. C. Naaman Keyser, 1946.

Robacker, Earl F. *Touch of the Dutchland.* New York: A. S. Barnes; London: Thomas Yoseloff, 1965.

Robert, Jean. *La Maison Rurale Permanente dans Les Alpes Françaises du Nord.* 2 vols., Grenoble: Imprimerie Allier Pére et Fils, 1939; Tours; Arrault et Cie Maitres, 1939.

Roberts, Isaac Phillips. *Autobiography of a Farm Boy.* Ithaca: Cornell University Press, 1946, first pub. 1916.

Roberts, Leonard W. *Up Cutshin and Down Greasy.* [Lexington]: University of Kentucky Press, 1959.

Roberts, Ned H. *The Muzzle-Loading Cap Lock Rifle.* Harrisburg: Stackpole, 1958, first pub. 1940.

Robertson, Ben. *Red Hills and Cotton: An Upcountry Memory.* New York: Alfred A. Knopf, 1942.

Robertson, Elizabeth Wells. *American Quilts.* New York: The Studio, 1948.

Rogers, Lore A., and Caleb W. Scribner. "The Peavey Cant-Dog." *The Chronicle of the Early American Industries Association,* XX:2 (June, 1967) pp. 17–21.

Rosenberger, Jesse Leonard. *The Pennsylvania Germans, A Sketch of Their History and Life, of the Mennonites, and of Side Lights from the Rosenberger Family.* Chicago: University of Chicago Press, 1923.

Ross, Malcolm. *Machine Age in the Hills.* New York: Macmillan, 1933.

Rowe, John. "Cornish Emigrants in America." *Folk Life,* 3 (1965) pp. 25–38.

Rubi, Christian. *Berner Bauernmalerei.* Berner Heimatbücher, Bern: Paul Haupt, 1948.

Russell, Carl P. *Guns on the Early Frontiers.* Berkeley and Los Angeles: University of California Press, 1962, first pub., 1957.

Salaman, R. A. "Tools of the Shipwright, 1650–1925." *Folk Life,* 5 (1967) pp. 19–51.

Salzman, L. F. *Building in England Down to 1540.* London: Oxford University Press, 1952.

Sandklef, Albert. *Singing Flails, A Study in Threshing-Floor Constructions, Flail-Threshing Traditions and the Magic Guarding of the House.* Folklore Fellows Communications No. 136, Helsinki: Suomalainen Tiedeakatemia, 1949.

Saucier, Corinne L. *Traditions de la Paroisse des Avoyelles en Louisiane.* Memoirs of the American Folklore Society Vol. 47, Philadelphia: American Folklore Society, 1956.

Sauer, Carl O. *The Geography of the Ozark Highlands of Missouri.* The Geographic Society of Chicago Bulletin No. 7, Chicago: University of Chicago, 1920.

Sawyer, Charles Winthrop. "The Why and How of Engraved Powder Horns." *Antiques,* XVI:4 (October, 1929) pp. 283–285.

Saxon, Lyle, Edward Dreyer, and Robert Tallant. *Gumbo Ya-Ya.* Boston: Houghton Mifflin, 1945.

Scarborough, Dorothy. *From a Southern Porch.* New York and London: G. P. Putnam's Sons, 1919.

Scheuermeier, Paul. *Bauernwerk in Italien der Italienischen und Rätoromanischen Schweiz.* Erlenbach and Zurich: Eugen Rentsch, 1943.

Scheybal, Josef V. "K Nekterým Otazkám Patrového Stavitelství na Slovensku." *Slovenský Národopis,* VIII:3 (1960) pp. 494–501.

Schiffer, Herbert. *Early Pennsylvania Hardware.* Whitford, Pa.: Whitford Press, 1966.

Schiffer, Margaret Berwind. *Furniture and Its Makers of Chester County, Pennsylvania.* Philadelphia: University of Pennsylvania Press, 1966.

Schilli, Hermann. *Das Schwarzwaldhus.* Stuttgart: W. Kohlhammer, 1953.

Schmidt, Leopold. *Volkskunst in Österreich.* Wien and Hannover: Forum, 1966.

Schoettle, Edwin J., ed. *Sailing Craft.* New York: Macmillan, 1928.

Schreiber, William I. *Our Amish Neighbors.* Chicago: University of Chicago Press, 1962.

Schreiber, William I. "The Pennsylvania Dutch Bank Barn in Ohio." *Journal of the Ohio Folklore Society,* II:1 (Spring, 1967) pp. 15–28.

Schrijnen, Joseph. *Nederlandsche Volkskunde.* 2 vols., Zutphen: W. J. Thieme, 1930.

Schulz, Ed. "Ted Hamner, Builder of Adirondack Guide Boats." *North Country Life,* II:2 (Spring, 1957) pp. 23–25.

Schwarz, A. "Early Forms of the Reel." *Ciba Review,* 59 (August, 1947) pp. 2130–2133.

Schwarze, Wolfgang. *Wohnkultur des 18. Jahrh. im Bergischen Land.* Wuppertal-Barmen: Schwarze and Oberhoff, 1964.

Schweitzer, H. J., ed. *Rural Sociology in a Changing Urbanized Society.* Background Papers for a 1964 Illinois seminar, Special Publication No. 11, Urbana: University of Illinois College of Agriculture, 1966.

Scofield, Edna. "The Evolution and Development of Tennessee Houses." *Journal of the Tennessee Academy of Science,* XI:4 (October, 1936) pp. 229–240.

Scroggs, William O. "Rural Life in the Lower Mississippi Valley About 1803." *Proceedings of the Mississippi Valley Historical Association,* VIII (1914–1915) pp. 262–277.

Sears, Robert. *A Pictorial Description of the United States.* New York: author, 1855.

Seebohm, M. E. [Mabel Elizabeth Christie]. *The Evolution of the English Farm.* Cambridge: Harvard University Press, 1927.

Seeger, Charles. "The Appalachian Dulcimer." *Journal of American Folklore,* 71:279 (January–March, 1958) pp. 40–51.

Séguin, Robert-Lionel. *Les Granges du Québec du XVIIe au XIXe siècle.* Musée National du Canada Bulletin No. 192, No. 2 de la Série des Bulletins d'Histoire, Ottawa: Ministère du Nord Canadien et des Ressources Nationales, 1963.

Semple, Ellen Churchill. "The Anglo-Saxons of the Kentucky Mountains: A Study in Anthropogeography." *The Geographical Journal,* XVII (1901) pp. 588–623.

Seyffert, Oskar. *Von der Wiege bis zum Grabe: Ein Beitrag zur sächsischen Volkskunst.* Wien, Gerlach and Wiedling, n.d., c. 1924.

Shaner, Richard H. "The Oley Valley Basketmaker." *Pennsylvania Folklife,* 14:1 (October, 1964) pp. 2–8.

Shaw, Margaret Fay. *Folksongs and Folklore of South Uist.* London: Routledge and Kegan Paul, 1955.

Shelley, Donald A. *The Fraktur-Writings or Illuminated Manuscripts of the Pennsylvania Germans.* Pennsylvania German Folklore Society, XXIII, Allentown: Schlechter's, 1961.

Sheppard, Muriel Earley. *Cabins in the Laurel.* Chapel Hill: University of North Carolina Press, 1946, first pub. 1935.

Sherman, Mandel, and Thomas R. Henry. *Hollow Folk.* New York: Thomas Y. Crowell, 1933.

Shoemaker, Alfred L. *Check List of Pennsylvania Dutch Printed Taufscheins.* Lancaster: Pennsylvania Dutch Folklore Center, 1952.

Shoemaker, Alfred L. *Hex, No!* Lancaster: Pennsylvania Dutch Folklore Center, 1953. Also in *Three Myths About the Pennsylvania Dutch Country,* Lancaster: Pennsylvania Dutch Folklore Center, 1951; *Pennsylvania Dutch Hex Signs,* Lancaster: Photo Arts Press, 1966.

Shoemaker, Alfred L., ed. *The Pennsylvania Barn.* Kutztown: Pennsylvania Folklife Society, 1959, 2nd ed.

Shoemaker, Alfred L. "Straw Roofs in the Pennsylvania Dutch Country." *The Pennsylvania Dutchman,* II:1 (May 1, 1950) p. 3.

Showalter, Mary Emma. *Mennonite Community Cookbook, Favorite Family Recipes.* Philadelphia and Toronto: John C. Winston, 1950.

Shumway, George, Edward Durell, and Howard C. Frey. *Conestoga Wagon, 1750–1850. Freight Carrier for 100 Years of America's Westward Expansion.* York, Pa.: George Shumway and Early American Industries Association, 1966, 2nd. ed.

Shurtleff, Harold R., Samuel Eliot Morison, ed. *The Log Cabin Myth.* Cambridge: Harvard University Press, 1939.

Sickler, Joseph S. *The Old Houses of Salem County.* Salem, N.J.: Sunbeam, 1949.

Simms, Jeptha R. *Trappers of New York.* Albany: J. Munsell, 1850, later eds.

Sinclair, Colin. *The Thatched Houses of the Old Highlands.* London and Edinburgh: Oliver and Boyd, 1953.

Singer, Charles, E. J. Holmyard, A. R. Hall, and Trevor I. Williams. *A History of Technology.* 5 vols., London: Oxford University Press, 1954–1958.

Singleton, Esther. *The Furniture of Our Forefathers.* New York: Doubleday, Page, 1901.

Sitterson, J. Carlyle. *Sugar Country: The Cane Industry in the South, 1753–1950.* [Lexington]: University of Kentucky Press, 1953.

Slay, Ronald J. *The Development of the Teaching of Agriculture in Mississippi.* New York: Teacher's College, Columbia University, 1928.

Sloane, Eric. *An Age of Barns.* New York: Funk and Wagnalls, n.d., 1966.

Sloane, Eric. *American Barns and Covered Bridges.* New York: Wilfred Funk, 1954.

Sloane, Eric. *A Museum of Early American Tools.* New York: Wilfred Funk, 1964.

Smith, David C. "Middle Range Farming in the Civil War Era: Life on a Farm in Seneca County, 1862–1866." *New York History,* XLVIII:4 (October, 1967) pp. 352–369.

Smith, Edward C., and Virginia van Horn Thompson. *Traditionally Pennsylvania Dutch.* New York: Hastings House, 1947.

Smith, Ellen D. "The Smith Plow." *A Collection of Papers Read Before the Bucks County Historical Society,* III (1909) pp. 11–17.

Smith, Elmer Lewis. *The Amish People.* New York: Exposition, 1958.

Smith, Elmer Lewis. *The Amish Today.* Pennsylvania German Folklore Society, XXIV, Allentown: Schlechter's, 1961.

Smith, Elmer L., and Mel Horst. *Hex Signs and Other Barn Decorations.* Witmer, Pa.: Applied Arts, 1965.

Smith, Elmer Lewis, John G. Stewart and M. Ellsworth Kyger. *The Pennsylvania Germans of the Shenandoah Valley,* The Pennsylvania German Folklore Society, XXVI, Allentown: Schlechter's, 1964.

Smith, H. R. Bradley. *Blacksmiths' and Farriers' Tools at Shelburne Museum—A History of Their Development from Forge to Factory.* Museum Pamphlet Series No. 7, Shelburne, Vt.: Shelburne Museum, 1966.

Smith, Mason Philip. "Burial Ground Art." *Down East*, XII:4 (November, 1965) pp. 16–19.

Smith, P. A. L. *Boyhood Memories of Fauquier*. Richmond, Va.: Old Dominion Press, 1926.

Sneller, Anne Gertrude. *A Vanished World*. Syracuse: Syracuse University Press, 1964.

Solon, L. M. *The Art of the Old English Potter*. New York: D. Appleton, 1886.

Sonn, Albert H. *Early American Wrought Iron*. 3 vols., New York: Charles Scribner's Sons, 1928.

Sooder, Melchior. "Die Alten Bienenwohnungen der Schweiz." *Schweizerisches Archiv für Volkskunde*, 43 (1946) pp. 588–620.

"Sorghum Canes." *Report of the Commissioner of Patents for the Year 1857: Agriculture*, Washington: James B. Steedman, 1858, pp. 181–226.

Spamer, Adolph. *Hessische Volkskunst*. Jena: Eugen Diedrichs, 1939.

Spargo, John. *Early American Pottery and China*. New York and London: Century, 1926.

Spears, John R. *The Story of the New England Whalers*. New York: Macmillan, 1910.

Speck, Frank G. "Decorative Art and Basketry of the Cherokee." *Bulletin of the Public Museum of the City of Milwaukee*, II:2 (July 27, 1920) pp. 53–86.

Speck, Frank G. *Decorative Art of Indian Tribes of Connecticut*. Canada Department of Mines Geological Survey Memoir 75, Anthropological Series No. 10, Ottawa: Government Printing Bureau, 1915.

Speck, Frank G. *Eastern Algonkian Block-Stamp Decoration: A New World Original or an Acculturated Art*. Research Series No. 1, Trenton: The Archeological Society of New Jersey, 1947.

Speck, Frank G. *Penobscot Man: The Life History of a Forest*

Tribe in Maine. Philadelphia: University of Pennsylvania Press, 1940.

Spencer, Audrey. *Spinning and Weaving at Upper Canada Village.* Toronto: Ryerson, 1964.

Spencer, J. E. "House Types of Southern Utah." *The Geographical Review,* XXV:3 (July, 1945) pp. 444–457.

Spinney, Frank O. "Chapman Lee, Country Cabinet Maker." *The New England Galaxy,* I:3 (Winter, 1960) pp. 34–38.

Springer, John S. *Forest Life and Forest Trees: Comprising Winter Camp-Life Among the Loggers, and Wild-Wood Adventure.* New York: Harper and Brothers, 1851.

Stackpole, E. J. *Tales of My Boyhood.* Harrisburg: Telegraph Printing, 1921.

Stackpole, Edouard A. *Scrimshaw at Mystic Seaport.* No. 33, Mystic, Conn.: Marine Historical Association, 1958.

Stackpole, Edouard A. *Small Craft at Mystic Seaport.* No. 36, Mystic, Conn.: Marine Historical Association, 1959.

Steensberg, Axel. *Ancient Harvesting Instruments: A Study in Archaeology and Human Geography.* Nationalmuseets Skrifter Arkaeologisk-Historisk Raekke, I, Copenhagen: I Kommission Hos Gyldendalske Boghandel, 1943.

Steensberg, Axel. "North West European Plough-Types of Prehistoric Times and the Middle Ages." *Acta Archaeologica,* VII (1936) pp. 244–280.

Stell, Cristopher. "Pennine Houses: An Introduction." *Folk Life,* 3 (1965) pp. 5–24.

Steinmetz, Rollin C. and Charles S. Rice. *Vanishing Crafts and Their Craftsmen.* New Brunswick, N.J.: Rutgers University Press, 1959.

Stoddard, S. R. *The Adirondacks: Illustrated.* Glens Falls, N.Y.: author, 1881.

Stotz, Charles Morse. *The Early Architecture of Western Pennsylvania.* New York and Pittsburgh: William Helburn, 1936; reprinted as *The Architectural Heritage of Early*

Western Pennsylvania in 1966 by the University of Pittsburgh Press.

Stoudt, John Joseph. *Early Pennsylvania Arts and Crafts.* New York: A. S. Barnes; London: Thomas Yoseloff, 1964.

Stoudt, John Joseph. *Pennsylvania German Folk Art: An Interpretation.* Pennsylvania German Folklore Society, XXVIII, Allentown: Schlecter's, 1966. Printed as *Consider the Lilies, How They Grow* as vol. II in 1937 and as *Pennsylvania Folk-Art: An Interpretation* in 1948.

Stoudt, John Joseph. *The Decorated Barns of Eastern Pennsylvania.* Home Craft Course, XV, Plymouth Meeting, Pa.: Mrs. C. Naaman Keyser, 1945.

Strawn, Laura B. "Applebutter Making as Practiced by Our Ancestors." *A Collection of Papers Read Before the Bucks County Historical Society,* IV (1917) pp. 331–333.

Street, Julia Montgomery. "Mountain Dulcimer." *North Carolina Folklore,* XIV:2 (November, 1966) pp. 26–30.

Sturtevant, William C. *Guide to Field Collecting of Ethnographic Specimens.* Information Leaflet 503, Washington: Smithsonian Institution, Museum of Natural History, 1967.

Sturtevant, William C. "Seminole Men's Clothing." in June Helm, ed., *Essays on the Verbal and Visual Arts: Proceedings of the 1966 Annual Spring Meeting of the American Ethnological Society.* Seattle and London: University of Washington Press for American Ethnological Society, 1967, pp. 160–174.

Sussman, Marvin B., ed. *Community Structure and Analysis.* New York: Thomas Y. Crowell, 1959.

Swain, Frank K. "Making a Dugout Boat in Mississippi." *A Collection of Papers Read Before the Bucks County Historical Society,* V (1926) pp. 87–89.

Swan, Mabel M. "French Provincial Chairs." *Antiques,* XVIII:4 (October, 1930) pp. 312–317.

Swanton, John R. *Indian Tribes of the Lower Mississippi Valley and Adjacent Coast of the Gulf of Mexico.* Bureau of

American Ethnology Bulletin, 43, Washington: Government, 1911.

Swanton, John R. *The Indians of the Southeastern United States.* Bureau of American Ethnology Bulletin, 137, Washington: Smithsonian Institution, 1946.

Swanton, John R. *Source Material for the Social and Ceremonial Life of the Choctaw Indians.* Bureau of American Ethnology Bulletin, 103, Washington: Government and Smithsonian Institution, 1931.

Symons, Harry. *Fences.* Toronto: Ryerson Press, 1958.

Szwed, John. *Private Cultures and Public Imagery: Interpersonal Relations in a Newfoundland Peasant Society.* Newfoundland Social and Economic Studies No. 2, St. Johns: Institute of Social and Economic Research Memorial University of Newfoundland, 1966.

Talve, Ilmar. *Bastu och Torkhus i Nordeuropa.* Nordiska Museets Handlingar, 53, Stockholm: Nordiska Museets, 1960.

Talve, Ilmar. "Om Bastubad På Svensk Landsbygd." *Folk-Liv,* XVI (1952) pp. 62–73.

Taylor, Erich A. O'D. "The Slate Gravestones of New England." *Old-Time New England,* XV:2 (October, 1924) pp. 58–67.

Taylor, Helen V. *A Time to Recall: The Delights of a Maine Childhood.* New York: W. W. Norton, 1963.

Taylor, Henry H. "Some Connecticut Yarn Reels." *Antiques,* XVII:6 (June, 1930) pp. 538–540.

Terry, T. B. *Our Farming; or, How We Have Made a Run-down Farm Bring Both Profit and Pleasure.* Philadelphia: The Farmer Co., 1893.

Thomas, Charles. "Archaeology and Folk-Life Studies." *Gwerin,* III:1 (June, 1960) pp. 7–17.

Thomas, Edith M. *Mary at the Farm and Book of Recipes Compiled During her Visit Among the "Pennsylvania Germans."* Norristown: John Hartenstine, 1915.

Thomas, Edith M. "Old Dutch Bakeovens." *A Collection of Papers Read Before the Bucks County Historical Society,* IV (1917) pp. 574–576.

Thompson, G. B. "Folk Culture and the People." *The Advancement of Science,* XIV:57 (June, 1958) pp. 480–486.

Thompson, G. B. *Primitive Land Transport of Ulster.* Transport Handbook No. 2, Publication No. 159, Belfast: Belfast Museum and Art Gallery, 1958.

Thompson, G. B. *Spinning Wheels (The John Horner Collection).* Publication No. 168, Belfast: Ulster Museum, 1964.

Thompson, Stith. "Advances in Folklore Studies." in A. L. Kroeber, ed., *Anthropology Today: An Encyclopedic Inventory.* Chicago: University of Chicago Press, 1955, pp. 587–596.

Thornborough, Laura. *The Great Smoky Mountains.* New York: Thomas Y. Crowell, 1937; Knoxville: University of Tennessee Press, 1962.

Thwing, Leroy. *Flickering Flames, A History of Domestic Lighting Through the Ages.* Rutland, Vt.: Charles E. Tuttle, 1958.

Todd, Sereno Edwards. *Todd's Country Homes and How to Save Money. A Practical Book by a Practical Man.* Philadelphia, Chicago, Cincinnati, and St.Louis: J. C. McCurdy, 1877.

Torell, Eleanor E. "Family Changes in Three Generations of Swedes." *American Swedish Historical Museum Year Book* (1946) pp. 61–75.

Traquair, Ramsay. "Hooked Rugs in Canada." *Canadian Geographical Journal,* XXVI:5 (May, 1943) pp. 240–254.

Trewartha, Glenn T. "Some Regional Characteristics of American Farmsteads." *Annals of the Association of American Geographers,* XXXVIII:3 (September, 1948) pp. 169–225.

Turner, Robert B., ed. *Lewis Miller: Sketches and Chronicles: The Reflections of a Nineteenth Century Pennsylvania German Folk Artist.* York: Historical Society of York County, 1967.

Turner, W. J. *Exmoor Village.* London: George G. Harrap, 1947.

Tyler, John M. *The New Stone Age in Northern Europe.* New York: Scribner, 1921.

Tyree, Marion Cabell. *Housekeeping in Old Virginia.* Louisville: John P. Morton, 1890.

Uebe, F. Rudolf. *Deutsche Bauernmöbel.* Berlin: Richard Carl Schmidt, 1924.

Uldall, Kai. *Dansk Folkekunst.* Copenhagen: Thaning and Appels, 1963.

Valetta, Clement. "Italian Immigrant Life in Northampton County, Pennsylvania, 1890–1915." *Pennsylvania Folklife,* 14:3 (Spring, 1965) pp. 36–45; 15:1 (Autumn, 1965) pp. 39–48.

Vance, Rupert B. *Human Factors in Cotton Culture: A Study in the Social Geography of the American South.* Chapel Hill: University of North Carolina Press, 1929.

Van Trump, James D., and Arthur P. Ziegler, Jr. *Landmark Architecture of Allegheny County, Pennsylvania.* Pittsburgh: Pittsburgh History and Landmarks Foundation, 1967.

van Wagenen, Jared. *The Golden Age of Homespun.* New York: Hill and Wang, 1963.

Vařeka, Josef. "Koliby Zvané Kram." *Slovenský Národopis,* IX:4 (1961) pp. 628–636.

Via, Vera V. "The Old Rail Fence." *Virginia Cavalcade,* XII:1 (Summer, 1962) pp. 33–40.

Vincent, John Robert. "A Study of Two Ozark Woodworking Industries." unpublished M.A. thesis, Anthropology, University of Missouri, June 1962.

Visted, Kristofer, and Hilmar Stigum. *Vår Gamle Bondekultur.* 2 vols., Oslo: J. W. Cappelens, 1951.

von Pelser-Berensberg, Franz. *Mitteilungen über trachten. Hausrat Wohn- und Lebenweise im Rheinland.* Düsseldorf: L. Schwann, 1909.

Vreim, Halvor. "Houses with Gables Looking on the Valley: Influence of the Terrain on the Placement of Buildings." *Folk-Liv*, 1938:3, pp. 295–315.

Vreim, Halvor. "The Ancient Settlements in Finnmark, Norway." *Folkliv*, 1937: 2/3, pp. 169–204.

Währen, Max. "Backen und Backhäuser in Berner Gebeiten." *Schweizer Volkskunde*, 52:2 (1962) pp. 17–22.

[Walker, P.] *The Traditional Tools of the Carpenter and of Other Woodworking Craftsmen*. [London]: K. T. B., 1966.

Walton, James. "Upland Houses: The Influence of Mountain Terrain on British Folk Building." *Antiquity*, XXX:119 (September, 1956) pp. 142–148.

Waring, George E., Jr., and W. S. Courtney. *The Farmers' and Mechanics' Manual*. New York: E. B. Treat, 1868.

Waterman, Thomas Tileston. *The Dwellings of Colonial America*. Chapel Hill: University of North Carolina Press, 1950.

Waterman, Thomas Tileston. *The Mansions of Virginia*. Chapel Hill: University of North Carolina Press, 1946.

Waterman, Thomas Tileston, and John A. Barrows. *Domestic Colonial Architecture of Tidewater Virginia*. New York: Charles Scribner's Sons, 1932.

Watkins, C. Malcolm. "North Devon Pottery and Its Export to America in the 17th Century." *Contributions from the Museum of History and Technology*, U.S. National Museum Bulletin 225, Paper 13, Washington: Smithsonian Institution, 1960, pp. 17–59.

Watkins, Floyd C., and Charles Hubert Watkins. *Yesterday in the Hills: Earthy and Nostalgic Tales of the Southern Hill Folk*. Chicago: Quadrangle, 1963.

Watkins, Lura Woodside. "The Byfield Stones—Our Earliest American Sculpture?" *Antiques*, LXXXIV:4 (October, 1963) pp. 420–423.

Watkins, Lura Woodside. *Early New England Potters and Their Wares.* Cambridge: Harvard University Press, 1950.

Watkins, Lura Woodside. *Early New England Pottery.* Booklet Series, Sturbridge: Old Sturbridge Village, 1959.

Wayland, John Water. *The German Element of the Shenandoah Valley of Virginia.* Charlottesville: author, 1907.

Weaver, Herbert. *Mississippi Farmers, 1850–1860.* Nashville: Vanderbilt University Press, 1945.

Webb, J. R. "Syrup Making." *North Carolina Folklore,* I:1 (June, 1948) p. 17.

Webster, David S. and William Kehoe. *Decoys at Shelburne Museum.* Museum Pamphlet No. 6, Shelburne, Vt.: Shelburne Museum, 1961.

Webster, Marie D. *Quilts: Their Story and How to Make Them.* Garden City: Doubleday, Doran, 1928.

Weiss, Richard. *Häuser und Landschaften der Schweiz.* Erlenbach, Zurich and Stuttgart: Eugen Rentsch, 1959.

Weller, Jack E. *Yesterday's People: Life in Contemporary Appalachia.* [Lexington]: University of Kentucky Press and Council of the Southern Mountains, 1965.

Wells, David A. *The Year-Book of Agriculture; or, The Annual of Agricultural Progress and Discovery, for 1855 and 1856.* Philadelphia: Childs and Peterson, 1856.

Welsh, Peter C. *American Folk Art: The Art and Spirit of a People. From the Eleanor and Mabel Van Alstyne Collection.* Washington: Smithsonian Institution, 1965.

Welsh, Peter C. *Tanning in the United States to 1850.* U.S. National Museum Bulletin 242, Washington: Smithsonian Institution, 1964.

Welsh, Peter C. "Woodworking Tools, 1600–1900." *Contributions from the Museum of History and Technology,* U.S. National Museum Bulletin 241, Paper 51, Washington: Smithsonian Institution, 1966, pp. 178–228.

Went, Arthur E. J. "Irish Fishing Spears." *The Journal of the*

Royal Society of Antiquaries of Ireland, LXXXII (1952) pp. 109–134.

Weygandt, Cornelius. *The Blue Hills.* New York: Henry Holt, 1936.

Weygandt, Cornelius. *The Dutch Country: Folks and Treasures in the Red Hills of Pennsylvania.* New York and London: D. Appleton-Century, 1939.

Weygandt, Cornelius. *The Heart of New Hampshire.* New York: G. P. Putnam's Sons, 1944.

Weygandt, Cornelius. *The Red Hills.* Philadelphia: University of Pennsylvania Press, 1929.

Weygandt, Cornelius. *The White Hills.* New York: Henry Holt, 1934.

Wharton, James. *The Bounty of the Chesapeake: Fishing in Colonial Virginia.* Williamsburg: Virginia 350th Anniversary Celebration, 1957.

"What is American Folk Art? A Symposium." *Antiques,* LVII:5 (May, 1950) pp. 355–362.

Whiffen, Marcus. *The Eighteenth-Century Houses of Williamsburg.* Williamsburg: Colonial Williamsburg, 1960.

Whitaker, Ian. "The Harrow in Scotland." *Scottish Studies,* 2:2 (1958) pp. 149–165.

White, William Chapman. *Adirondack Country.* New York: Duell, Sloan and Pearce; Boston: Little, Brown, 1954.

Whitehill, Walter Muir, and Wendell D. and Jane N. Garrett. *The Arts in Early America.* Chapel Hill: University of North Carolina for Institute of Early American History and Culture at Williamsburg, Virginia, 1965.

Wightman, Orrin Sage, and Margaret Davis Cate. *Early Days of Coastal Georgia.* St. Simons Island, Ga.: Fort Frederica Association, 1955.

Wilder, Louise Beebe. *Lucius Beebe of Wakefield and Sylenda Morris Beebe, His Wife: Their Forbears and Descendents.* New York: Knickerbocker Press, 1930.

Wildhaber, Robert. "A Bibliographical Introduction to American Folklife." *New York Folklore Quarterly*, XXI:4 (December, 1965) pp. 259–302.

Wildhaber, Robert. "Gerstenmörser, Gerstenstampfe, Gerstenwalze." *Schweizerisches Archiv für Volkskunde*, 45:3 (1948) pp. 177–208.

Wildung, Frank H. *Woodworking Tools at Shelburne Museum*. Museum Pamphlet Series No. 3, Shelburne, Vt.: Shelburne Museum, 1957.

Wiley, H. W. "Table Sirups." *Yearbook of the United States Department of Agriculture: 1905*, Washington: Government, 1906, pp. 241–248.

Wilhelm, E. J., Jr. "Folk Settlement Types in the Blue Ridge Mountains." *Keystone Folklore Quarterly*, XII:3 (Fall, 1967) pp. 151–174.

Williams, Cratis. "Moonshining in the Mountains." *North Carolina Folklore*, XV:1 (May, 1967) pp. 11–17.

Williams, Hattie Plum. "A Social Study of the Russian Germans." *University Studies Published by the University of Nebraska*, XVI:3 (July, 1916) pp. 127–227.

Williams, Henry Lionel. *Country Furniture of Early America*. New York: A. S. Barnes; London: Thomas Yoseloff, 1963.

Williams, Henry Lionel and Ottalie K. Williams. *A Guide to Old American Houses, 1700–1900*. New York: A. S. Barnes; London: Thomas Yoseloff, 1962.

Williams, Jonathan. "The Southern Appalachians." *Crafts Horizons*, XXVI:3 (June, 1966) pp. 46–67.

Williams, W. M. *The Country Craftsman: A Study of Some Rural Crafts and the Rural Industries Organisation in England*. Dartington Hall Studies in Rural Sociology, London: Routledge and Kegan Paul, 1958.

Willoughby, Charles C. *Antiquities of the New England Indians*. Cambridge: Peabody Museum, 1935.

Wilson, Charles Morrow. *Backwoods America*. Chapel Hill: University of North Carolina Press, 1934.

Wilson, Charles Morrow. *The Bodacious Ozarks: True Tales of the Backhills*. New York: Hastings House, 1959.

Wilson, Gordon (assisted by Mary Alice Hanson). *Folkways of the Mammoth Cave Region*. Bowling Green and Mammoth Cave, Ky.: author, 1962.

Wilson, H. G. "The Adirondack Pack-Basket." *Fur News and Outdoor World*, XXXIII:4 (April, 1921) p. 22.

Wilson, Harold Fisher. *The Hill Country of Northern New England*. Columbia University Series in the History of American Agriculture, III, New York: Columbia University Press, 1936.

Winchester, Alice, ed. *The Antiques Book*. New York: A. A. Wyn, 1950.

"Winter in the South, A." *Harper's New Monthly Magazine*, XV: LXXXVIII (September, 1857), pp. 433–451.

Withers, Robert Steele. "The Stake and Rider Fence." *Missouri Historical Review*, XLIV: 3 (April, 1950) pp. 225–231.

Wittlinger, Carlton O. "Early Manufacturing in Lancaster County, Pennsylvania, 1710–1840." unpublished Ph.D. thesis, History, University of Pennsylvania, 1953.

Wolcott, Imogene. *The Yankee Cook Book*. New York: Coward-McCann, 1939.

Wolcott, Stephen C. "The Frow—A Useful Tool." *The Chronicle of the Early American Industries Association*, I:6 (July, 1934) pp. 1,3.

Wolff, Eldon G. "Wyatt Atkinson: Riflesmith." *Lore*, 14:2 (Spring, 1964) pp. 38–52; reprinted as Milwaukee Public Museum Publication in History No. 6.

Wood, Ralph, ed. *The Pennsylvania Germans*. Princeton: Princeton University Press, 1942.

Wood-Jones, Raymond B. *Traditional Domestic Architecture in*

the *Banbury Region*. Manchester: Manchester University Press, 1963.

Woodbury, Robert S. *History of the Lathe to 1800*. Cambridge: Massachusetts Institute of Technology, 1964.

Woodward, Carl Raymond. *Ploughs and Politicks: Charles Read of New Jersey and His Notes on Agriculture*. New Brunswick: Rutgers University Press, 1941.

Woofter, T. J. *Black Yeomanry*. New York: Henry Holt, 1930.

Works Projects Administration. *Kentucky, A Guide to the Bluegrass State*. New York: Harcourt, Brace, 1942.

Works Projects Administration. *West Virginia, A Guide to the Mountain State*. New York: Oxford University Press, 1941.

Worthington, Addison F. *Twelve Old Houses West of Chesapeake Bay*. The Monograph Series, Boston: Rogers and Manson, 1918; New York: Arrow, 1931.

Wright, Martin. "Log Culture in Hill Louisiana." unpublished Ph.D. dissertation, Geography and Anthropology, Louisiana State University, August, 1956.

Wright, Martin. "The Antecedents of the Double-Pen House Type." *Annals of the Association of American Geographers*, 48:2 (June, 1958) pp. 109–117.

Xan, Erna Oleson. *Wisconsin My Home*. Madison: University of Wisconsin Press, 1952.

Yoder, Don. "The Costumes of the 'Plain People'." in *In the Dutch Country*. Lancaster: Pennsylvania Dutch Folklore Center, n.d., c. 1954, pp. 9–11; also in *Pennsylvania Folklife*, 11: Special Issue (1960) pp. 29–31; and in *The Pennsylvania Dutch Folk Culture*, n.p.: n.p., n.d., probably: Lancaster: Pennsylvania Folklife Society, 1962, pp. 4–10.

Yoder, Don. "The Folklife Studies Movement." *Pennsylvania Folklife*, 13:3 (July, 1963) pp. 43–56.

Yoder, Don. "Men's Costume Among the Plain People." *The Pennsylvania Dutchman*, IV:15 (Easter, 1953) pp. 6–7, 9.

Yoder, Don. "Pennsylvanians Called It Mush." *Pennsylvania Folk-life*, XIII:2 (Winter, 1962–1963) pp. 27–49.

Yoder, Don. "Sauerkraut in the Pennsylvania Folk-Culture." *Pennsylvania Folklife*, 12:2 (Summer, 1961) pp. 56–69.

Yoder, Don. "Schnitz in the Pennsylvania Folk-Culture." *Pennsylvania Folklife*, 12:3 (Fall, 1961) pp. 44–53.

Yoder, John Paul. "Social Isolation Devices in an Amish-Mennonite Community." unpublished M.A. thesis, Sociology, Pennsylvania State College, August, 1941.

Young, Pauline V. *The Pilgrims of Russian-Town: The Community of Spiritual Christian Jumpers in America.* Chicago: University of Chicago Press, 1932.

Zehner, Olive G. "Early Barn-Scene Painter." *The Pennsylvania Dutchman*, IV:10 (January 15, 1953) pp. 16–15.

Zehner, Olive G. "Ohio Fractur." *The Dutchman*, 6:3 (Winter, 1954–1955) pp. 13–15.

Zehner, Olive G. "The Hills from Hamburg." *The Pennsylvania Dutchman*, IV:11 (February 1, 1953) pp. 16, 13.

Zelenin, Dmitrij. *Russische (Ostslavische) Volkskunde.* Berlin and Leipzig: Walter de Gruyter, 1927.

Zelinsky, Wilbur. "The Log House in Georgia." *The Geographical Review*, XLIII:2 (April, 1953) pp. 173–193.

Zelinsky, Wilbur. "The New England Connecting Barn." *The Geographical Review*, XLVIII:4 (October, 1958) pp. 540–553.

Zelinsky, Wilbur. "Walls and Fences." *Landscape*, 8:3 (1959) pp. 14–20.

Zelinsky, Wilbur. "Where the South Begins: The Northern Limit of the Cis-Appalachian South in Terms of Settlement Landscape." *Social Forces*, 30:2 (December, 1951) pp. 172–178.

Zinsli, P. "Vom Brotbacken in Safien." *Schweizer Volkskunde*, 31:1 (1941) pp. 2–5.

INDEX

Italicized numbers indicate pages on which there are illustrations.